SELECTED PAINTINGS AND SCULPTURE

FROM THE YALE UNIVERSITY ART GALLERY

SELECTED Paintings and Sculpture

FROM THE Yale University Art Gallery

INTRODUCTION: ANDREW CARNDUFF RITCHIE

COMMENTARIES: KATHARINE B. NEILSON

PUBLISHED FOR THE YALE UNIVERSITY ART GALLERY BY

YALE UNIVERSITY PRESS, NEW HAVEN AND LONDON 1972

This publication has been made possible by a fund
provided by Mrs. John Day Jackson.

Library of Congress catalog card number: 76–179475
ISBN: 0–300–01562–3 (cloth) 0–300–01566–6 (paper)

Designed by Sally Sullivan
and set in Linotype Garamond type.
Printed in the United States of America by
Eastern Press, Incorporated,
New Haven, Connecticut.
Colorplates printed in Germany by Brüder Hartmann, Berlin.

Published in Great Britain, Europe, and Africa by
Yale University Press, Ltd., London. Distributed in Canada by
McGill-Queen's University Press, Montreal; in Latin
America by Kaiman & Polon, Inc., New York City; in India by
UBS Publishers' Distributors Pvt., Ltd., Delhi; in
Japan by John Weatherhill, Inc., Tokyo.

# CONTENTS

Introduction

Note to the Reader

Colorplates

Paintings

Thirteenth to Sixteenth Centuries   1

Seventeenth Century   *Dutch*   17
                      *Flemish*   23
                      *French*   26
                      *German*   27
                      *Italian*   28
                      *Spanish*   30

Eighteenth Century   *American*   31
                     *British*   45
                     *French*   51
                     *Italian*   53

Nineteenth Century   *American*   57
                     *British*   70
                     *Dutch*   72
                     *French*   73

Twentieth Century   *American*   87
                    *Belgian*   95
                    *Chilean*   97
                    *Dutch*   98
                    *French*   99
                    *Hungarian*   104
                    *Italian*   105
                    *Russian*   107
                    *Spanish*   111

Sculpture

Twelfth to Seventeenth Centuries   116

Eighteenth Century   *French*   125
                     *German*   128

Nineteenth Century   *American*   129
                     *French*   132

Twentieth Century   *American*   133
                    *British*   143
                    *French*   147
                    *German*   151
                    *Italian*   152
                    *Romanian*   153
                    *Swiss*   154

Index of Artists   following last entry

# INTRODUCTION

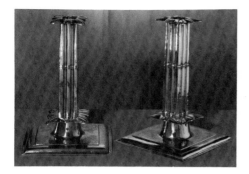

*Pair of silver candlesticks,* Jeremiah Dummer,
Boston, Massachusetts, ca. 1680–90
The Mabel Brady Garvan Collection
1935.234, 1953.22.1

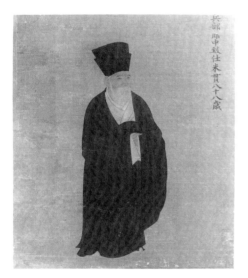

*Chu Kuan,* Chinese, Sung Dynasty,
11th century A.D.
The Hobart and Edward Small Moore
Memorial Collection   1953.27.11

*Christian Baptistery from Dura-Europos,*
ca. 230 A.D.

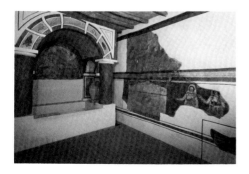

University art museums are often uneven in the extent and
the quality of their collections. For the most part they are
dependent on donors for as much as ninety per cent of their
holdings, and consequently the flow and balance of
acquisitions is almost impossible to predict or control.
Yale, however, in this connection has been fortunate in
two respects: its art gallery, founded in 1832, has been
in existence longer than any other college or university
art gallery on this continent; and it has been particularly
fortunate in the generosity and perceptiveness of a long
line of donors. As the years have passed and donors with a
wide diversity of interests in collecting have come to the
assistance of the Gallery, a fairly respectable balance of
representation in the arts from ancient times to the
immediate present has emerged.

While the present picture book is limited to European
and American painting and sculpture from the thirteenth
century to the present, a word about the range of the
Gallery's other collections is in order. In number, scope,
and quality the Mabel Brady Garvan Collection of
American colonial furniture, silver, pewter, ceramics,
and prints is far and away the most important collection
in the Gallery, aside from paintings and sculpture. Next
in importance and extensiveness must be the combined
Hobart and Ada Small Moore Collections of Near and Far
Eastern textiles, paintings, bronzes, sculpture, and
ceramics. Perhaps equally important and remarkably
extensive is the Rebecca Darlington Stoddard Collection
of Greek and Etruscan vases. Following these relatively
comprehensive and cohesive collections mention must be
made of the art and artifacts from the Roman frontier
town in Syria, Dura-Europos, excavated in the late 1920s
and early 1930s by Yale University in collaboration with
the French government. These are of extraordinary
archaeological and, to some degree, artistic interest,
including as they do a Roman Mithraic shrine with wall
paintings and carvings, some painted tiles from a syna-
gogue, and fragmentary wall paintings from one of the
earliest known Christian baptisteries. Piecing out these
collections of ancient art, but in no comprehensive way,
the Gallery has acquired over the years other examples of
Mesopotamian, Egyptian, Greek, and Roman art; for
example, five alabaster relief carvings from the palace of
the Assyrian king Ashur-Nasir-pal (883–39 B.C.),
purchased by the University in 1854, and more recently a
life-size marble *Torso of a Youth* from Asia Minor, first

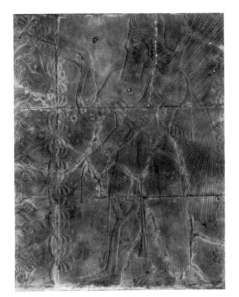

*Winged Figure from the Palace of Ashur-Nasir-pal,* Assyrian, 9th century B.C.
University purchase   1854.1

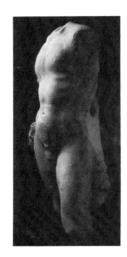

*Torso of a Youth,*
Asia Minor,
1st century A.D.
Gift of the Yale
University Art
Gallery Associates
1961.26

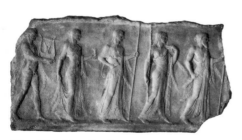

*Five Divinities,* Greek, 1st century B.C.–
2nd century A.D.
Leonard C. Hanna, B.A. 1913, Fund
1965.132

century A.D., and a Greek marble frieze of *Five Divinities,* first century B.C.–second century A.D.

Within the past two decades the Gallery has also been presented with two relatively small but distinguished collections: the Linton Collection of African art, given and promised by Mr. and Mrs. James Osborn, and Pre-Columbian art, given by Mr. and Mrs. Fred Olsen.

Of prime importance for the study of the history of art the Gallery's collection of drawings, watercolors, and prints is of considerable size and diversity, consisting of many thousands of works in these various media and dating from the Renaissance to the present day. Several donors have been responsible for the growth of these collections, among them the late Edward B. Greene of the class of 1900, the late Frederic George Achelis of the class of 1907, the late Miss Edith Wetmore, whose father was a Yale graduate, class of 1867, and Mr. and Mrs. Walter Bareiss, class of 1940S. Prints, drawings, and watercolors are housed together in a department on the fourth floor, recently modernized and containing an air-conditioned storage room, a viewing and seminar room, and a public exhibition gallery for changing exhibitions.

With this brief outline of the resources of the Gallery, other than Western paintings and sculpture, it is of interest to note something of the chronology of the Gallery's acquisitions and the several buildings in which they have been exhibited.

Following Yale College's foundation in 1701, for more than a century the art collections consisted largely of portraits, which hung in various buildings on the campus. A few of these are worthy of mention for one reason or another. Elihu Yale in 1718 sent his college a portrait of George I, painted in the studio of the most fashionable portrait painter of his day working in England, the German-born Sir Godfrey Kneller. A portrait of Elihu Yale himself, painted in 1717, was given to the college in 1789 by Dudley North, Elihu Yale's grandson. The full-length portrait, *Washington at Trenton,* by John Trumbull, was the gift of the Connecticut Branch of the Society of the Cincinnati in 1806. Painted in 1729 and given in 1808, the most remarkable of these historical portraits is that of *The Bermuda Group (Dean Berkeley and His Entourage),* by John Smibert, probably the first group portrait painted in America.

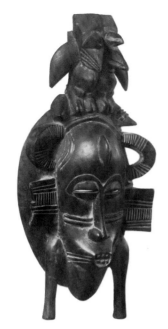

*Dance Mask,* Senufo, Ivory Coast, Africa
Gift of Mr. and Mrs. James M. Osborn
for the Linton Collection of African Art
1960.33.5

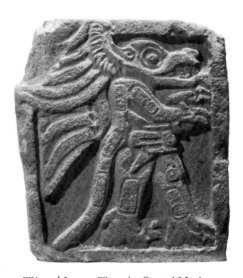

*Winged Jaguar,* Tlaxcala, Central Mexico,
before 500 A.D.
Gift of Mr. and Mrs. Fred Olsen    1958.15.7

Such portraits as these and a few others that must go unmentioned did not warrant a gallery to themselves. The acquisition by the college of nearly one hundred pictures by the "patriot-artist" John Trumbull surely did, and in fact the building of a gallery for their presentation was part of the contract with Trumbull, together with an annuity of $1,000, and a promise to bury him and his wife under the gallery and to refuse all loans from the collection on pain of losing the whole collection to Trumbull's alma mater, Harvard, if this condition were violated. Yale did meet and has continued to meet all of Trumbull's conditions. Professor Benjamin Silliman, Yale class of 1796 and Trumbull's nephew-in-law, was largely responsible for persuading his college to agree to these arrangements. A gallery was built and opened to students and the public in 1832, and Silliman was appointed curator. This building was demolished in 1901 but Trumbull's and his wife's remains have been piously moved twice since their original interment, following as they have two succeeding locations for the exhibition of his paintings. And no loans have been made meanwhile.

The acquisition by the College of Trumbull's original paintings of *The Declaration of Independence, The Battle of Bunker's Hill,* and other scenes from the Revolution, together with upwards of sixty portrait miniatures painted from life and used in transferring likenesses to the larger canvases, brought immediate artistic and historical acclaim to Yale. While these original Revolution paintings were copied much later on a larger scale for the Capitol in Washington and again for the Wadsworth Atheneum in Hartford, and the subjects achieved national recognition by engravings in generations of schoolbooks on American history, the fact remains that those who wish to study Trumbull when he was at the height of his patriotic fervor in these paintings must come to the Yale Art Gallery. And it should be added that to get closest to Trumbull's spirit and technical virtuosity the miniature portraits, not so widely reproduced, are of prime importance.

If Trumbull's collection was acquired with some unusual conditions attached, the next large collection of paintings came to Yale in 1871 by default. James Jackson Jarves, undoubtedly following the taste for early Italian paintings promoted at first by the German Nazarene painters and later by the English Pre-Raphaelites, became such an enthusiastic collector of thirteenth-, fourteenth-, and

fifteenth-century Italian paintings that he in effect bankrupted himself in the process. His evangelical zeal "to promote the diffusion of artistic knowledge and aesthetic taste in America" led him, as part of his education program, to deposit his collection on loan in the new Art School building, the first in the western hemisphere, given to Yale in 1864 by Augustus Russell Street, class of 1812, and known today as Street Hall. The collection served as collateral for a loan by Yale to Jarves of $20,000, which at the end of three years, including a one-year extension, Jarves was unable to pay back. The collection was therefore put up to auction in 1871 and Yale, the only bidder, rather regretfully no doubt from the Treasurer's standpoint, acquired the collection of 119 paintings for $22,000.*
It should be said at once that it took another generation to begin to appreciate how important the Jarves Collection was. It was for many years after its acquisition the largest and most representative collection of its kind on this continent. It has, of course, long since been surpassed by collections in a number of our major metropolitan museums; but even so it remains probably the richest resource for study of early Italian painting in any American university. Furthermore, it has attracted within recent years additional gifts of paintings of the period by such donors as the late Maitland F. Griggs, class of 1896, the late Louis M. Rabinowitz, and the late Robert Lehman, class of 1913.

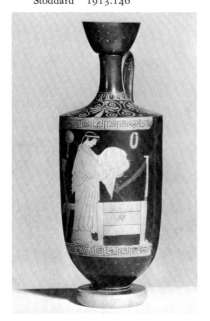

*Lecythus* (oil flask), "Painter of the Yale Lecythus," Greek, Attic, 1st half 5th century B.C. Gift of Rebecca Darlington Stoddard 1913.146

Forty years elapsed between the acquisition of the Trumbull and Jarves collections. Another forty years or so were to elapse before the coming to the Gallery in 1913 of the Stoddard Collection of Greek and Etruscan vases. Numerous examples of early American art, early Italian art, ancient art, in that order, then, had come to the Yale Art Gallery over a period of eighty years, and the need for a museum building separate from the Art School in Street Hall became increasingly obvious. Plans for a new building were begun in 1924 and the building was completed in 1928. With the prospect of a new building important new gifts came to the Gallery, including five life-size medieval French sculptures, presented by Maitland F. Griggs, and valuable collections of Rembrandt and Dürer prints, gifts of Frederic George Achelis. The 1928

*A more extensive account of this transaction is recorded by Charles Seymour, Jr., in his catalogue of *Early Italian Paintings in the Yale University Art Gallery,* published for the Gallery by the Yale University Press in 1970.

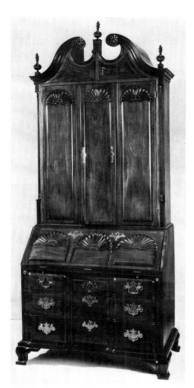

*Block front secretary bookcase,*
possibly Goddard-Townsend
workshop, Newport, Rhode Island,
ca. 1785
The Mabel Brady Garvan
Collection    1940.320

building was no sooner opened than in the following year
the hundreds of objects from Dura-Europos began to
arrive, and hard upon their arrival came the announced
gift in 1930 of the extraordinarily comprehensive and
qualitatively superb Mabel Brady Garvan Collection of
colonial and early-nineteenth-century American art. This
collection, the gift of Francis P. Garvan, class of 1897,
was made in honor of his wife, and it immediately thrust
Yale into the forefront of museums, university or other-
wise, containing important collections of American art.
The value of the Garvan and related collections for teach-
ing in departments such as history, American studies, and
art history, cannot be overestimated. The ordinary visitor
is equally indebted to Mr. Garvan for the visual evidence
of an earlier America which his collections offer.

Supplementing the Garvan Collection and definitely
enriching the Gallery's representation of early American
portraiture, John Hill Morgan, class of 1893, and his wife
gave an important collection of paintings and portrait
miniatures between 1937 and 1951 and also provided a
purchase fund for future acquisitions in this field.

Up to this point the Yale Art Gallery had little or nothing
to show of modern art. The Depression years of the 1930s
did little to correct this imbalance. However, in 1941 a
very significant correction was made by the late Katherine
S. Dreier's gift of the so-called Société Anonyme Collection
of modern paintings, sculpture, and prints, which she had
formed in collaboration with Marcel Duchamp. Miss
Dreier, like Duchamp, was a painter. In the introduction
to the Société Anonyme catalogue published in 1950
(now out of print), George Heard Hamilton, then Curator
of the Collection, had this to say:

"Although other collections of contemporary art have
entered public museums it must be admitted that most of
these were formed by persons who were primarily collec-
tors or museum administrators rather than artists them-
selves. That fact should not be forgotten as one examines
the works described in this volume or studies them in the
galleries at Yale. They were selected by artists, which
means that their choices were governed by their own im-
mediate understanding of the issues which they knew to
be important for the future of modern art. All other con-
siderations which may from time to time affect one's
choice, such issues as that thorny problem of what forever
indeterminable value the future may set, or the temporary

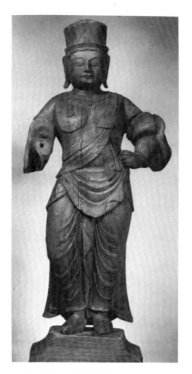

*Bon Ten, a Buddhist Deity,*
Japanese, Heian Period,
794–1185 A.D.
Leonard C. Hanna, B.A. 1913,
Fund   1963.31

*Sphinx,* Etruscan, from Vulci, late
6th century B.C.
Leonard C. Hanna, B.A. 1913,
Fund   1966.59

eminence of some particular artist or school, were absent
as the Collection of the Société Anonyme was formed.
For these reasons the Collection holds for all of us the
excitement of discovery. Here is not merely a sequence of
familiar figures carefully arranged to provide an historical
survey of modern art; this *is* modern art in the sense that
here are the issues and the personalities who made it, some
well-known, others now or still obscure, who have estab-
lished what we must consider the progressive liberalizing
tendencies of the twentieth century. Throughout the entire
Collection there resides, we believe, that spirit of enduring
affection, that sense of intimate participation, in these
fundamental problems of expression, which could only
come from the continued presence of those gifted per-
sonalities who have participated in the creation of modern
art. No group of scholars or curators, however learned,
could have or would have formed a collection as have
Katherine Dreier and Marcel Duchamp and their asso-
ciates, artists of such distinction as Kandinsky, Man Ray,
and Campendonk."

Since 1950 the Gallery's representation of contemporary
American and European art has expanded steadily and
altogether is now the most extensive of any university
museum in America or elsewhere.

The addition of the Société Anonyme Collection led to the
need for further exhibition space and in 1953 a modern
wing, designed by Louis Kahn, was connected with the
1928 building, extending the museum complex on Chapel
Street from High to York Streets. This new air-conditioned
wing has in turn attracted further distinguished gifts and
purchases of painting and sculpture. The two most notable
gifts of the past decade were the bequests of Stephen C.
Clark, class of 1903, and Louis M. Rabinowitz. The Clark
bequest brought to Yale our first paintings by Hals, Van
Gogh, Manet, Homer, and Hopper, and some of our
finest paintings by Corot, Copley, Eakins, and Bellows.
The Rabinowitz bequest, already mentioned, supplements
the Jarves Collection of early Italian paintings and in-
cludes paintings contemporary with them from northern
Europe. The past decade or so has also seen the addition
to our collections of several hundred paintings, sculptures,
drawings, and watercolors, and several thousand prints.
This considerable flowering of the Gallery's holdings in
almost all areas has been made possible by many donors
too numerous to mention by name, and by purchases made

to fill out points of strength or strengthen points of weakness in our collections as a whole.

I should like to add a word of thanks here to my associate, Katharine B. Neilson, who has written the commentaries to the following illustrations. These commentaries are designed for the general reader and are intended both in language and in the selection of illustrations to introduce the Gallery visitor with only a limited time at his disposal to a selection of the most important paintings and sculpture on exhibition. More exhaustive catalogues of certain areas of the Gallery collections have been published recently: *French and School of Paris Paintings* by Françoise Forster-Hahn, *Early Italian Paintings* by Charles Seymour, Jr., *Far Eastern Art* by George Lee, *European Drawings and Watercolors 1500–1900* by Egbert Haverkamp-Begemann and Anne-Marie Logan, and *American Silver* by Kathryn C. Buhler and Graham Hood. The reader is referred to these publications for further information. Other catalogues such as those on American furniture and twentieth-century art are in preparation.

ANDREW CARNDUFF RITCHIE
*Director Emeritus*

NOTE TO THE READER

The catalogue entries following the colorplates are arranged chronologically by century, and within each century alphabetically by artist's nationality (e.g. American, British, etc.). Entries under each nationality appear in chronological, not alphabetical, sequence. This arrange--ment is intended to give a clearer picture of the development of painting and sculpture since ca. 1100 than would an alphabetical listing of artists. The index at the back of the book gives such an alphabetical list for convenient reference.

Each entry includes the artist's name and life dates, title of the work and its date if known, medium, dimensions in inches (height precedes width; diameter and length are sometimes added in the case of sculpture), provenance (whether gift or purchase), and finally the accession number by which the object is identified in the registrar's files (the first four digits of this number indicate the year of acquisition). When no specific artist can be named, the object is classified according to country of origin and century. Where no date follows the title of a work, it is because no specific date has been recorded or can be deduced on the basis of existing evidence.

# Colorplates

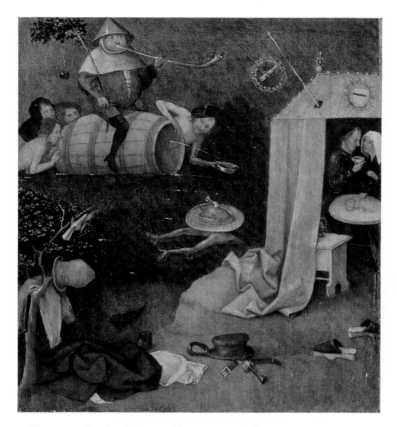

1. Hieronymus Bosch, *Allegory of Intemperance* [4]

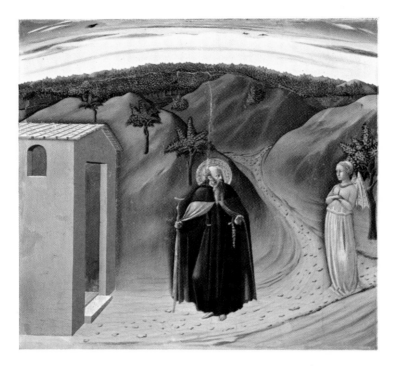

2. Sassetta (?) or "Osservanza Master," *Temptation of St. Anthony* [10]

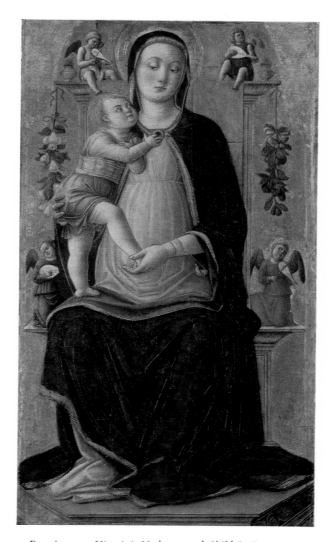

3. Bartolommeo Vivarini, *Madonna and Child* [12]

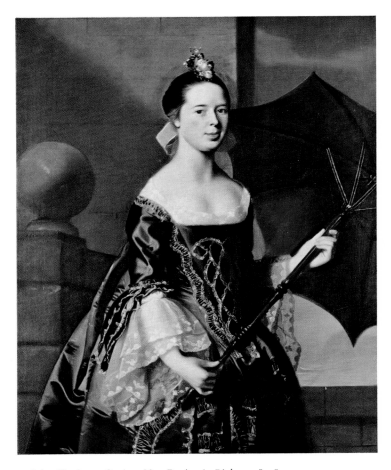

4. John Singleton Copley, *Mrs. Benjamin Pickman* [33]

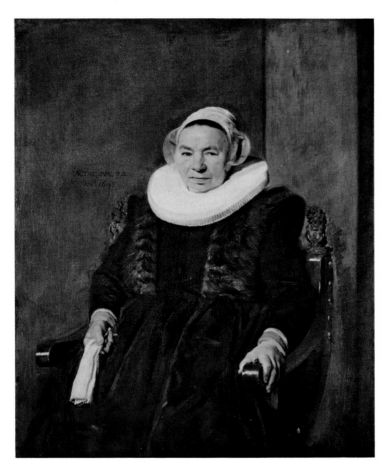

5. Frans Hals, *Mevrouw Bodolphe* [20]

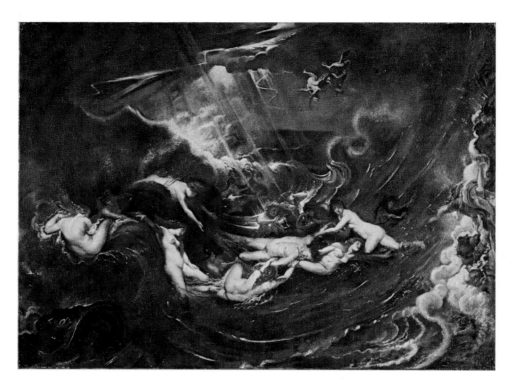

6. Peter Paul Rubens, *Hero and Leander* [23]

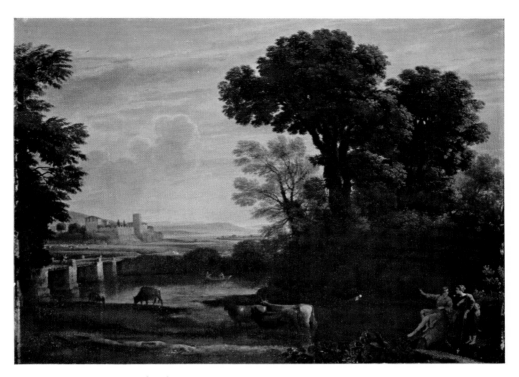

7. Claude Lorrain, *A Pastoral* [26]

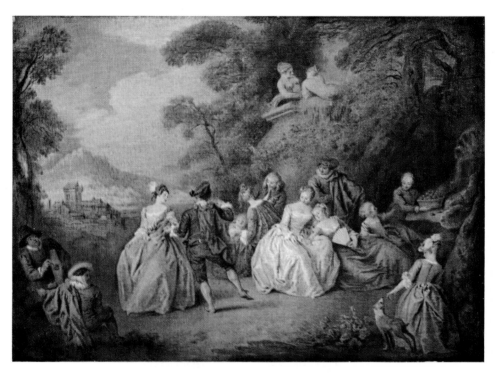

8. Jean-Baptiste Pater, *Courtly Scene in a Park* [51]

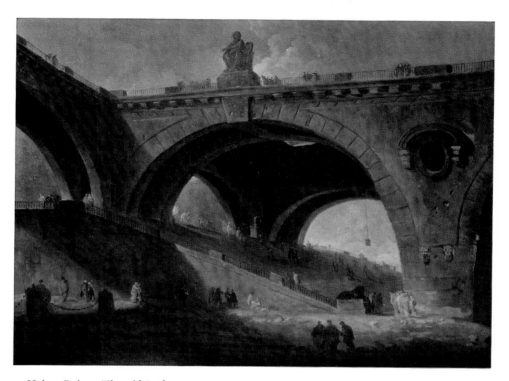

9. Hubert Robert, *The Old Bridge* [52]

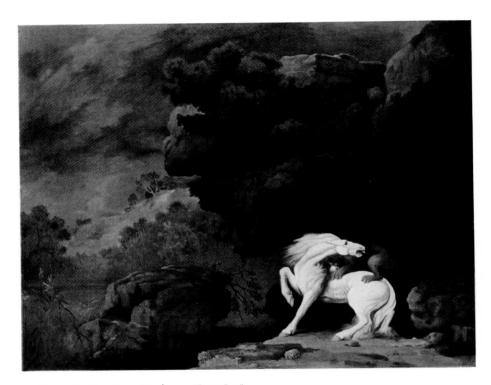

10. George Stubbs, *Lion Attacking a Horse* [49]

11. Winslow Homer, *The Morning Bell* [64]

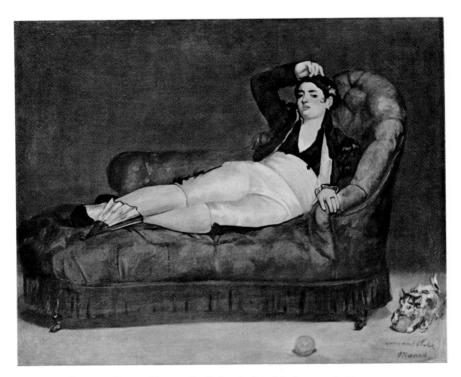

12. Edouard Manet, *Young Woman Reclining in Spanish Costume* [78]

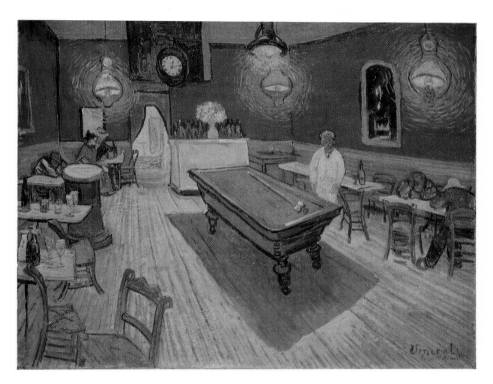

13. Vincent Van Gogh, *Night Café* [72]

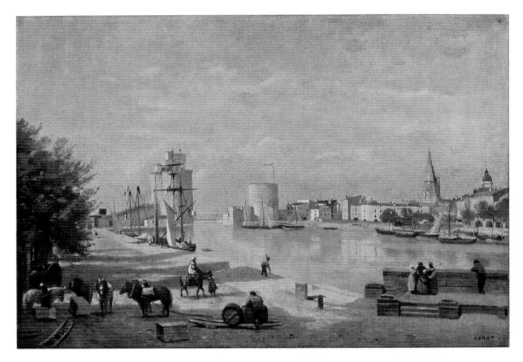

14. Jean-Baptiste Camille Corot, *The Harbor of La Rochelle* [73]

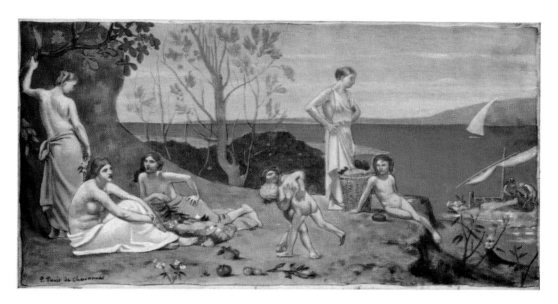

15. Pierre Puvis de Chavannes, *The Pleasant Land* [76]

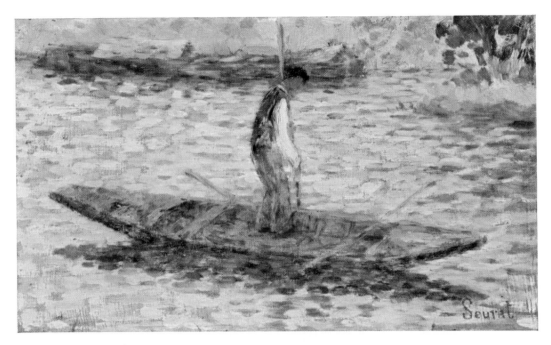

16. Georges Seurat, *Fisherman* [84]

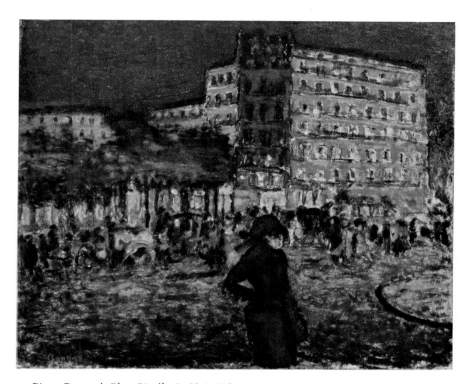

17. Pierre Bonnard, *Place Pigalle, La Nuit* [86]

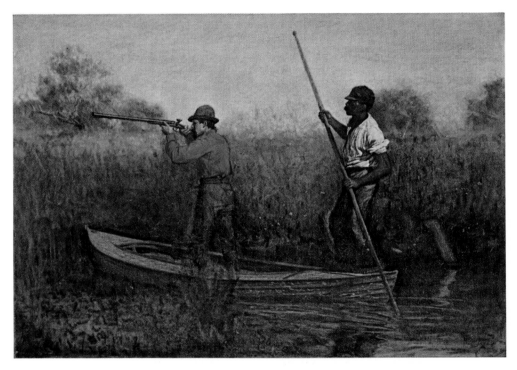

18. Thomas Eakins, *Will Schuster and Blackman Going Shooting for Rail* [67]

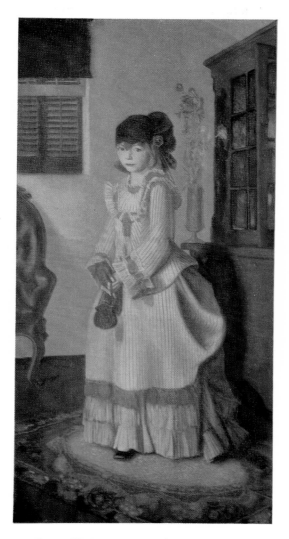

19. George Wesley Bellows, *Lady Jean* [87]

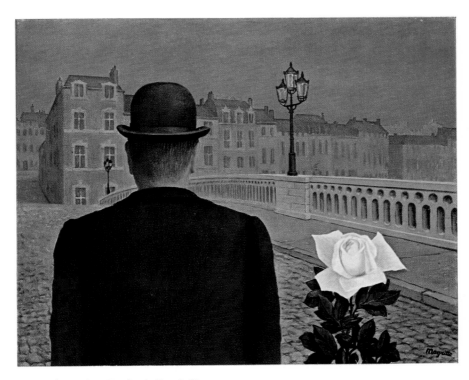

20. René Magritte, *Pandora's Box* [96]

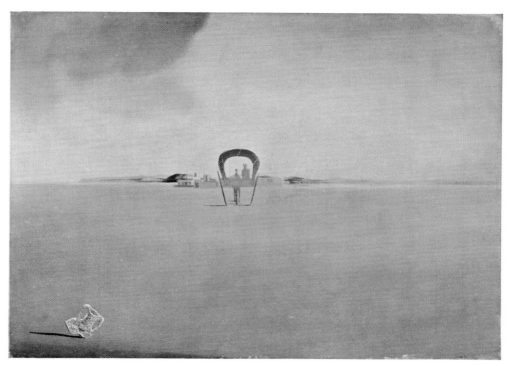

21. Salvador Dali, *The Phantom Cart* [115]

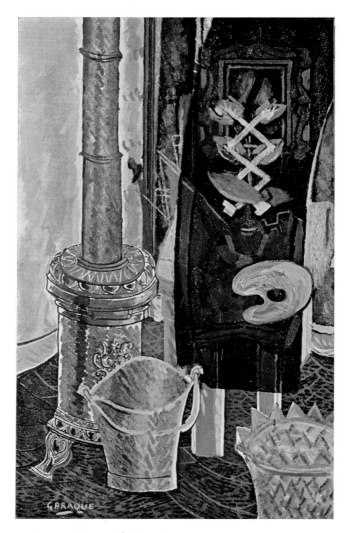

22. Georges Braque, *The Stove* [102]

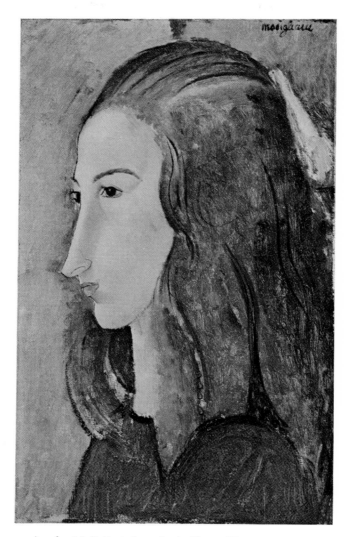

23. Amedeo Modigliani, *Portrait of a Young Woman* [105]

24. Joseph Stella, *Brooklyn Bridge* [88]

25. Kasimir Malevich, *Scissors Grinder* [109]

26. Pablo Ruiz Picasso, *Dog and Cock* {112}

27. Pablo Ruiz Picasso, *First Steps* [113]

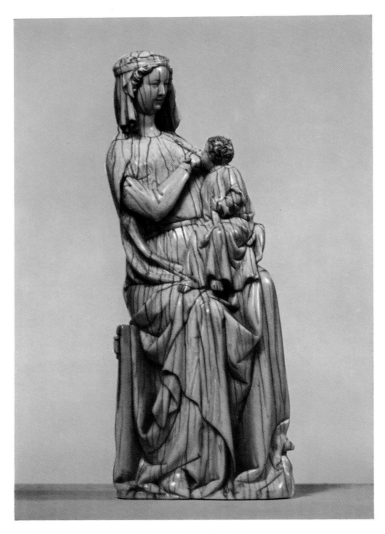

28. French, 14th century, *Virgin and Child* [118]

Paintings

1. "MAGDALEN MASTER"

Italian, 2nd half of 13th century

*Madonna and Child with Saints,*
ca. 1270

Egg tempera on panel reinforced
by linen

41¼ x 63 in. (including frame)

University purchase from
James Jackson Jarves

1871.3

The name "Magdalen Master" is a fictitious one chosen to describe the characteristics of a painting of St. Mary Magdalen in the Accademia, Florence. It indicates a style found in Florence about 1250–90, which seems to come from a workshop involving several masters working together and characterized by both Byzantine and medieval Tuscan features.

In this panel the Virgin is enthroned between St. Leonard and St. Peter, each identified by a Latin inscription. St. Leonard's position at the Virgin's right—the place of honor—may mean that the altarpiece was painted for a church dedicated to that deacon saint, quite possibly S. Leonardo in Arcetri, a small Romanesque church on the outskirts of Florence.

The style of the picture, with its boldly outlined forms and clear flat colors, has something of the hieratic power of Byzantine mosaics. Seen by the light of altar candles, it must have combined decorative splendor with an awesome vision of divine mystery, tempered by the popular Gothic theme of the human Mother nursing her Child. The small scenes at the sides illustrate events in the life of St. Peter.

2. AMBROGIO LORENZETTI
(attributed to)

Italian, active 1319–1348

*St. Martin and the Beggar*
ca. 1340–45

Egg tempera on panel

11¾ x 8³⁄₁₆ in.

University purchase from
James Jackson Jarves

1871.11

Ambrogio Lorenzetti and his older brother Pietro were two of the most important Sienese painters in the early fourteenth century. Ambrogio was active in Siena and Florence from 1319 to 1348 when he died, probably of the plague which was so devastating in that year. His contact with the more progressive Florentine painting doubtless accounts for a new monumentality in his altarpieces and frescoes, the most famous of which are the *Good and Bad Government* murals in the Palazzo Pubblico, Siena.

*St. Martin and the Beggar* illustrates the story of the young Christian soldier who shared his cloak with a freezing beggar subsequently revealed as Christ himself. This act of mercy would be an appropriate subject for an altarpiece destined for a charitable institution. Recent research has identified the Yale *St. Martin* as originally part of Ambrogio's so-called *Small Maestà* (Madonna Enthroned in Majesty) painted for the Ospedale di S. Maria della Scala in Siena. If equine anatomy was not Ambrogio's strong point, he nevertheless told his story with sympathy, charm, and characteristic delicacy of detail. The compassionate saint is represented not as a Roman soldier but as a young Sienese warrior better fitted for the Palio than for the battlefield.

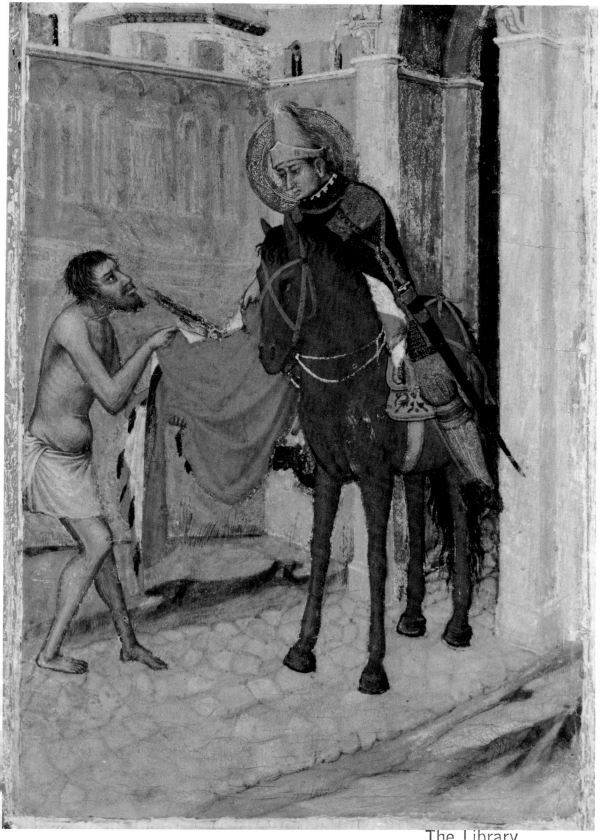

64147

3. TADDEO GADDI

Italian, active 1327–1366

*Entombment of Christ,* ca. 1345

Egg tempera on panel

$45\frac{5}{8} \times 29\frac{11}{16}$ in.

University purchase from
James Jackson Jarves

1871.8

Taddeo Gaddi is described in a document of 1347 as one of the best painters in Florence. Vasari, the famous sixteenth-century biographer, says he was a godson and pupil of Giotto. Between 1327 and 1332 he worked on the frescoes in the Baroncelli chapel in Sta. Croce in Florence; he was active in Pisa in 1342. He died in 1366.

Although the presence of the coffin dictates the title of this picture, the subject is actually not so much an Entombment as a Pietà—the dead Christ in the arms of his mother after the Deposition. Like Giotto, Taddeo presents the scene through human eyes and feelings; even the mourning angels seem involved with the grief of the Virgin Mary and St. John, instead of appearing in traditional fashion as supernatural, and compositionally decorative, witnesses of the event. This humanizing tendency in fourteenth-century art reflects the influence of St. Francis of Assisi and of various mystical writers of the day, among them the Umbrian poet and mystic Fra Simone of Cascia who is known to have been a friend of Taddeo Gaddi in Florence.

The *Entombment* has been cut down slightly from its original size; nearly half of the figure of St. John has been lost, and the composition therefore seems unduly crowded. The powerful modeling of the figures and the controlled intensity of the facial expressions convey much of the dramatic force characteristic of Giotto.

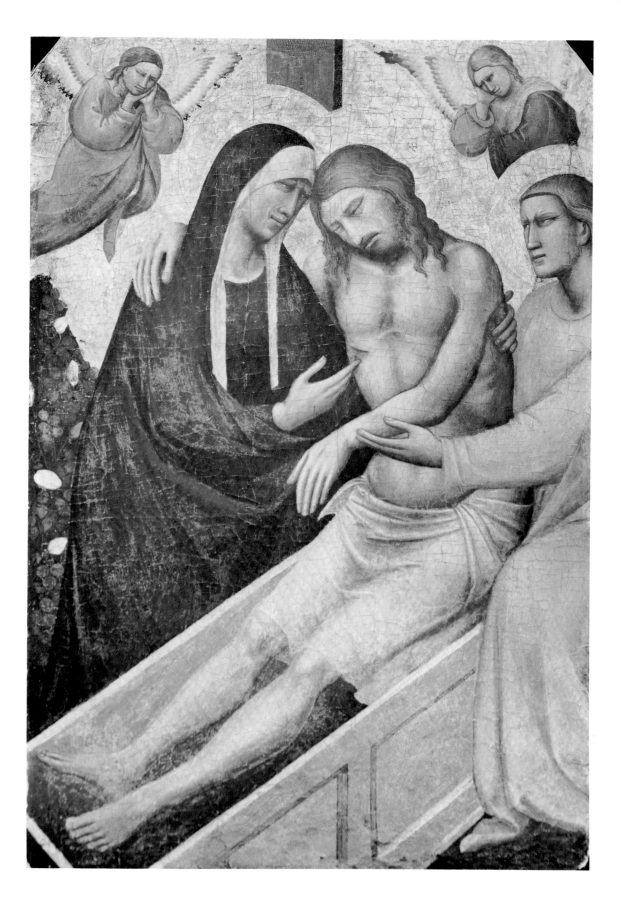

4. HIERONYMUS BOSCH

Dutch, ca. 1450–1516

*Allegory of Intemperance,*
ca. 1495–1500

Oil on panel

13⁵⁄₁₆ x 12⅛ in.

Gift of Hannah D. and
Louis M. Rabinowitz

1959.15.22

Colorplate 1

A fragment cut from a larger picture, this little panel is a treatise on the deadly sin of gluttony. But Bosch paints his fantasies with such obvious relish that it is hard to tell how far he is genuinely concerned with the moral implied in the subject. The balloon-shaped person riding a wine barrel has been described as a mock Silenus or follower of Bacchus, in contemporary costume. A Netherlandish saying, "More are drowned in a goblet than in the sea," may be the explanation of the swimmer filling his bowl from the barrel. One of the figures pushing this cask, who wears what may be a monk's black hood, is perhaps a reference to the church, which was subject to many a satirical allusion in the late fifteenth century. On the tent which shelters a loving couple sharing a drink is painted a coat of arms; this has been identified as belonging to the Dutch family De Bergh, of 's Hertogenbosch, the painter's birthplace. The tavern sign stuck on the tent roof shows a pig's hoof hanging in a wreath—doubtless another reference to gluttony.

Bosch, a popular painter and designer for engravings, was famous for his proto-surrealist visions and fantasies. Much has been written about him in recent years from a psychoanalytical point of view. Pieter Bruegel the Elder borrowed many subjects from him. He worked mainly in his native town, where he died in 1516.

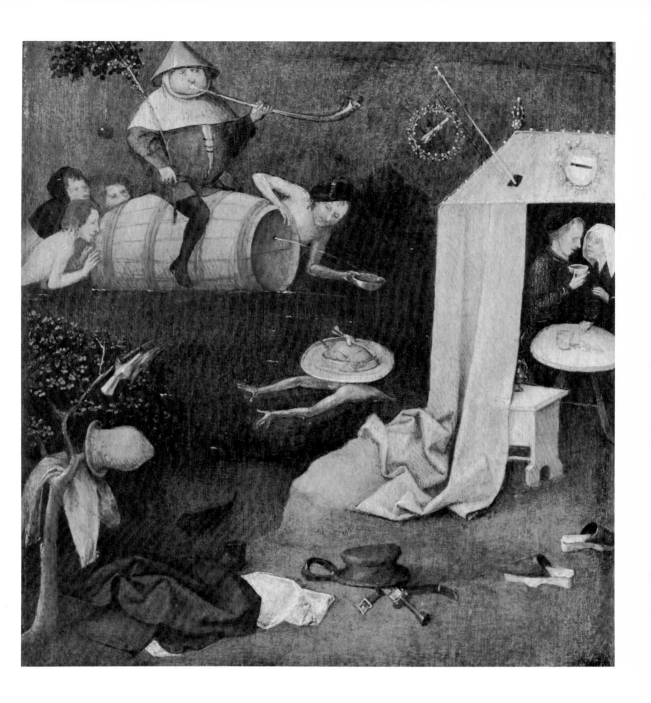

5. AMBROSIUS BENSON

Flemish, 1495/1500–1550

*Nativity,* ca. 1525–30

Oil on panel

36 x 20¾ in.

Gift of Mr. and Mrs. Chauncey
McCormick

1948.297

Ambrosius Benson was a fellow worker with Adriaen
Isenbrandt in the shop of Gerard David, whose quiet,
conservative style is reflected in this small panel. Certain
elements are characteristically Flemish, for example the
ecclesiastical vestments (copes and albs) worn by the angels,
like actors in the medieval mystery plays. Like the musician
angels of the Van Eycks' Ghent altarpiece, they are
wingless; this, however, may be due to trimming of the
panel, which has had triangular pieces added at the upper
corners. The nocturnal effect, a comparatively new feature
in European painting, belongs to the dramatic aims of the
Flemish Mannerists, but apart from this, Benson seems to
have been virtually untouched by Mannerist concerns; his
figures and compositional arrangements are traditional.
The homely detail of the wicker basket in the foreground,
open to show swaddling bands, also appears in paintings
by David.

Various examples of Christian symbolism may be noticed.
Instead of a manger, the Child's bed is the base of a column
covered with a white cloth—a not uncommon reference to
the eucharistic bread offered on the altar at mass. The
bundle of wheat similarly refers to the "living bread," and
to Bethlehem which means "house of bread." A fallen
section of a column behind the Child may symbolize the
Old Covenant overthrown.

Benson was a prosperous painter and citizen of Bruges,
where he was active in civic affairs. Many of his pictures,
including this one, have been found in Spain, but since
he had numerous Spanish clients in Bruges, we cannot take
this as evidence that he ever left his native country.

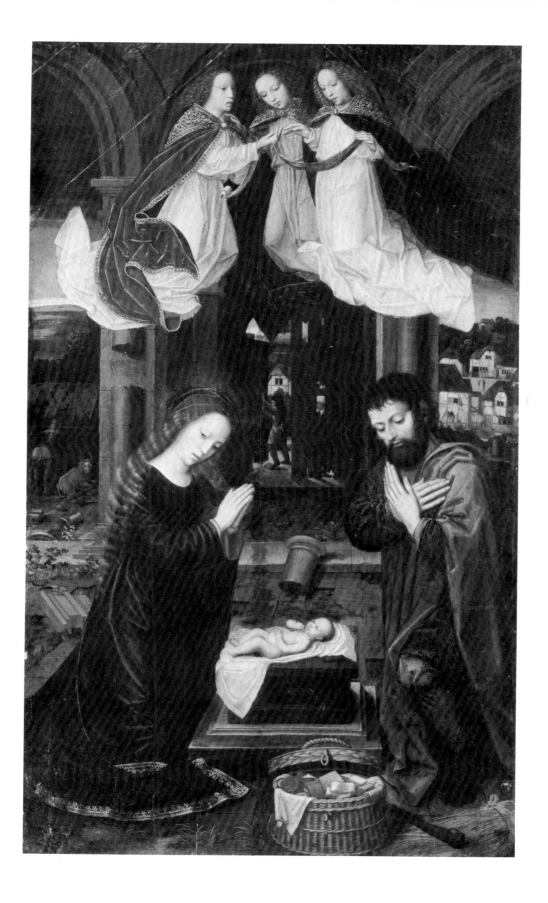

## 6. LUCAS CRANACH THE ELDER

German, 1472–1553

*Crucifixion with the Converted Centurion,* 1538

Oil on panel

$23\frac{5}{8}$ x 16 in.

Gift of Hannah D. and Louis M. Rabinowitz

1959.15.23

Cranach was a staunch supporter and friend of Martin Luther, who was a witness to his marriage and godfather to one of his children. Such Crucifixion pictures as this one, with its emphasis on the converted centurion, had a special appeal for Protestants at that time, since they illustrated clearly the doctrine of salvation by faith. Not only does the centurion make his affirmation, lettered on the panel, WARLICH DIESER MENSCH IST GOTTES SVN GEWEST ("Truly this man was the Son of God") but the two thieves, repentant and unrepentant, symbolize the awesome contrast between salvation and damnation. There is an added time-liness in the fact that the centurion, splendid in Maximilian armor and plumed hat, represents the Protestant elector of Saxony, John Frederick, who summoned Cranach to Wittenberg as court painter in 1504, an appointment which was to last nearly fifty years.

Born in Franconia, Cranach remained essentially a provincial artist, although he seems to have had some knowledge of Italian art, presumably through prints. He himself was an engraver and designer of woodcuts. A trip to the Low Countries in 1509, as representative of the Saxon court at festivities honoring the emperor Charles V, seems to have left him totally unaffected by Flemish art. After his patron's defeat at the battle of Mühlberg in 1547, he went with the elector to Augsburg, where he met Titian, and each painted the other's portrait; these unfortunately have disappeared. One wonders what Titian may have thought of Cranach's naïve but often appealing mytho-logical pictures, of which, together with religious subjects, he turned out huge numbers, aided by his sons and assistants.

Two other versions of Yale's *Crucifixion with the Converted Centurion* are known: one in the Kress Collection, the other in the collection of Prince Lippe in Germany.

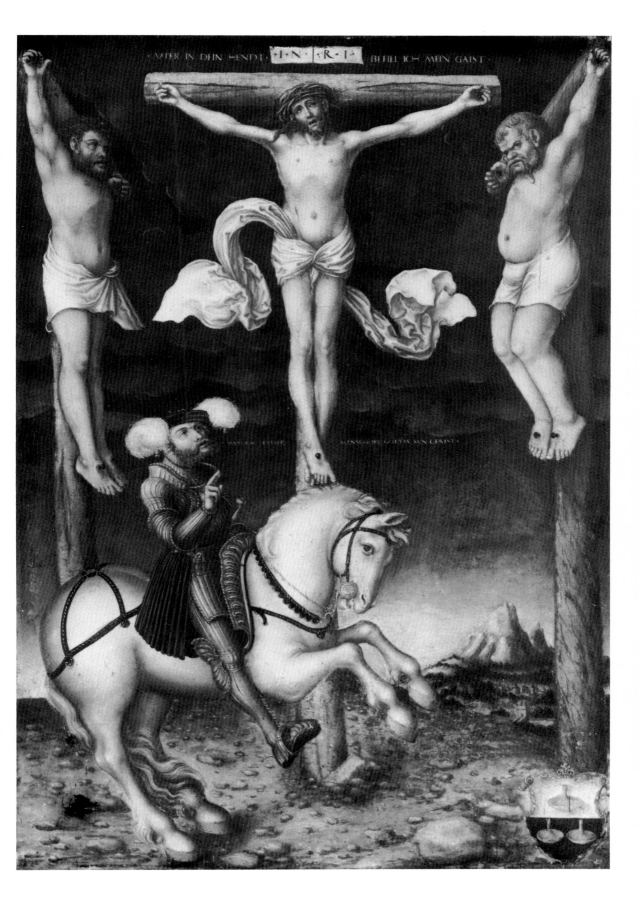

VATER IN DEIN HENDT · I · N · R · I · BEFIEL ICH MEIN GAIST

WARLICH DIESER MENSCH IST GOTTES SUN GWEST

7. MASTER OF MESSKIRCH

German (Swabia), ca. 1500–1543

*St. Gangolfus,* ca. 1535–40

Oil on wood panel

$26\frac{3}{8} \times 8\frac{3}{16}$ in.

Gift of Walter Bareiss, B.A. 1940

1954.43.1

*St. Gregory,* ca. 1535–40

Oil on wood panel

$25 \times 10\frac{1}{4}$ in.

Gift of Walter Bareiss, B.A. 1940

1954.43.2

These two panels originally formed parts of one or another altarpieces painted about 1535–40 for the Collegiate Church of Messkirch in Baden-Württemberg, southern Germany. The unnamed master responsible for these eleven altarpieces, known as the Master of Messkirch, employed various studio assistants; his style shows the influence of Dürer and of the Danube School painters Albrecht Altdorfer and Wolf Huber, especially their graphic work.

St. Gangolfus (Gangulphus) was especially venerated in the vicinity of Lake Constance. He was a Burgundian nobleman noted for his piety and charity. Plagued by his unfaithful wife, he was murdered at her instigation in 760 near Avallon, and became the patron of unhappy marriages. He is represented here in a pink poncho-like garment over a blue-green tunic edged with gray fur; he holds the sword and palm of his martyrdom. An inscription above his head, O DOMINI IESU DEI VIVI, is probably to be read as one half of the invocation completed on a companion panel showing St. Lucy, now in the Staatliche Kunsthalle, Karlsruhe; the full sentence would read (in imperfect Latin): O DOMINI IESU CHRISTI FILI DEI VIVI MISERERE NOSTER ("O Lord Jesus Christ, son of the living God, have mercy on us.")

St. Gregory is vested in a green-blue chasuble, golden yellow alb, and papal tiara; he carries the triple cross reserved for popes. Both figures, in form and color, suggest the influence of contemporary Italian Mannerism.

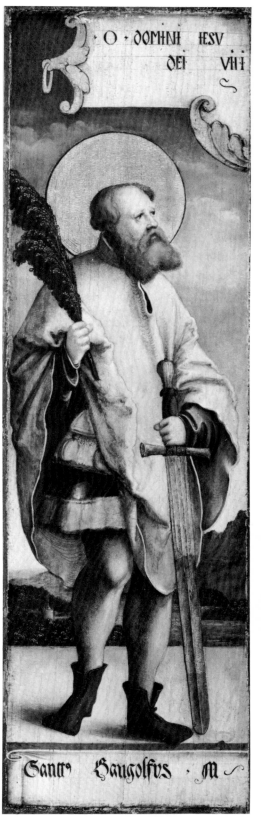

O · DOMINI · IESV ·
DEI · VITI ·

Santr Baugolfvs · M

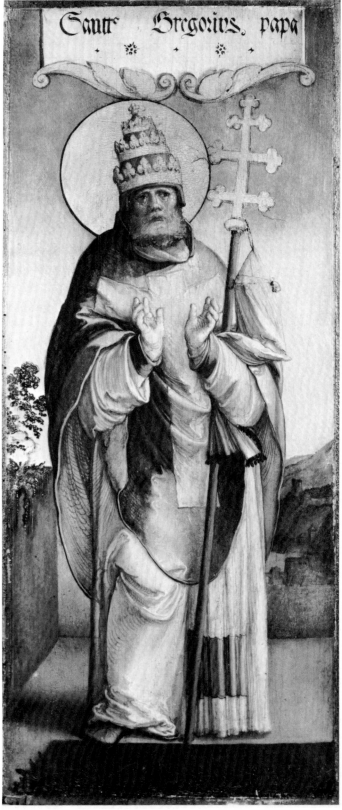

Santr Gregorivs papa

## 8. GENTILE DA FABRIANO

Italian, ca. 1370–1427

*Madonna and Child,* ca. 1424–25

Egg tempera on panel

36 x 24¾ in.

University purchase from
James Jackson Jarves

1871.66

Considered one of Yale's most important pictures, this is the only mature work signed by Gentile (GENT [ILE DA ?] FABRIANO, on the architectural frame at the lower left). Born in the Umbrian town of Fabriano, he worked in Venice in the early 1400s. In 1421 he was enrolled in the Confraternity of St. Luke in Florence, where he painted his famous *Adoration of the Magi* for Palla Strozzi in 1423. He died in Rome while working on frescoes in the basilica of St. John Lateran.

The Jarves *Madonna,* which had been slightly cut down on all four sides when it was acquired, is a particularly attractive example of blended late medieval and early Renaissance characteristics. The architectural frame with its decoration of fruit and flowers has been compared to Ghiberti's north doors of the Baptistery in Florence, finished in 1424. One may recognize red and white roses, regarded in medieval times as symbols of the Virgin Mary and to be found blooming in Paradise, as well as the pomegranate which signifies immortality and resurrection.

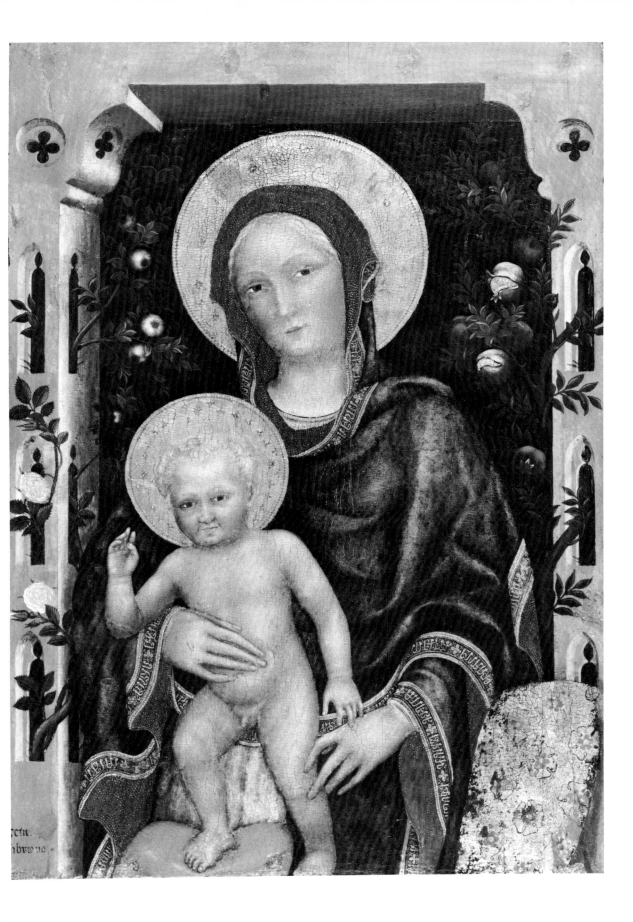

9. SASSETTA (STEFANO DI GIOVANNI)

Italian, 1392–1450

*The Virgin Annunciate,* ca. 1430

Egg tempera on wood

$23\frac{1}{4}$ x $19\frac{5}{8}$ in.

Gift of Hannah D. and Louis M. Rabinowitz

1959.15.5

The work of Stefano di Giovanni da Cortona (known as Sassetta) illustrates at its most charming the lingering of the Italian Gothic style in fifteenth-century Siena. In contrast to the vigor and growing naturalism of Florentine painting, Sassetta's figures have a medieval grace and elegance. The Virgin Mary, delicately outlined against the old-fashioned gold leaf background, is both aristocratic and humble. In the inlaid pavement one sees a reflection of the fifteenth-century interest in linear perspective, but the form of the young woman is as incorporeal as a vision. Together with a companion panel showing the angel Gabriel, now in Massa Marittima near Siena, the Yale panel originally formed part of an altarpiece, *The Madonna of the Snows,* painted by Sassetta for the chapel of St. Boniface in the cathedral of Siena. The central panel of this altarpiece and its predella are now in the Contini-Bonacossi Collection in Florence.

Active chiefly in Siena, Sassetta was recorded as a member of the painters' guild there in 1428. His earliest recorded commission of importance was an altarpiece of 1423–26 for Siena's woolworkers' guild, the Arte della Lana. Master of a large and active bottega, his most important pupils were Sano di Pietro and Vecchietta.

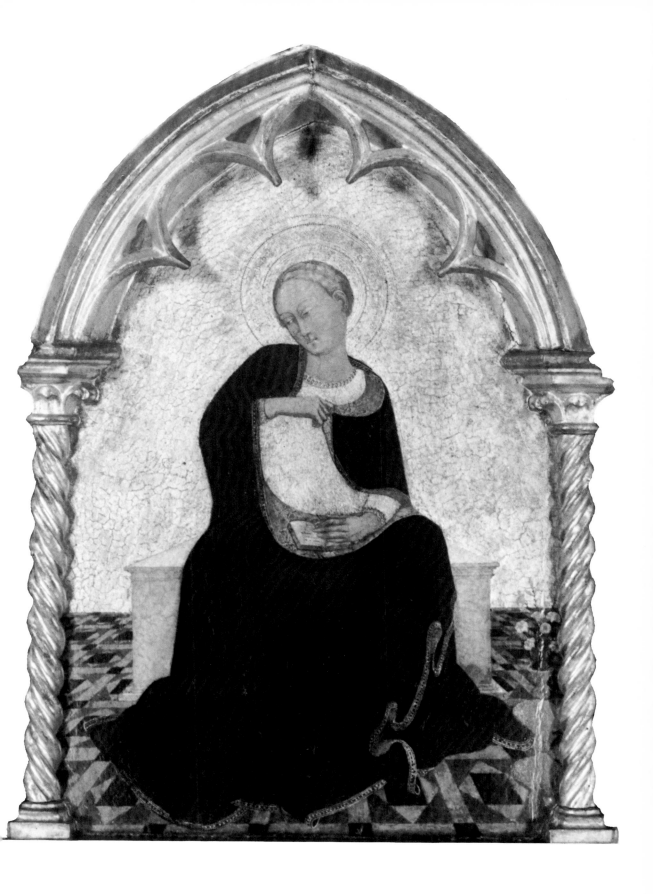

10. SASSETTA (?) or
"OSSERVANZA MASTER"

Italian, 15th century

*Temptation of St. Anthony,* ca. 1430

Egg tempera on panel

$14\frac{7}{8}$ x $15\frac{13}{16}$ in.

University purchase from
James Jackson Jarves

1871.57

Colorplate 2

Like many successful Italian Renaissance painters, Sassetta had various associates and assistants whose styles reflect those of the master. Recent scholarship has suggested that this panel may be by such an associate, called the "Osservanza Master" from a large unsigned altarpiece by the same hand in the church of the Osservanza near Siena.

The *Temptation of St. Anthony,* with its companion piece *St. Anthony Tormented by Demons,* also owned by Yale (1871.58), once formed part of a Sienese altarpiece illustrating the legendary life of the saint. Anthony "the Abbot," a fourth-century hermit in the Egyptian Thebaid, was a man of such exceptional holiness that he constituted a major challenge to the devil. When physical torments and terrors failed to overpower Anthony, the devil sent a demon in the form of an alluring woman, who was equally unsuccessful but provided a favorite subject for painters. The temptress is shown here in a pink gown slit at the side to reveal her hairy skin. Her bat's wings also identify her as Satan's emissary. The saint responds with an expression of mild annoyance, or perhaps even of pity.

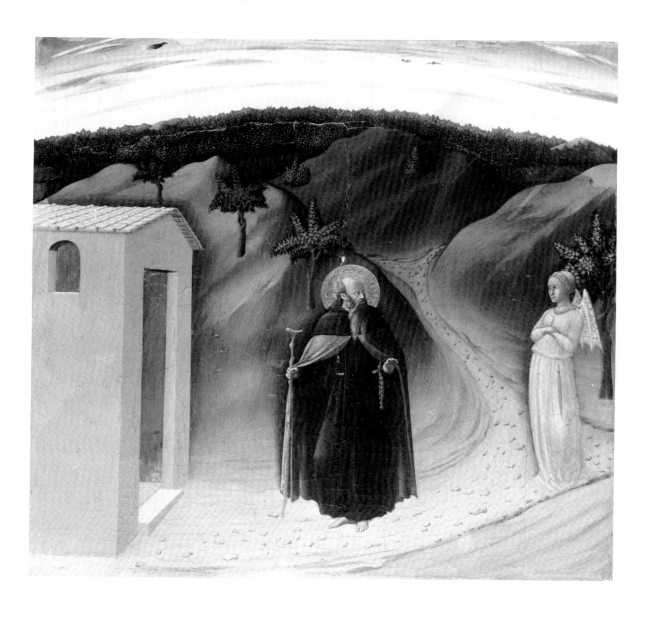

## 11. ANTONIO POLLAIUOLO

Italian, 1429–1498

*Hercules and Deianira,* ca. 1470

Egg tempera and oil (?) on canvas
(transferred from panel in 1867)

$21\frac{1}{2}$ x $31\frac{3}{16}$ in.

University purchase from
James Jackson Jarves

1871.42

This small picture is perhaps the most important example in Yale's collection of Italian paintings. It has survived a transfer from wood panel to canvas, and has undergone several cleanings and restorations; in the course of the 1915 cleaning the figure of Deianira was discovered. It had been completely overpainted before Jarves acquired the picture.

According to Greek legend, the centaur Nessus offered to carry Hercules's wife Deianira across a river. On reaching the farther bank he made off with her, whereupon Hercules drew his bow and killed the centaur. Nessus's poisoned blood, permeating the cloak which he gave to Deianira as he breathed his last, was ultimately to induce the suicide of Hercules himself.

One of the greatest masters of the human body in violent action, Antonio Pollaiuolo was primarily a sculptor. Like many Renaissance masters, he was first trained as a goldsmith. He was born in Florence, where he and his younger brother Piero had a shop. Both were summoned to Rome in 1484 to execute two papal tombs in bronze for St. Peter's, and they died there.

The Yale *Hercules* is remarkable not only for its mastery of vigorous movement but for the treatment of landscape— a naturalistic view of the Arno valley with the city of Florence in the distance. Ancient Greek tradition symbolized uncivilized man as the half-human, half-animal centaur; Hercules, a son of Jupiter, here becomes an allegory of enlightened Florence destroying ignorance and man's lower nature. But if, as is possible, the picture once formed part of a marriage chest, the subject might have been chosen simply as an example of marital devotion and also, perhaps, of masculine valor.

12. BARTOLOMMEO VIVARINI

Italian, 1431/32–after 1491

*Madonna and Child,* ca. 1465

Egg tempera on panel

45¾ x 25¾ in.

Gift of Hannah D. and
Louis M. Rabinowitz

1959.15.12

Colorplate 3

Bartolommeo Vivarini's work has a material richness and solidity of form derived from Mantegna and the young Giovanni Bellini. Active between 1450 and 1491, he studied with his brother Antonio Vivarini and later collaborated with him in his Venetian studio. His fondness for garlands of fruit and flowers recalls Mantegna and the Paduan school. The plump, firmly modeled forms of the Virgin and Child are themselves like ripe fruit, as are the small musician angels perched on the throne.

The panel has lost part of its original top, which must originally have had the shape of a round arch—a type popular in early Renaissance Venice. It once formed the center of a polyptych, i.e. an altarpiece made up of several compartments.

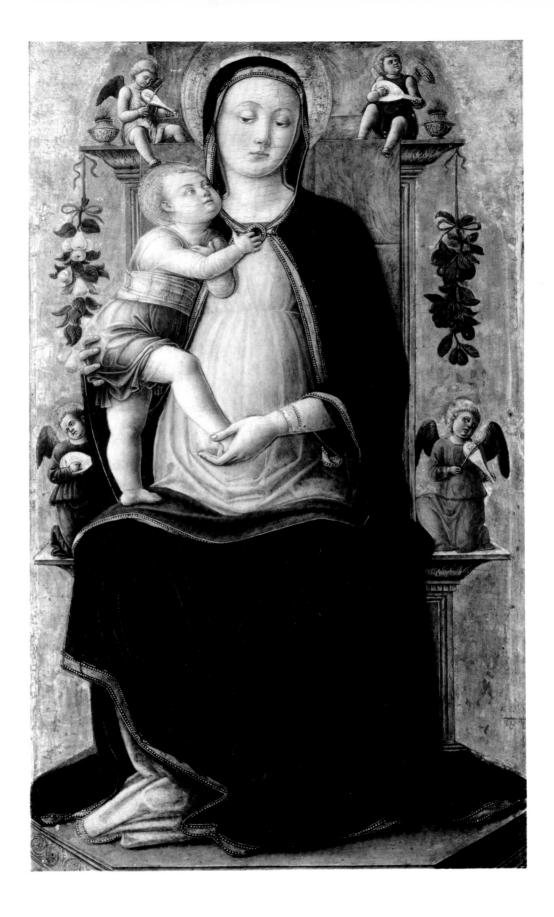

13. FRANCESCO DI GIORGIO

Italian, 1439–1502

and NEROCCIO DEI LANDI

Italian, 1447–1500

*Annunciation,* 1468/69–75

Egg tempera on panel

19 x 50⅝ in.

University purchase from
James Jackson Jarves

1871.63

This beautiful panel, one of the greatest treasures in the Jarves collection, must once have been the top section of a large altarpiece. It combines the graceful medieval Sienese tradition with the more vigorous elements—both naturalistic and classicizing—of fifteenth-century Florentine art which were beginning to affect the more progressive Sienese masters.

For many years attributed to Neroccio dei Landi, the panel is now generally believed to owe its more progressive elements to the painter and architect Francesco di Giorgio, who collaborated with Neroccio between 1468/69 and 1475. Francesco's hand may be seen in the concern for perspective, the architectural and sculptural details including the neoclassical reliefs on the parapet, and the energetic figure of the angel. The slender, graceful figure of the Virgin is attributed to Neroccio, who worked in the tradition of such fourteenth-century Sienese masters as Duccio and Simone Martini. The pale, silvery tonality of the panel as a whole is characteristic of both collaborating painters.

14. LUCA SIGNORELLI

Italian, 1441–1523

*Adoration of the Magi,* ca. 1515

Egg tempera on panel

$13\frac{3}{4} \times 17\frac{1}{4}$ in.

University purchase from
James Jackson Jarves

1871.69

In the opening years of the High Renaissance, Signorelli was one of Italy's greatest masters of the human figure. He was born in Cortona and died there in 1523. A pupil and associate of Piero della Francesca in Arezzo, he later came under the influence of Antonio Pollaiuolo and Andrea del Verrocchio in Florence.

The *Adoration of the Magi,* together with a *Nativity* now in the Philadelphia Museum of Art, once formed part of a predella which may originally have been attached to an altarpiece now in S. Domenico, Cortona; this was commissioned in 1515 by Giovanni Sernini who became bishop of Cortona in the following year. According to Jarves, he found the Yale *Adoration* in the bishop's palace there.

Signorelli's physically powerful figures are given material splendor (at that time of a rather old-fashioned sort) through the sumptuous gilded robes of the kings. The oldest king kneels to worship the Child; his crown lies at Mary's feet, and his covered jar of gold is visible just above her. The second king shows his gift of frankincense to Joseph, who looks both puzzled and anxious. The youngest king stands at the left, with a group of attendants; the camels and horses which have brought the royal visitors can be seen in the distance.

15. FRANCIA

Italian, ca. 1450–1517

*Gambaro Madonna,* 1495

Oil and egg tempera on panel

29½ x 21 9/16 in.

Gift of Hannah D. and
Louis M. Rabinowitz

1959.15.10

This beautiful example of Francia's work is documented
by the inscription at the base of the panel, which reads:
IACOBVS GAMBARVS BONON [ENSIS] PER FRANCIAM
AVRIFABRVM HOC OPVS FIERI CVRAVIT, 1495 ("Jacopo
del Gambaro of Bologna had this work made by Francia
the goldsmith, in 1495"). Gambaro was a fellow member
of the goldsmiths' guild of Bologna with Francia, whose
real name was Francesco di Marco di Giacomo Raibolini.
The exquisitely finished little picture must have given
great satisfaction to its owner. Stylistically it echoes
Perugino's tender sweetness and spacious treatment of
landscape, qualities taken over by Raphael, who may have
come under Francia's influence as well as Perugino's. The
Virgin Mary holds an apple, symbolic of the fall of man;
the Child, as Redeemer of Mankind, reaches for the fruit.

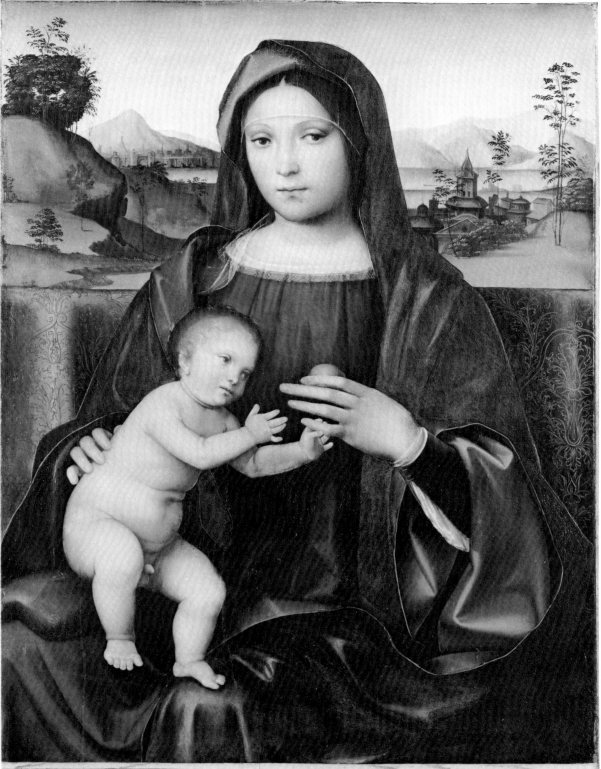

IACOBVS·LAMBARVS·BONON·PER·FRANCIAM·AVRIFABRVM·HOC·OPVS·FIERI·CVRAVIT·1495

16. RIDOLFO GHIRLANDAIO
(attributed to)

Italian, 1483–1561

*Lady with a Rabbit,* ca. 1505

Egg tempera (?) or oil (?) on panel

23 x 17¾ in.

University purchase from
James Jackson Jarves

1871.72

One of the Gallery's most popular pictures, this portrait was attributed for many years to Piero di Cosimo. Recent scholarship has proposed the slightly later painter Ridolfo Ghirlandaio, a Florentine whose style fits into that of the developing High Renaissance of the early sixteenth century.

Ridolfo, son of the better known Domenico Ghirlandaio, was born in Florence in the same year as Raphael of Urbino, whom he outlived by over forty years. He was influenced by both Raphael and Piero di Cosimo. The *Lady with a Rabbit,* posed like Leonardo's *Mona Lisa,* recalls Raphael's *Portrait of Maddalena Doni* in Florence. Known in Jarves's day as *The Princess Vitelli,* the Yale picture may actually represent a member of that family, which owned property in Città di Castello near Arezzo. Quite possibly it is a bridal portrait; the rabbit is an old symbol of physical love and of fertility, meanings taken over from pagan lore. The firm smooth contours, and the color scheme of brown, black, and white against pale flesh tones, have an elegance and purity suggestive of Ridolfo's contemporary Hans Holbein the Younger. The airy landscape background echoes Raphael. Whoever she was, and whoever painted her, the *Lady with a Rabbit* continues to exert a fascination which was surely hers in life.

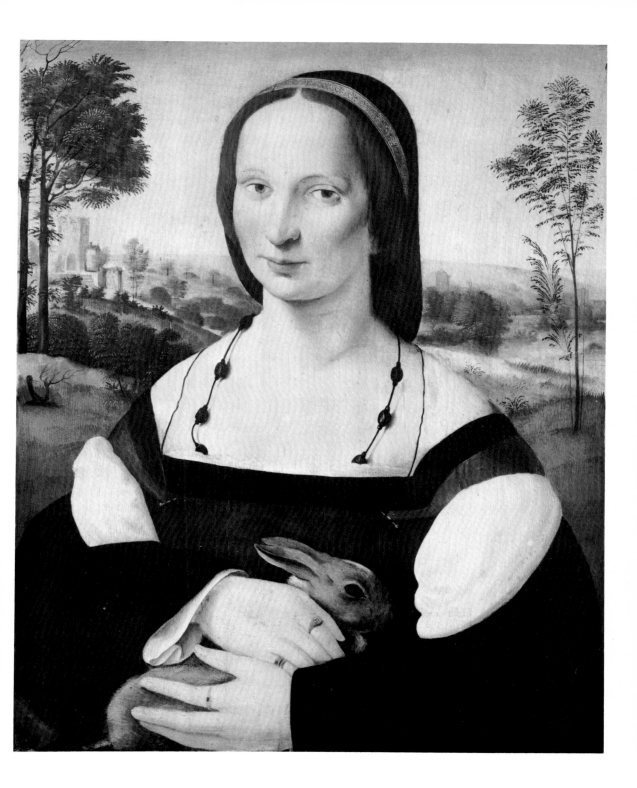

## 17. JACQUES DE GHEYN

Dutch, 1565–1629

*Vanitas,* 1621

Oil on wood

46¼ x 65⅛ in.

Gift of the Yale University
Art Gallery Associates

1957.36

The title of this picture is derived from the line in
Ecclesiastes, "Vanitas vanitatum, et omnia vanitas" ("Vanity
of vanities, all is vanity"). Such still lifes with skulls may
usually be taken as warnings of the brevity of life and
the advisability of repentance while yet there is time.
De Gheyn's *Vanitas,* however, seems rather to celebrate the
virtues to be sought in this present life: man's intellectual
powers constructively used and enjoyed. This is deduced
from the inscription lettered on the sheet of paper pinned
to the tablecloth: SERVARE MODUM, FINEMQUE TUERI,
NATURAM SEQUI ("[to] observe moderation, be mindful
of one's end, and follow nature"). The quotation may have
been suggested by de Gheyn's friend Hugo Grotius; it is
taken from Lucan's *Pharsalia,* of which Grotius had
published an annotated edition in 1614. The objects
represented in careful detail are those related to the life
of mind and imagination; the skull is crowned with laurel,
symbolic of both victory and immortality. De Gheyn seems
to have been the originator of the "Vanitas" still life. Those
that followed (and their popularity was increased by
seventeenth-century plague and war) usually have an
undercurrent of Calvinistic morality: food, drink, and
sometimes tobacco are set out with an implicit warning
against overindulgence in these pleasures.

Jacques de Gheyn was born in Antwerp, the son of a Dutch
glass painter. He studied in Haarlem with the famous
engraver Hendrik Goltzius, and later worked in Leiden,
Amsterdam, and the Hague, where he was buried. He was
successful not only as a painter but as a designer of stained
glass windows, medals, monumental fountains, and formal
gardens. His prints and drawings are among his finest
work.

The Yale *Vanitas* was at one time claimed to be the earliest
existing work by Rembrandt, partly because of the over-
painting of the artist's monogram. Cleaning which took
place before the picture came to Yale revealed de Gheyn's
monogram. The date, 1621, is also visible.

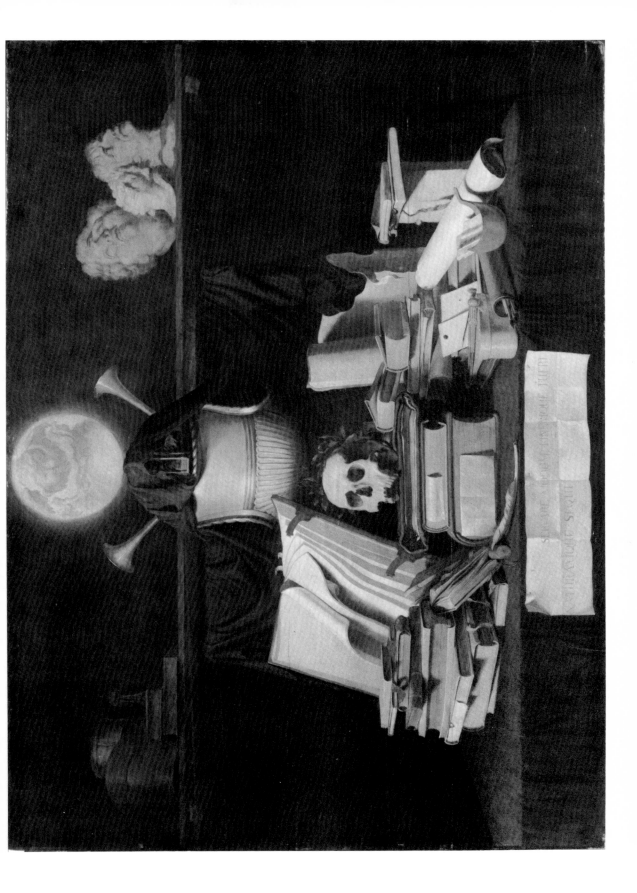

18. JOACHIM ANTHONISZ UYTEWAEL

Dutch, 1566–1638

*The Deluge,* ca. 1610–20

Oil on canvas

56 x 72 in.

Leonard C. Hanna, Jr., B.A. 1913, Fund

1964.40

This is a rare and important work by Uytewael, one of the very few in the United States. It is a fine example of Dutch Mannerism—that style, current in late-sixteenth-century Europe, which lies between the High Renaissance and the Baroque. Exaggerated anatomy, postures and gestures bordering on the physically impossible, and off-center compositions contain elements found in the late works of Michelangelo and Tintoretto. The repose, balance and clarity of the High Renaissance are replaced by the unexpected in form and design: violent, often nonpurposive movement and startling contrasts or distortions in spatial relationships. One is sometimes reminded of the stylized, expressionist patterns of modern dance; indeed, the Mannerist painter is apt to be a sophisticated choreographer rather than a reporter of rational visual appearance.

Uytewael, who also spelled his name Uytenael, Uytenwael, or Wtewael, was born in Utrecht and died there. He spent four years in Italy traveling with the bishop of Malines, then two years in France, returning to Utrecht in 1592. In 1611 he took an active part in the founding of the local painters' guild. *The Deluge,* a favorite subject of his and one generally popular at the time, reflects the great agonized nudes of Michelangelo's Sistine Chapel frescoes. It is interesting to realize that the canvas may have been finished about the time that the Pilgrims were landing from the *Mayflower* in 1620. A preparatory drawing for the Yale picture is preserved in the Print Room of the Staatliche Museen in Berlin.

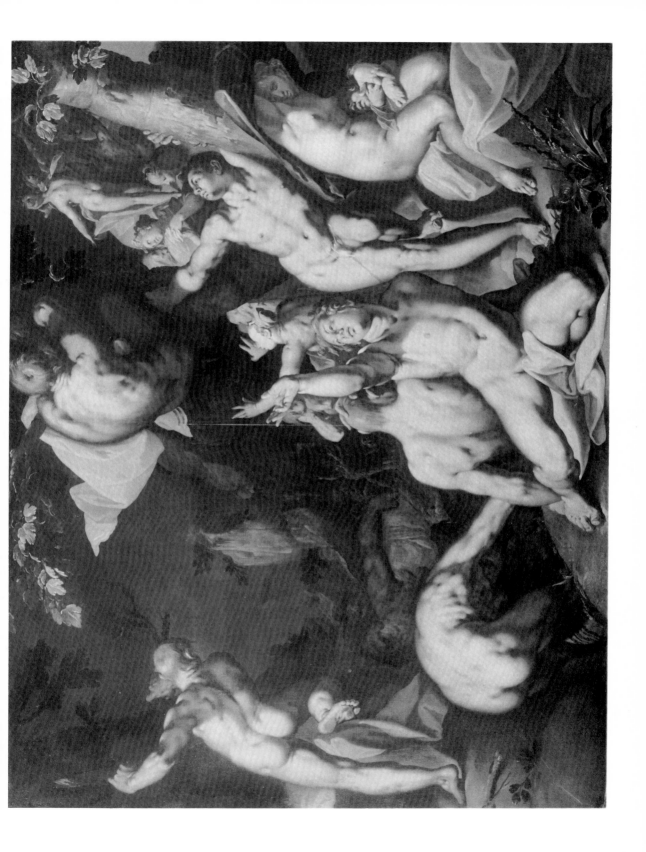

## 19. FRANS HALS

Dutch, 1580(?)–1666

*De Heer Bodolphe,* 1643

Oil on canvas

48¾₁₆ x 38⅞ in.

Bequest of Stephen Carlton Clark,
B.A. 1903

1961.18.23

All we really know about de Heer Bodolphe is that in 1643
at the age of seventy-three, he sat to a painter some ten
years his junior; the inscription on the canvas reads
AETAT SVAE 73 AN⁰ 1643 (AETATIS SUAE 73, ANNO 1643,
"In the year of his age seventy-three, in the year 1643").
Frans Hals's monogram follows, the letters F and H
superimposed. The sitter's name is probably wrong;
"Bodolphe," said to have been written on the picture but
no longer in existence, is not Dutch; it may conceivably
have been Rodolphe, a French form which could be Roelof
or Roelofsz in Dutch, or Rodolphus in Latin. But if historic
data are missing, reality is not. This stern, convincing,
clearly prosperous Dutch citizen is his own biography, set
forth in Hals's superb brushwork as dictated by the artist's
unerring eye. In contrast to the dashing brilliance of the
earlier portraits—the shooting company or "doelen"
groups, and the *Laughing Cavalier,* for example—Hals's
portraits of the 1640s have a dignity, sobriety, and sense
of personality that sets them among the finest human
documents of all time. Heer Bodolphe, like his wife (see
No. 20), is entirely without pretense or self-importance,
but he knows his own power; his face reveals a strong will
and a keen, well-furnished mind. The grip of his hands
on his gloves gives evidence of a tight rein held on all
his affairs.

Hals was born in Antwerp, the son of a clothworker and
weaver from Malines. About 1585 the family moved to
Haarlem, where Hals was recorded in 1610 as a member
of the painters' guild. Essentially a figure painter, he carried
out with equal skill the dazzling military groups, quick
sketches of fisherboys and ragamuffins, tavern revelers,
and solid bourgeois portraits such as those of the Bodolphe
couple. His rapid, splintery brushwork, recording visual
rather than tactile experience like that of his younger
contemporary Velazquez, anticipates Impressionism.
Frequently in debt and in difficulties with the law, he died
in poverty, well over eighty years old, in Haarlem, where
he is buried in the cathedral of St. Bavon.

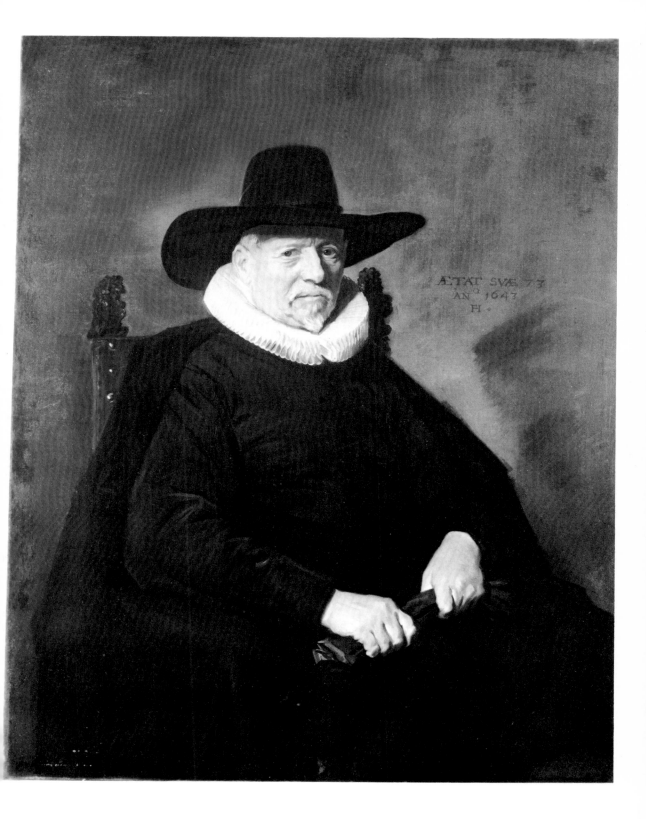

ÆTAT SVÆ 73
AN.º 1643
H.

## 20. FRANS HALS

Dutch, 1580(?)–1666

*Mevrouw Bodolphe,* 1643

Oil on canvas

48³⁄₁₆ x 44¼ in.

Bequest of Stephen Carlton Clark, B.A. 1903

1961.18.24

Colorplate 5

AETAT SVAE 72 – AN⁰ 1643 ("Aged seventy-two, in the year 1643"): so reads the inscription on Mevrouw Bodolphe's portrait, followed by the painter's monogram FH. For all her seventy-two years, this lady is no image of old age; she is, rather, an embodiment of physical vigor and mental keenness, of wisdom, dignity, and common sense. She must surely have had a sense of humor as well. One can imagine her as one of the Regentesses of the Old Men's Almshouse in Haarlem whom Hals recorded so poignantly in his group portrait of 1664, now preserved in the Frans Hals Museum in that city. The brilliance of handling, in a color scheme of black, brown, and white, is unsurpassed in his work.

There is plenty of evidence that Hals appreciated the buxom young girls of Haarlem, in the tavern, the fish market, or at home. But his response to older women, to whom in his last years he and other paupers must have owed much in the way of compassion and tolerance as well as an occasional tongue-lashing, is splendidly expressed in portraits like this one. Painter and sitter saw each other without pretense or illusions, and surely with understanding.

In the 1640s Hals was at the height of his powers. The bright color and vivacious mood of his earlier canvases have become graver and more dignified, but no less masterful. Portraits such as those of the Bodolphe couple can hold their own in the company of Rembrandt.

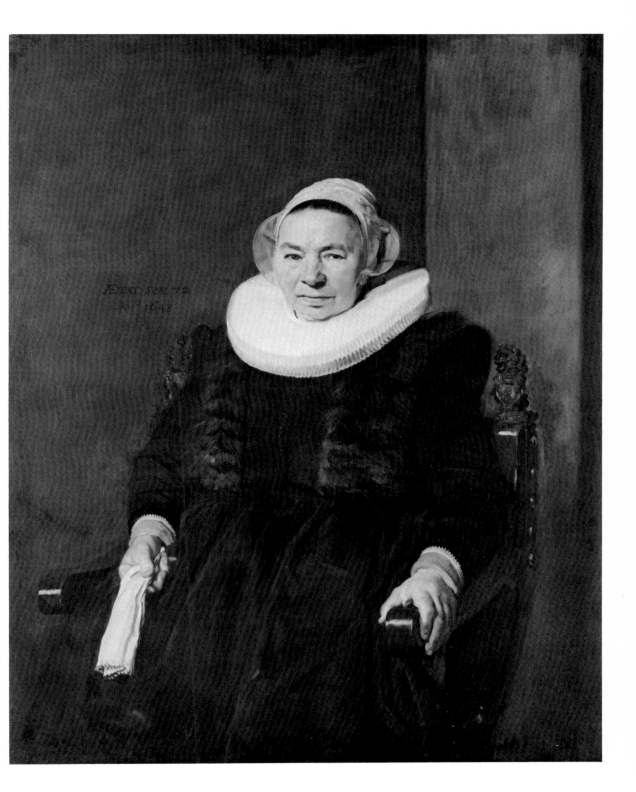

21. JAN BAPTIST WEENIX

Dutch, 1621–1660/63

*Landscape with Shepherdess*

Oil on canvas

29½ x 43¾ in.

Gerard and Barclay Funds

1960.39

Born in Amsterdam, Weenix was one of a number of Dutch seventeenth-century painters who visited Italy. He spent four years there (1643–47), counting among his patrons Cardinal Giovanni Battista Pamphili, who became Pope Innocent X in 1644 and posed for Velazquez's famous portrait. Returning to Holland, Weenix worked in Utrecht, where he became director of the painters' guild. His son Jan was also a successful painter.

In addition to his still lifes with dead game, which were popular in his day, the elder Weenix specialized in landscapes with peasants, cattle, and other animals set among ancient Roman ruins. In contrast to the Italians and such expatriate French painters as Claude Lorrain and Poussin, Weenix and his fellow countrymen preferred to give their human figures the costume of the day rather than classicizing them as nymphs, shepherds, or Olympian divinities. The figures thus constitute a kind of pastoral genre, and would seem to be at home on a Netherlands farm were it not for the presence of crumbling Roman vaults in the distance. The men traveling in the wagon at the left wear hats that might have fitted Rembrandt's Syndics or some prosperous citizen who sat to Hals. Yet there is an attractive kind of poetry in the contrast between the disappearing past and the matter-of-fact present: a mood which anticipates the romantic sentiments of Giovanni Battista Piranesi's engravings and the eighteenth century's passion for picturesque ruins. Light and color are charmingly handled, the gold tone of the shepherdess's jacket recurring in the cattle and elsewhere in the composition.

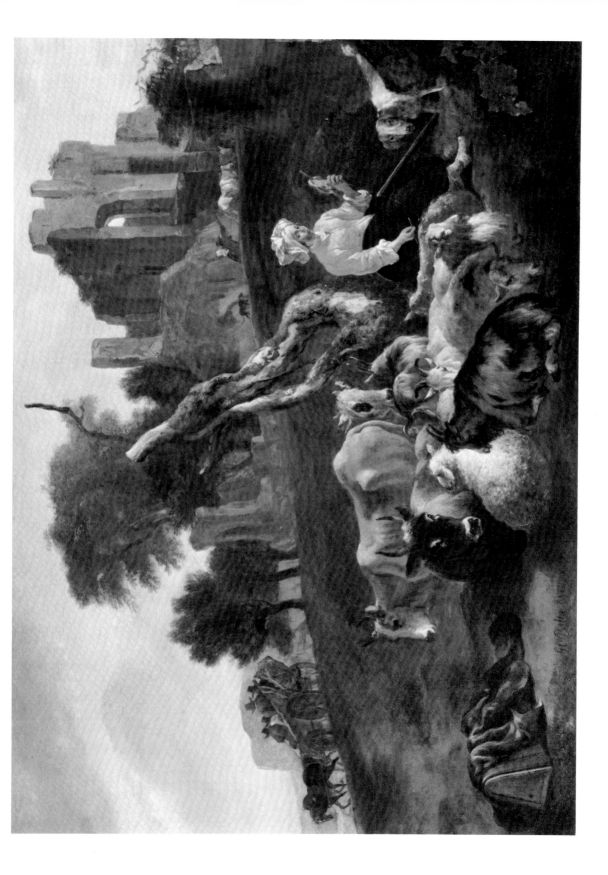

22. KAREL DU JARDIN

Dutch, 1622/25–1678

*The Story of the Soldier*

Oil on canvas

35¼ x 31½ in.

Leonard C. Hanna, Jr.,
B.A. 1913, Fund

1966.84

A young soldier with bandaged forehead recounts his military exploits to an audience which receives his narrative with varying feelings. The boy perched on the wall is evidently impressed; the woman, pausing with a platter of meat in her hands, looks faintly skeptical if not disapproving, and the officer at the right, in breastplate and helmet, makes a gesture, borrowed from Italy, to warn the listener not to believe all he hears. The entire scene suggests a moment in a stage play, which indeed it may actually be. The setting makes use of objects borrowed from antiquity and subject to symbolic interpretation: the red stone sarcophagus, bespeaking death, rests on a heavy base decorated with Venus and Cupid in low relief—a clear suggestion of conquests in love, and the nude athlete carved in the medallion on the wall at the left implies manly prowess in general.

Karel Du Jardin was born in Amsterdam and studied with Nicholas Berchem. Like his teacher, he visited Italy, returning to the Netherlands in 1650. In 1674 he went back to Italy, working in Rome and then in Venice, where he died. He specialized in Italianate landscapes with ruins, peopled by travelers, peasants, and the like; he also painted portraits and, occasionally, religious subjects. His paint surfaces have an enamelled smoothness, glowing under the borrowed light of Italy and capable of brilliant reflections such as those of the red cloak caught by the polished armor and echoed in the still life on the table.

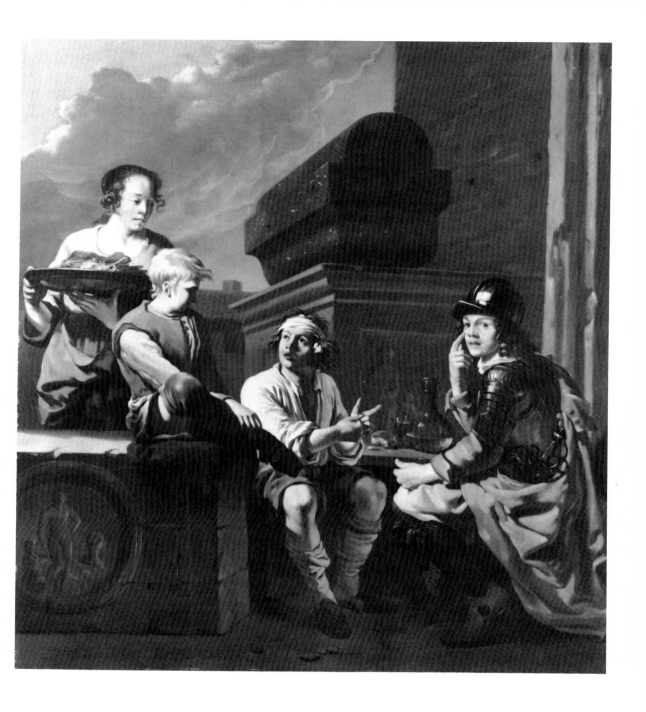

23. PETER PAUL RUBENS

Flemish, 1577–1640

*Hero and Leander,* 1605–06

Oil on canvas

33¾ x 50⅜ in.

Director's Purchase Fund,
gift of Mrs. Frederick W. Hilles

1962.25

Colorplate 6

This painting illustrates the ancient Greek story in which
Leander swam the Hellespont for midnight meetings with
his beloved Hero, custodian of the doves and sparrows
of Aphrodite in her tower high above the sea. On a fatal
night of storm he perished in the waves, and the despairing
Hero cast herself into the sea to join him in death. Michael
Jaffé, in *The Burlington Magazine* of December 1958,
has beautifully described the picture: "Leander in the
Hellespont lies drowned. He is borne by nereids towards
his Hero. These nymphs of the dark sea, and their sisters,
hair all unbraided and bright with coral, make about his
corpse a garland of sorrow, a painted bas-relief travelling
in the hollow of the wave that is about to break upon
the rocks."

The picture is an important early example of Rubens's
work in Italy. Born in Siegen, Westphalia, of parents
temporarily exiled from Flanders, he was brought in 1587
to Antwerp, where he studied with Adam van Noort and
later under Otto van Veen. From 1600 to 1608 he was
in Italy, first in Genoa, Mantua, and Venice where he was
influenced by Titian and Tintoretto; he also visited Rome
where he studied the frescoes of Michelangelo. Returning
to Antwerp in 1608, he became head of a flourishing
workshop and undertook, with many assistants, great
decorative compositions, altarpieces, and historical subjects
for royalty and the nobility. Well educated and a fine
linguist, he served as ambassador to the court of Spain and
was knighted by Charles I of England.

Yale's canvas may once have belonged to Rembrandt; it is
known to have been owned by the Dutch painter in
England, Sir Peter Lely. A larger version, painted some
years later, is in the Dresden Museum.

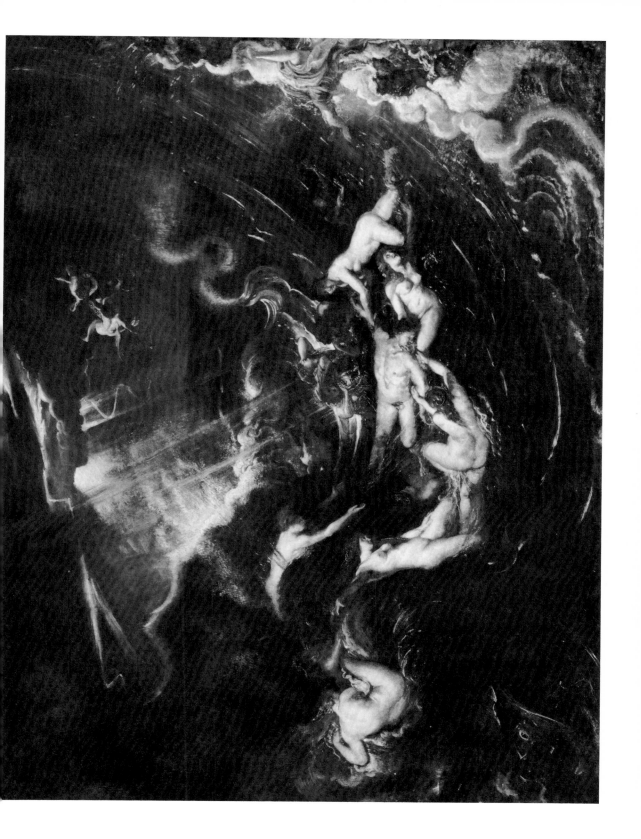

24. PETER PAUL RUBENS

Flemish, 1577–1640

*Assumption of the Virgin,* 1636–38

Oil on panel

22 x 16 in.

Gift of Henry Sage Goodwin,
B.A. 1927

1965.35

This small panel is a study for Rubens's altarpiece formerly in the Lichtenstein Collection in Vienna. He painted several versions of the Assumption (the Virgin Mary being received bodily into heaven), notably the large canvas over the high altar in the cathedral of Antwerp. It was his custom to sketch out his compositions in thin oil washes on small wooden panels such as the Yale example, leaving the finished painting to be carried out in part or in whole by the many assistants who worked in his Antwerp studio.

Baroque concern with light, space, and movement is brilliantly shown in this sketch, which is entirely by the master's own hand. Here the mystery of the Assumption is translated into a drama of physical energy; in the characteristic spirit of the Counter-Reformation, enthusiasm and joy triumph over wonder and awe. According to the tradition, flowers were found in the Virgin's empty tomb; the woman kneeling at the left of the composition holds a blossom or two as evidence of the miracle.

Trained in boyhood at the court of the Spanish viceroys in Flanders, and a devout Catholic with a thorough classical education, Rubens developed a style perfectly suited to express the aims of seventeenth-century royalty and of the church of the Counter-Reformation.

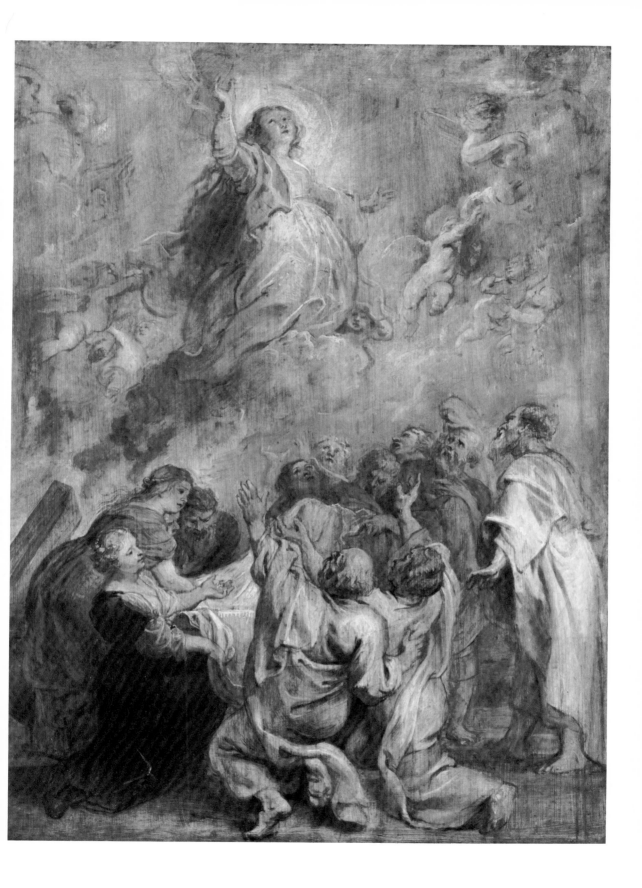

## 25. DAVID TENIERS THE YOUNGER

Flemish, 1610–1690

*Bagpiper in an Inn*

Oil on canvas

22 x 19⅛ in.

Stephen Carlton Clark,
B.A. 1903, Fund

1966.88

Small tavern scenes such as this one were popular throughout the Low Countries in the seventeenth century. The Dutch painter Adriaen Brouwer, who specialized in them, visited Teniers's native Antwerp in the 1630s and exerted a strong influence on him. But Teniers's characters tend to be less coarse and boisterous than Brouwer's. Frank Jewett Mather has remarked that "For Brouwer the pot-house was a place of joyous or frantic disorder; for Teniers it was a place of decent conviviality." Here, there is less conviviality than quiet concentration. The picture is beautifully painted in earthy tones of brown and gray, heightened with occasional bright touches such as the red tassels of the bagpipe. Textures, especially in the still life, are skillfully suggested.

Teniers liked to show a second room beyond a doorway, often, as here, with card players and smokers before a fireplace. The interplay of rectangles—doorway, fireplace and its frame, low box seat, and sheet of paper pinned to the chimney piece—prophesies Mondrian.

Like his painter-father David Teniers the Elder, Teniers the Younger had a varied repertory of subjects: peasant dances and kermesses, landscapes with cattle, and genre scenes. He acquired a reputation for speedy performance; it is said that he could complete a picture in a few afternoon hours, and he turned out large numbers of these so-called "after dinners." He was prosperous and successful all his life. Rubens was a witness at his marriage to a daughter of Jan Bruegel, son of the great Pieter Bruegel the Elder. He was court painter to the regent Archduke Leopold Wilhelm, whose collection he catalogued; among those who bought his pictures were Philip IV of Spain, William of Orange, and Queen Christina of Sweden.

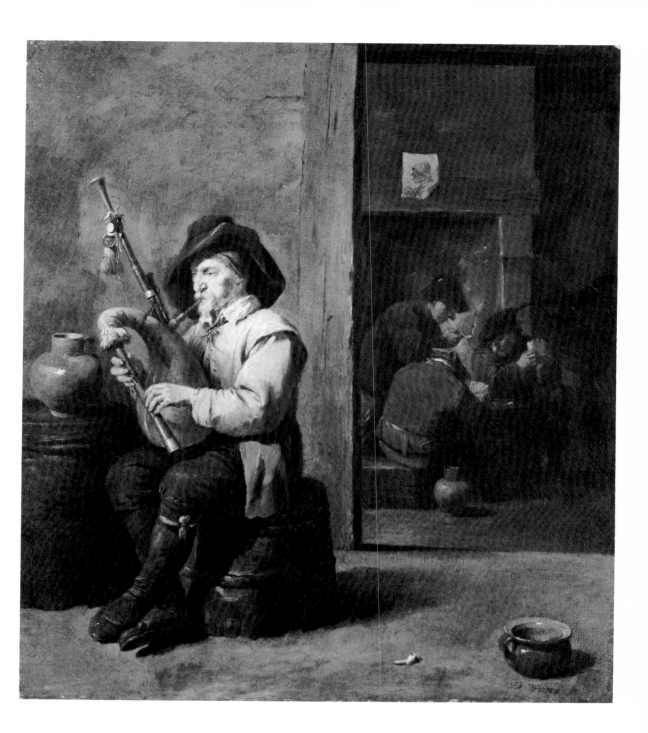

## 26. CLAUDE LORRAIN

French, 1600–1682

*A Pastoral,* 1648(?)

Oil on copper

15⅞ x 21⅝ in.

University purchase,
Leonard C. Hanna, Jr.,
B.A. 1913, Fund

1959.47

Colorplate 7

Born in Chamagne (Vosges) in 1600, Claude Gellée was called Lorrain or le Lorrain from the region of his birth. He went to Italy in his early youth, visiting Naples and Venice. In 1627, after a brief return to France he settled in Rome, where he remained until his death. He was influenced by the Carracci and Domenichino.

Claude's paintings—the larger ones on canvas, the smaller ones, like the Yale picture, on copper—were much sought after; many were commissioned by members of the nobility, foreign ambassadors, and princes of the church. He kept a record of his works by means of drawings collected in his *Liber Veritatis,* which contains a sketch, dated 1648, of the composition of the Yale *Pastoral.*

The *Pastoral* was apparently ordered by a military engineer and collector from Zurich, Hans Georg Werdmüller, who was in Venice on a military mission in 1650. It shows Claude's characteristic idealized landscape with a group of trees dominating the right foreground, a minor accent of foliage at the left, and the luminous center marked by cattle wading in a stream crossed by a bridge. The Italian walled town in the distance might, depending on the literary context, be transformed into classic ruins or a setting for a biblical event. A poet of sunrise and sunset, Claude has colored this tiny pastoral scene with a pink glow that suffuses earth, clouds, and horizon. The warm rose is echoed in the tunic of the shepherd in the lower right corner; his companion's dress repeats the intense blue of the sky. The mood is that of Milton's poems written a decade or so earlier, such as *Lycidas* and *Il Penseroso.*

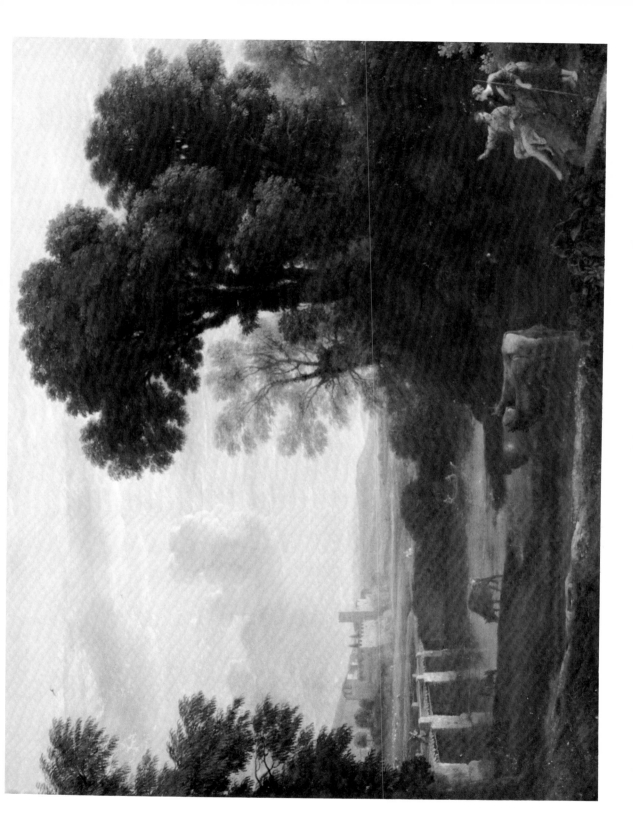

27. ADAM ELSHEIMER

German, 1574/78–1620

*Coronis and Apollo*

Oil and copper

7 x 9¼ in.

Maitland F. Griggs, B.A. 1896, Fund

1956.17.1

Formerly called *Cephalus and Procris,* this painting, together with other existing versions, is now believed to represent the story of Coronis and Apollo. Coronis was a princess of Thessaly with whom Apollo fell in love; their child was Aesculapius, the great physician. During her pregnancy Coronis had a love affair with Ischys, a young Arcadian; enraged when this infidelity was reported to him (according to legend, by a white crow), Apollo sent Artemis to kill Coronis, and had her body thrown upon a funeral pyre. He took away the child, which was very near birth, and gave him to the old centaur Chiron, who had knowledge of healing, to bring up. One version of the story adds that Apollo turned the white crow black, to be forever after a sign of evil tidings.

In Elsheimer's painting a fire is being kindled in the distance; a satyr brings an armful of wood. The fatal arrow lies on the ground at Coronis's feet. All suggestion of the grimness of the subject is lost in the gently poetic mood evoked by the landscape and by the luminous body of the dead Coronis, which is like that of a dreaming Venus. The picture is a tiny love lyric in paint.

Elsheimer was born in Frankfurt, the son of a poor tailor who managed to send him to Italy to study. He visited Venice in 1598, arriving two years later in Rome, where he spent the rest of his life. He painted many small oils on copper, depicting religious and mythological subjects in the landscape settings for which he became famous. He also made etchings, and many of his fine drawings survive. Light effects particularly interested him. A slow worker, he never became rich, although his work was admired and he had a considerable following. Among his friends in Rome were the Dutch masters Pieter Lastman and Jacob Pynas, through whose work his influence ultimately reached Rembrandt.

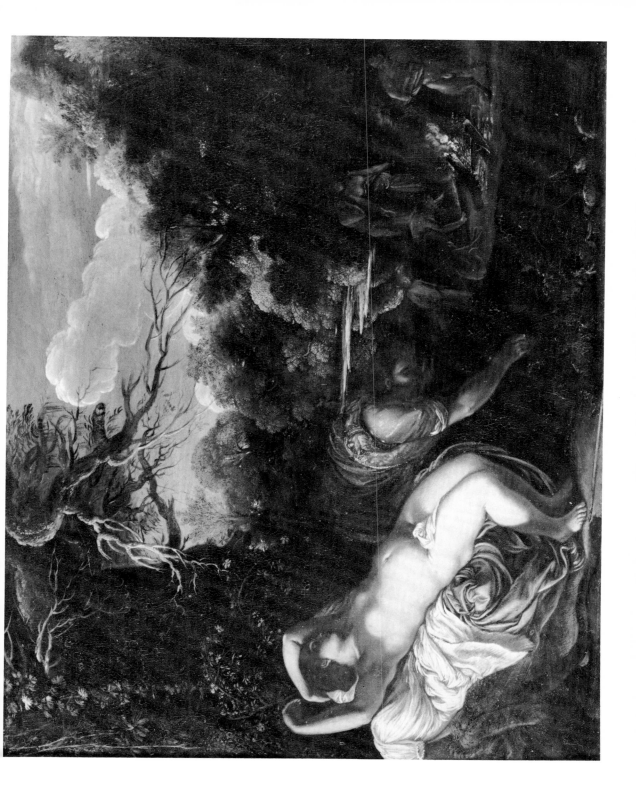

## 28. FRANÇOIS NOMÉ

Italian, 17th century

*The Circumcision in the Temple,* 1623

Oil on canvas

47¾ x 58⅜ in.

Leonard C. Hanna, Jr. B.A. 1913, Fund

1960.45

This mysterious canvas draws us into a world of fantasy and paradox: the theatrical flights of fancy and the irrational spatial relationships of Mannerism. The ceremony takes place in a building whose interior merges with its own exterior; exaggerations of size and proportion are everywhere, and the vivid spot lighting is as arbitrary as it is convincing. Architecturally the temple shows borrowings from the Angevin Gothic style of Naples, as does the lofty sculptured tomb; the observers in the balcony above this have no visible means of access to their high perch. Sunshine blazes from the window at the left, yet midnight darkness covers the sky at the right. The small attenuated figures recall the engravings of Jacques Callot and the paintings of Alessandro Magnasco (see No. 53). The twisted columns of Bernini's baldacchino in St. Peter's recur at the left, but structurally and spatially they make no sense. Suggestions of the Dutch Baroque have also been pointed out. Yet the ultimate effect of this strange mixture of elements is—like Rembrandt's early *Presentation in the Temple*—a visual drama of a highly expressive sort. The date, 1623, appears on a cartouche hanging in the sunshine above the altar.

The artist, whose signature reads FRANCISCO DIDNOMÉ, is a mysterious seventeenth-century master identified by some scholars with a certain Monsù Desiderio, also perhaps one Didier Barra. A François Nomé is recorded as having been born in Metz in 1593; he traveled to Rome in 1602 and to Naples in 1610, working there until 1618. He is said to have painted Magnasco-like scenes of nature's violence. Nomé signed his work on occasion as François Didier Nomé, which would seem to match the shortened name seen on the Yale painting. Whatever the scholars' interpretation of these discrepancies, there is no denying the fascination of this picture, which is an exceptionally interesting and important example of late Mannerist work.

29. SALVATOR ROSA

Italian, 1615–1673

*Landscape with Figures (Bathers)*

Oil on canvas

30 x 40 in.

Gift of Mr. and Mrs. James W. Fosburgh, B.A. 1933

1957.34.2

Salvator Rosa worked successfully as a painter, engraver, poet, musician, and playwright. Born in Naples, he studied painting there with his uncle Domenico Antonio Greco. Summoned to the court of the Medici in Florence in 1640, he became the center of a group of literary men who met in his house. In 1649 he returned to Rome, where he had worked some years earlier for Cardinal Brancacci. He died there in 1673.

Although he painted battle pieces, and very occasionally portraits, Salvator Rosa was primarily a landscape painter, preferring wild, rocky scenery peopled by brigands (who were plentiful in the Italy of his day), gypsies, and figures from literary sources such as the Bible or romantic poetry. Although no dramatic narrative is identifiable in the Yale picture, the strongly contrasted light and shadow, the sweeping diagonals of the composition, and the half-dead trees bending as though in storm, combine to evoke a characteristic romantic-baroque atmosphere. Salvator's landscapes were popular in eighteenth-century England among devotees of the "picturesque"; their dark, often menacing mood was perfectly suited to the taste of lovers of the "Gothick."

30. JUAN DE VALDES LÉAL
   (attributed to)

Spanish, 1630–1690

*A Spanish Ecclesiastic*

Oil on canvas

72⅞ x 44¼ in.

Gift of James W. Fosburgh,
B.A. 1933

1959.14

There is a macabre legend that St. Bonaventura, the great thirteenth-century Franciscan, was supernaturally granted three days between his death and his burial in which to finish writing his life of St. Francis of Assisi. The corpselike figure in this portrait, seated at his writing table with pen poised in air, was for a long time believed to represent the dead St. Bonaventura. Convincing and fascinating as this identification may be, there is good evidence against it. Although the writer is wearing the gray habit of a Franciscan, he also wears the biretta of a doctor of laws and the shoulder cape worn by canons, bishops, and cardinals, manifestly inappropriate for St. Bonaventura; he also wears the cross of La Orden de los Dominicos, the mark of an official of the Inquisition at the time of Charles II. Moreover, evidence of the sitter's identity is provided by the partly damaged inscription on the long scroll at the left, which states that the portrait represents Fray Juan de San Bernardo, an ecclesiastic of high rank who held office in the Inquisition and whose books and sermons still exist. He died in Seville in 1700 at the age of seventy. The portrait was probably painted in the 1680s.

The picture was acquired in Spain in 1835 for Louis-Philippe of France, by his agent Baron Taylor; at that time it was called a Zurbarán. Later it was attributed to Murillo. But the sinister mood and rather gloomy color, combined with the suggestion of death and judgment which so often occupied Valdes Léal, point to that master as the most probable artist. Valdes Léal was born and died in Seville, where he was a rival of Murillo. Active chiefly in his native city, he also spent some time in Cordova. In addition to painting, he worked in architecture, sculpture, and etching.

## 31. JOHN SMIBERT

American, 1688–1751

*The Bermuda Group (Dean Berkeley and His Entourage)*, 1729

Oil on canvas

70 x 93 in.

Gift of Isaac Lothrop
of Plymouth, Massachusetts

1808.1

This well-known painting is the first large group picture painted on American soil. Smibert, a Scotsman, had met Dean Berkeley (later bishop of Cloyne in Ireland) when the latter was in London making plans for the establishment of a college in Bermuda "for the better supplying churches in our foreign plantations, and for converting the savage Americans to Christianity." Smibert was invited to join the faculty as a teacher of painting and perspective. In 1729 the party sailed to Newport, Rhode Island, where they settled down to wait for additional funds from England. During this period, the dean, together with his wife who holds their son Henry, posed for Smibert's group portrait. Mrs. Berkeley's friend Miss Handcock sits next to her; the artist himself stands at the extreme left, looking out at the spectator. The remaining three men have been variously identified; one of them may well be John Wainwright, who commissioned the picture. The seated man writing in a large book has been thought to represent James Dalton, the dean's secretary. Smibert's signature and the date, 1729, can be seen on the edge of a small volume supporting the writer's open book. The composition as well as the subject seems to have influenced Robert Feke's *Isaac Royall and His Family,* painted in 1741 and now in the possession of the Harvard Law School.

Smibert left England just as William Hogarth was coming into prominence; he was an almost exact contemporary of Bach and Handel (the latter destined to have enormous success in London). When the Bermuda College scheme fell through, Smibert established a studio in Boston, where he maintained a collection of copies and prints after various old masters. He enjoyed a professional reputation far higher than he would have had in London, and his collection served as an important source of study for his New England contemporaries pursuing careers in painting.

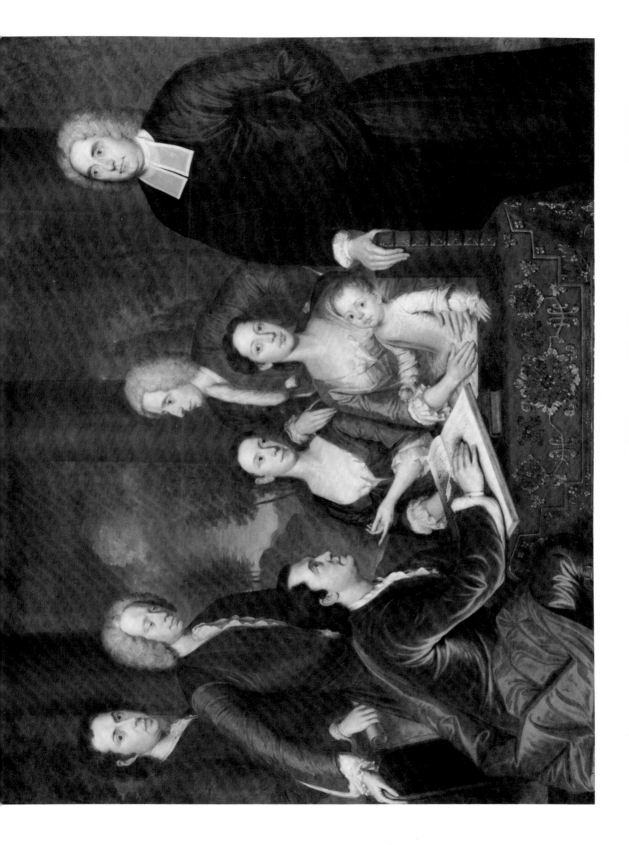

32. JOHN SINGLETON COPLEY

American, 1738–1815

*Benjamin Pickman,* ca. 1761

Oil on canvas

50⅜ x 40¼ in.

Bequest of Edith Malvina K. Wetmore

1966.79.2

Benjamin Pickman, a prosperous young merchant of Salem, posed for this portrait at the age of twenty-one, according to the inscription. Born in 1740, he was graduated from Harvard College in 1759, and in 1762 he married a well-to-do Salem girl, Mary Toppan, whose portrait also is in Yale's collection (No. 33).

Benjamin Pickman was enough of a loyalist to go to England in 1775, but when he returned to Salem ten years later he seems to have encountered no ill feeling, and was elected town treasurer in 1788. It was said of him that he "had not lost a shilling by the war, but on the contrary gained by it."

Copley's portrait, painted when the artist himself was in his early twenties, shows a serious, confident young man wearing a gray suit and scarlet waistcoat lavishly trimmed with gold buttons.

Born in Boston, Copley received his first training from his stepfather Peter Pelham, an engraver. As a painter he was largely self-taught. He developed a carefully finished style in which his sitters were precisely and unsparingly recorded. Among his subjects were John Hancock, John Adams, Paul Revere, and many members of the Boston aristocracy. He went to Italy in 1774 and later settled in London, where his work was influenced by the more facile and showy style of Sir Joshua Reynolds and George Romney. He never returned to his native land.

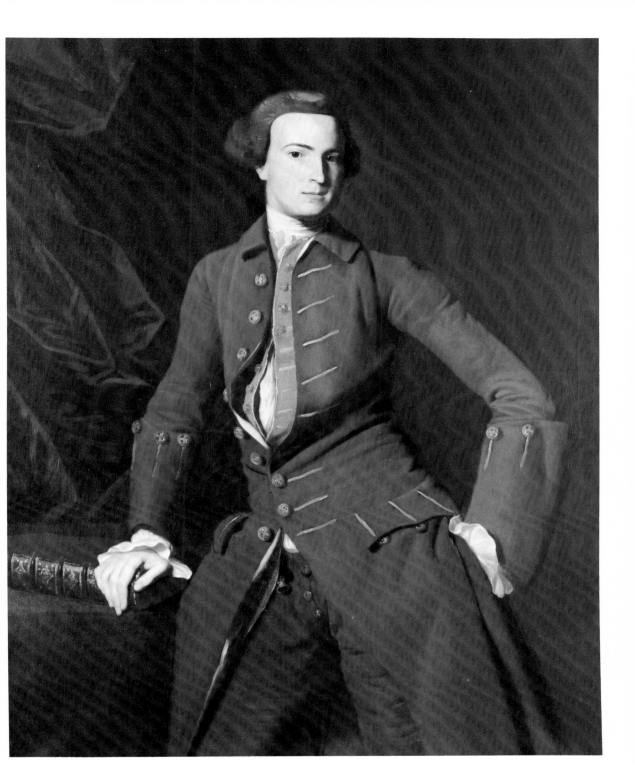

33. JOHN SINGLETON COPLEY

American, 1738–1815

*Mrs. Benjamin Pickman
(Mary Toppan)*, 1763

Oil on canvas

50 x 40 in.

Bequest of Edith Malvina K.
Wetmore

1966.79.3

Colorplate 4

This delightful young lady posed for Copley in 1763, when she was nineteen and a bride of about a year; the portrait was commissioned as a companion piece to Copley's likeness of her husband (No. 32). Daughter of a Salem doctor, Mary Toppan Pickman inherited considerable property. Her blue satin dress is richly embellished with lace and gilt braid (what satisfaction Copley's female sitters must have derived from his ability to record the latest fashions and fabrics!). A little knot of flowers and feathers is perched above her forehead like the headdress of a ballerina; a white ribbon is tied at the nape of her neck. Her blue-green parasol is balanced compositionally at the left by a mass of stone architecture more reminiscent of the stately backgrounds in English portraiture than indigenous to Salem.

Although not beautiful in the conventional sense, Mary Pickman is remarkably winning: alert, self-assured, obviously pleased with life. The canvas is a distinguished example of early work by one of America's most brilliant portraitists.

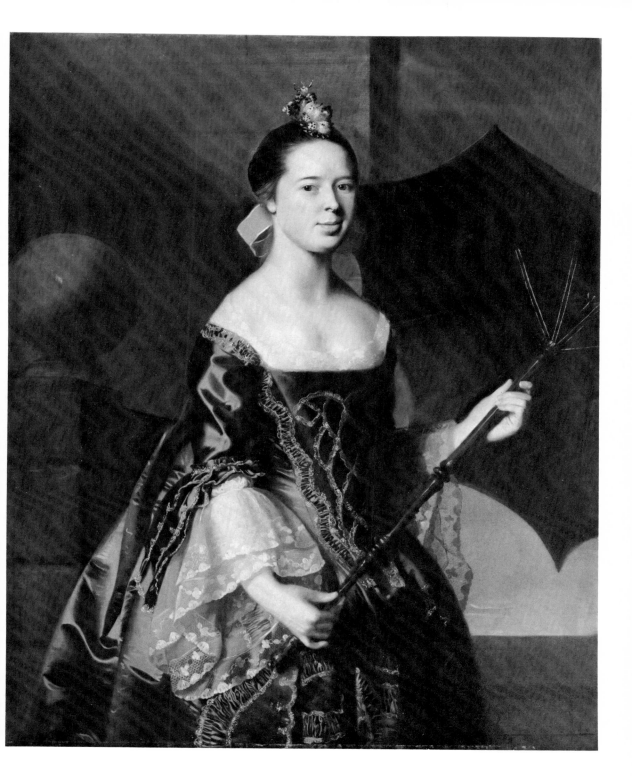

34. JOHN SINGLETON COPLEY

American, 1738–1815

*Isaac Smith,* 1769

Oil on canvas

49¼ x 39½ in.

Gift of Maitland F. Griggs,
B.A. 1896

1941.73

Isaac Smith, wearing a plum-colored suit with gold buttons, sits in a chair upholstered in blue brocade to match the curtain draped at the left of the canvas. As he often did, Copley made the lower half of the figure rather too small, as though he had not bothered to plan the proportions correctly when laying out his composition. But there is nothing diminished or inadequate in the fine head under its powdered wig, or in the self-confident pose of the sitter, who was fifty years old at the time.

A self-made man, lacking a college education, Isaac Smith became a prosperous Boston merchant whose shop advertised "choice Madeira, Sherry, Lisbon and Malaga wine, Jesuits bark, cordage of all sizes, currants. Also Sea Coal for grates." A moderate Whig, he was a member of Samuel Cooper's fashionable Brattle Square Congregational church, where Copley and Susanna ("Sukey") Clarke were married in 1769, the year of the Smith portraits. Isaac Smith's six children were baptized there.

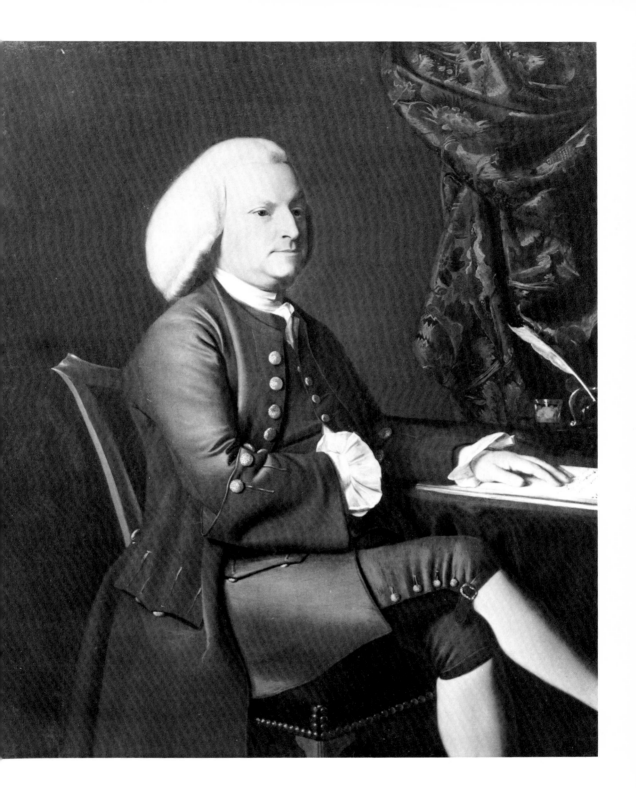

## 35. JOHN SINGLETON COPLEY

American, 1738–1815

*Mrs. Isaac Smith*
*(Elizabeth Storer)*, 1769

Oil on canvas

$50\frac{1}{8}$ x $40\frac{1}{8}$ in.

Gift of Maitland F. Griggs, B.A. 1896

1943.74

Mrs. Isaac Smith and her husband (No. 34) present the observer with as attractive a couple as ever sat to Copley. They were painted five years before the artist left for England in 1774, the period of some of his greatest work.

Mrs. Smith, richly dressed in a reddish purple sacque over a bright blue gown, sits in a Chippendale-style armchair upholstered in yellow damask: A necklace of pearls is wound snugly around her neck; other pearls decorate the sleeves of her sacque and ornament her hair. She holds a bunch of green grapes, a few of which reflect the strong red of the grape leaves. The brushwork is beautifully free and sure, rendering textures with great skill. Through all this material sumptuousness Mrs. Smith looks out at us with an irresistible expression of mingled appraisal, skepticism, and humor; one can hardly help returning that half smile. Copley has caught what must have been a characteristic twist of her mouth—the feature which more than anything else brings the woman before us as a living presence. What a wife for Isaac, and what a mother for their six children!

Copley was not a painter to flatter his sitters, nor did he make concessions to prevailing fashion. Compare Mrs. Smith with the wasp-waisted, tightly laced ladies in Smibert's painting of Dean Berkeley and his entourage (No. 31), so elegantly artificial in their postures. But Copley was certainly conscious of the decorative as well as the historical and social functions of his portraits. Hung in the Yale Gallery among the fine examples of furniture and silver belonging to the Garvan Collection, they may easily be imagined as they would have looked in a handsome drawing room, blending the painted richness of their color and texture with the actual damask, mahogany, and porcelain of the furnishings. Prosperity, comfort, and virtue in eighteenth-century Boston could scarcely be better symbolized.

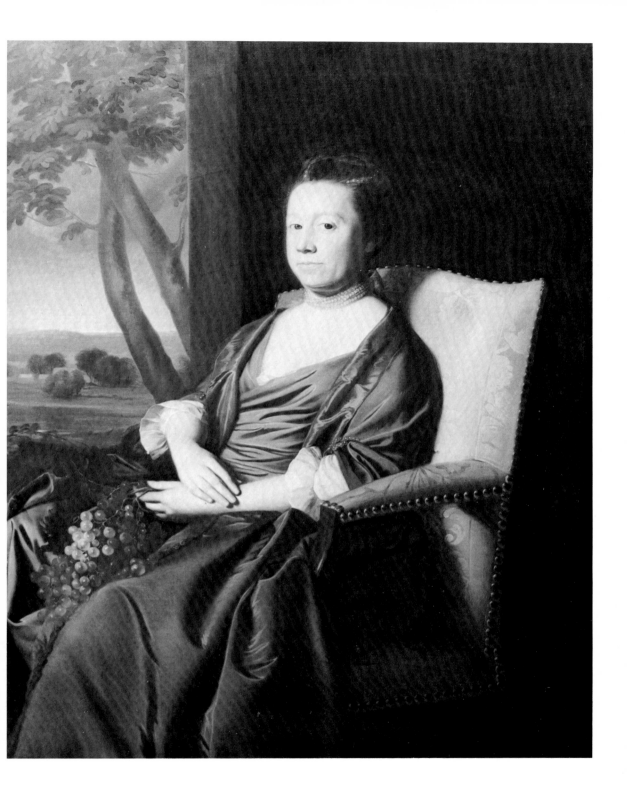

36. BENJAMIN WEST

American, 1738–1820

*Agrippina Landing at Brundisium
with the Ashes of Germanicus,* 1768

Oil on canvas

64½ x 106½ in.

Gift of Louis M. Rabinowitz

1947.16

This painting is a landmark in the development of
Neoclassicism, the powerfully influential academic style
which dominated western art in the last quarter of the
eighteenth-century and some decades thereafter. Based on a
careful study of classical antiquity, Neoclassicism received
special support from the excavations at Pompeii and
Herculaneum, and from the writings of Lessing and
Winckelmann. Historical accuracy was aimed at but was
presented in terms of antique Roman (and later, Greek)
sculpture and architecture. Elevating subject matter was
strongly emphasized; the virtues of stoicism, self-sacrifice,
and high moral principle were exemplified through great
figures and events of ancient history. Color was deliberately
subdued in order to suggest sculpture and to maintain
solemnity of mood.

In West's canvas, the widowed Agrippina, granddaughter
of Augustus Caesar, is seen carrying the ashes of her
husband Germanicus, treacherously murdered by order of
his uncle, the emperor Tiberius. Her two children were also
destined for a grim history. The little girl, Agrippina II,
became the mother of Nero; the boy, Caius, later ruled as
the cruel and mentally deranged emperor Caligula, or
"Little Boots," the nickname he acquired as a boy in
Germany where his father was fighting. Commenting on
the painting, Jules Prown has written: "The picture is a
tribute to a hero who has sacrificed his life for his
country. . . . But more importantly it dramatizes the
admirable performance of Agrippina. . . . Her courage,
stoicism, and dignity in the face of tragic circumstances,
normative behavior in classical times, is presented here to
inspire emulation."

West's painting anticipates by more than fifteen years the
great Neoclassic compositions of Jacques-Louis David, with
their political overtones relating to the French Revolution.
A Quaker, he was born in Springfield, Pennsylvania, and
was a successful portrait painter before he was twenty. In
1760 he went to Italy with funds raised by admirers in
Philadelphia, and after three years of study he settled in
London, where he remained for the rest of his life. He was
a founder of the Royal Academy of Arts, and became its
second president, succeeding Sir Joshua Reynolds; he also
became court painter to George III. An influential teacher,
he was generous in giving help and advice to aspiring artists
from America.

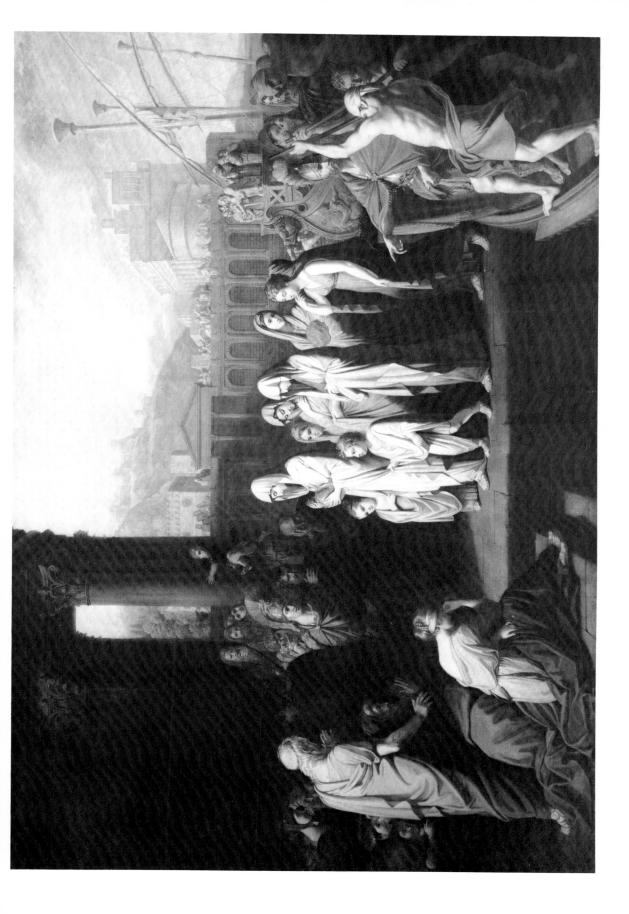

37. SAMUEL KING

American, 1749–1819

*Portrait of Ezra Stiles,* 1771

Oil on canvas

33½ x 27½ in.

Bequest of Dr. Charles C. Foote, great-grandson (by marriage) of Ezra Stiles

1955.3.1

This benign and charming clergyman was the seventh president of Yale College, where he was professor of ecclesiastical history. He served parishes in Newport, Rhode Island, and New Haven, and also studied law. The depth and range of his scholarship are suggested by the books he personally chose for inclusion in this portrait. On the bright red and blue labels we read "Plato," "Livy," "Eusebius"; "Du Halde's *History of China,*" published by a Jesuit missionary in 1735; a volume in Hebrew, and selections from such theologians as Watts, Hooker, Mather, and Chauncey. In his diary of over forty-five bound volumes, now owned by Yale, Stiles gave a detailed description of this portrait, interpreting the two curious symbols to be seen at the left of the composition: "On the shaft [of the column] is one circle and one trajectory around a solar point, as an emblem of the Newtonian or Pythagorean system of the Sun and Planets and Comets.... At the top of the visible part of the pillar and on the other side of the wall, is an emblem of the Universe or Intellectual World. It is as it were one Sheet of Omniscience."

It is, moreover, an image of the Christian faith in redemption; there is a tiny representation of the Crucifixion, and the words ALL HAPPY IN GOD. "These emblems," wrote Stiles, "are more descriptive of my mind, than the Effigies of my face." That face is, nevertheless, attractively recorded by the painter, who was only twenty-two at the time and had a primitive's disregard for the matter of physical proportions.

King was born in Newport and received some artistic training in Boston. He made nautical instruments and gave lessons in painting to the young Gilbert Stuart and Washington Allston, among others. Yale owns his portrait of Mrs. Ezra Stiles.

38. CHARLES WILLSON PEALE

American, 1741–1827

*Washington at Princeton, 1781*

Oil on canvas

95 x 61 in.

Gift of the Yale University Art
Gallery Associates and
Mrs. Henry B. Loomis in Memory of
Henry Bradford Loomis, B.A. 1875

1942.319

Washington is known to have been painted by Peale no
fewer than seven times. This likeness, the so-called Colonial
type, is in all but minor details a repetition of the one now
in the Pennsylvania Academy of the Fine Arts, Phila-
delphia. It shows the American commander leaning confi-
dently on a cannon, his horse held by an attendant in the
background, and several Hessian banners, captured at the
battle of Trenton, at his feet. In the distance a detachment
of British prisoners is being led across the wintry landscape
toward a building which is presumed to be Nassau Hall;
this setting may however be Trenton rather than Princeton.
The battle of Princeton was fought on January 3, 1777, ten
days after the famous crossing of the Delaware. Yale's por-
trait, known to have been in Spain for some time, is very
likely one that was ordered from Peale by the Spanish am-
bassador Don Juan Marailles.

Charles Willson Peale, who gave his artist-sons such names
as Raphaelle, Rembrandt, and Rubens, was born in
St. Paul's Parish, Maryland. A brief period of study with
John Hesselius (whom he paid with a saddle made by him-
self) was followed by a trip to Boston, where he visited
Smibert's old studio and met Copley. In 1766 he went to
London, thanks to the generosity of some Maryland pa-
trons, and spent three years studying under Benjamin West.
He served with the Continental army throughout the Revo-
lution. Early in life he had worked not only as a saddler but
also as a silversmith and maker of clocks and watches.
History and science fascinated him; his painting, *Exhuming
the Mastodon,* executed in 1806, records his personal
experience of the exciting event some five years earlier.
When he founded the Pennsylvania Academy of the Fine
Arts in 1807 (preceded by his Columbianum Academy of
1795) he included natural history specimens along with the
works of art. Like Trumbull, he is an important figure not
only for the development of American painting but also
as a conscientious recorder of the history of the young
republic.

39. RALPH EARL

American, 1751–1801

*Roger Sherman,* ca. 1776–77

*Oil on canvas*

64⅝ x 49¾ in.

Gift of Roger Sherman White

1918.3

Presented to Yale in 1918 by a great-grandson of Roger Sherman, this portrait records Connecticut's great patriot as he looked during the first years of the Revolution. Starting as a shoemaker, he had worked his way up the legal ladder, becoming a lawyer and ultimately judge of the Connecticut supreme court. When he signed the Declaration of Independence, which he had helped to draw up, he had been a member of the general assembly of Connecticut; he also served in the Continental Congress, the Constitutional Convention, and in Congress both as representative and as senator. He appears before us here, stern and solid as the Windsor chair he sits in—an unforgettable image of integrity and high principle.

"These are the times that try men's souls," wrote Thomas Paine in 1776. Ralph Earl shows us a soul superbly equal to the challenge of those trials. In contrast to the more elegant and fashionable portraits painted by Earl after the Revolution (No. 40, *Mrs. Moseley and Her Son Charles,* for example), the Sherman likeness is almost puritanically austere in form and color; only the curtain at the left conforms to popular tradition. Like the prose of Thomas Jefferson, everything is lucid, dignified, and harmoniously designed. *Roger Sherman* has rightly been called Earl's masterpiece.

Although born in Worcester county, Massachusetts, Earl worked chiefly in Connecticut; he also spent some time in Massachusetts, Rhode Island, Vermont, New York, and Long Island. An early American painter of landscape, he sketched the battle sites of Lexington and Concord in 1775. He died "of intemperance" in Bolton, Connecticut, described as "a quiet dying place" by the local minister of the Congregational church, Mr. Colton, who befriended him.

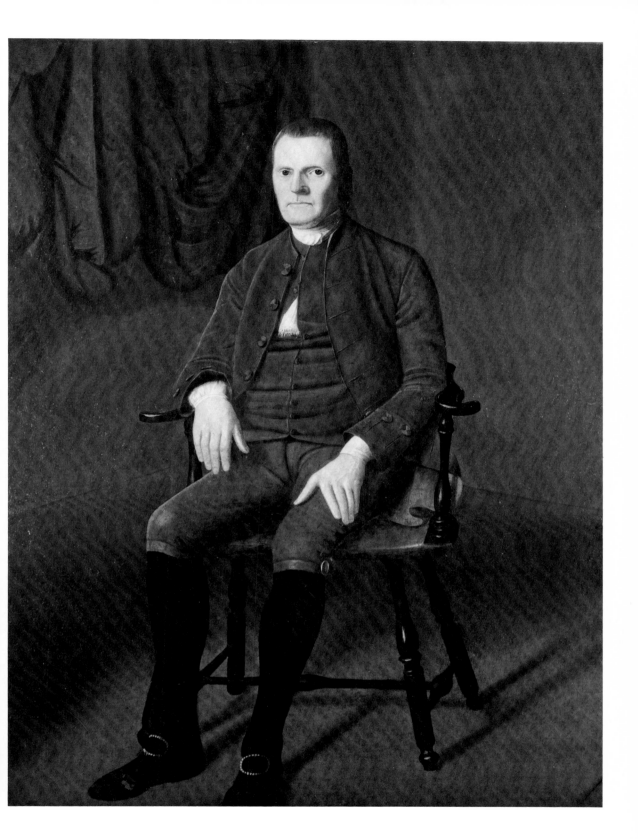

40. RALPH EARL

American, 1751–1801

*Mrs. William Moseley and Her Son Charles,* 1791

Oil on canvas

86¾ x 68¼ in.

Bequest of Mrs. Katharine Rankin Wolcott Verplanck

1942.64

Mrs. Moseley was Laura Wolcott, daughter of Oliver W. Wolcott, B.A. 1747, of Litchfield, a signer of the Declaration of Independence and governor of Connecticut in 1796–97. She was twenty-nine years old when she posed for this portrait; her son was between four and five, although, like many children painted by Earl, he looks considerably older. Charles died at the age of twenty-eight, having taken his B.A. from Yale in 1808 and then practiced law in Hartford.

Of her experience while sitting for this portrait, Mrs. Moseley wrote to her brother: "I am told that you begin to indulge hard thoughts of me for not writing oftener; you ought to consider that my attention has been engrossed by Mr. Earl, and that I have had enough to do, to acquire the grace of patience; I assure you, I have nearly attained it, and probably in the course of two or three months shall arrive at a state of perfection in this virtue."

The town in the background of the painting has been called Litchfield, but since Mrs. Moseley's letter was sent from Hartford, this identification is open to question, the more so because two domes are seen on the horizon— scarcely Litchfield architecture. Earl had spent the years 1778–85 in England; one might conjecture that he based the landscape on some English topographical print.

Less brilliant than those by his contemporary Copley, Earl's portraits have an equal probity and sense of the sitter's personality. Their rather stiff figures, clearly outlined against interior or outdoor backgrounds, seem symbols of human dignity and self-respect—sometimes touched, as in Mrs. Moseley's case, with an engaging awareness of social status. There is great charm in the strongly asserted design and in the cool harmonies of color.

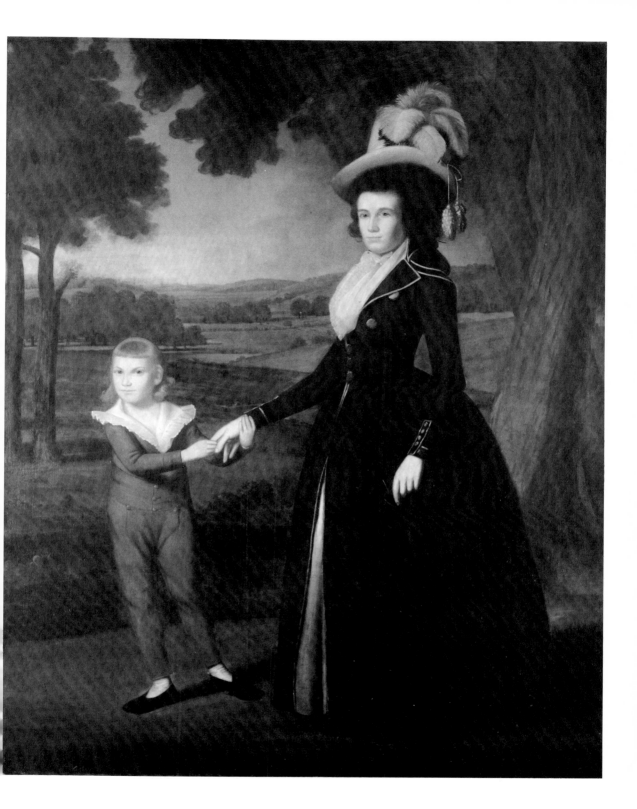

41. GILBERT STUART

American, 1755–1828

*Sarah Webb Swan*
*(Mrs. William Sullivan)*

Oil on canvas

35 x 27 $^{15}/_{16}$ in.

The John Hill Morgan Collection

1943.65

Sarah Webb Swan was the daughter of Colonel James Swan, who came to America from Scotland in 1765 and became a staunch supporter of the Revolution, fighting at Bunker's Hill. She was married in 1802 to William Sullivan, whose father, James S. Sullivan, became governor of Massachusetts and posed for Stuart in Boston in 1807. His daughter-in-law's portrait may well have been painted about that time. Wearing a white dress and turban, she sits with quiet dignity in an Empire chair upholstered in blue; the bright red of her cashmere shawl is picked up in the cord and tassel of the curtain behind her. The background, with its column and sweeping curtain, fits the traditional formula for the "grand manner" descended from Titian through Van Dyck to Stuart's contemporaries Sir Joshua Reynolds, George Romney, and many another. The special liveliness of the coiling cord and tassel is a pleasant touch from the hand of a painter who was also a gifted musician and eked out a meager living, when he was in England in 1775–77, by playing the organ in a London church.

Noted for his speed of performance in portrait painting (two or three sittings often sufficed), Stuart was well qualified to catch the essentials of a feminine likeness and give it life and freshness. Sarah Sullivan is not a conventional beauty, but her firm mouth and chin, long nose, and wide-set blue eyes present an image of competence and modest self-assurance worthy of Jane Austen. The portrait is a fine example of Stuart's late period.

Gilbert Stuart was born in Narragansett, Rhode Island, where his Scottish father had a snuff mill. In 1769 he went to Scotland with the painter Cosmo Hamilton, who had been painting portraits in Newport; six years later he made a second trip abroad and became a pupil and assistant of Benjamin West in London. He gradually found success as a painter of portraits, in which he specialized and in which he held his own in spite of the popularity of Reynolds, Gainsborough, and other British masters. Prosperous at last, he began living so extravagantly that he ran into debt; this pattern was repeated during five years in Ireland. His fallen fortunes drove him back to America in 1793. First in New York, then in Washington and Boston, he rose once more to preeminence as the most fashionable portrait painter in the area, adding to his fame by his several likenesses of George Washington.

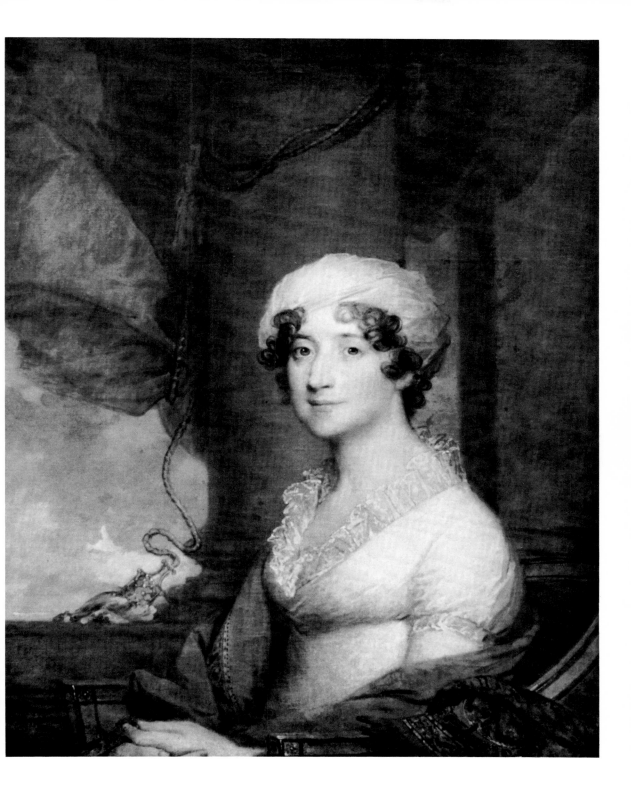

## 42. GILBERT STUART

American, 1755–1828

*John Trumbull,* ca. 1818

Oil on wood panel

$25\frac{5}{16}$ x $21\frac{7}{16}$ in.

Bequest of Herbert L. Pratt

1945.238

When John Trumbull returned from England in 1804, Gilbert Stuart was established in Boston as the leading portrait painter in New England; he therefore took up residence in New York, not wishing to risk competition with the already successful and more brilliant master. The Yale portrait seems to have been painted in Boston, presumably in 1818 when Trumbull was sixty-two years old.

Stuart's free, sparkling brushwork and transparent color are well exemplified in this dignified, urbane likeness of a man who was at this time on his way to becoming, in the words of his biographer and a former director of the Yale Gallery, Theodore Sizer, "a disillusioned, querulous, debt-ridden old man." Characteristically, Stuart has presented his sitter's best features; there is no indication of Trumbull's one blind eye. It is a source of satisfaction to Yale University to own this portrait of the founding father of its art collections.

In addition to the portrait of Trumbull, and the likeness of Sarah Webb Swan (No. 41), Yale owns several male and female portraits by Stuart, including one of Aaron Burr's only daughter, Theodosia.

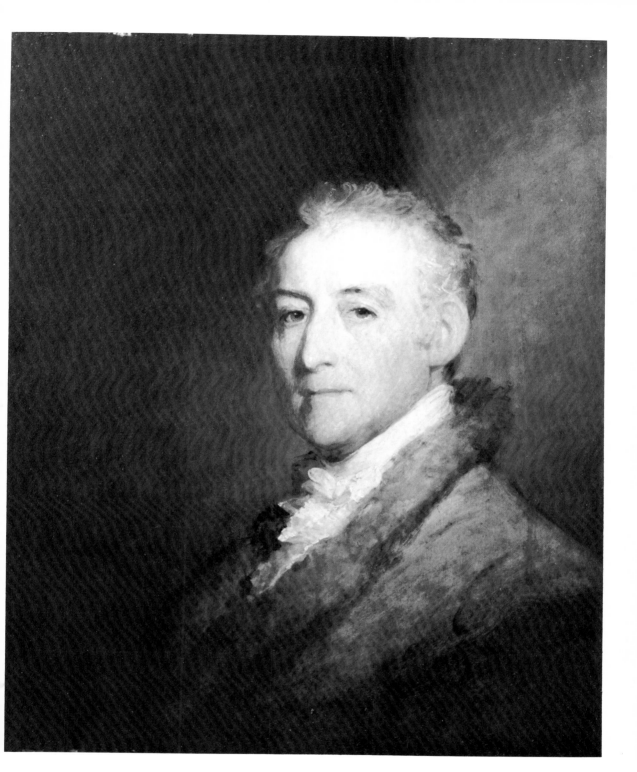

## 43. JOHN TRUMBULL

American, 1756–1843

*The Death of General Warren at the Battle of Bunker's Hill, June 17, 1775*, 1786

Oil on canvas

25 x 34 in.

Purchased from the artist

1832.1

Trumbull witnessed this battle on June 17, 1775, from across Boston harbor. The episode represented is the death of the American General Warren, who lies dying on the ground, threatened by the bayonet of a redcoat who is being restrained by the British Major Small. Behind Small, Major Pitcairn falls mortally wounded into the arms of his fellow officers. Colonel Israel Putnam may be seen at the extreme left, brandishing his sword. In the right foreground striking the pose of a Greek warrior in classical art, is 2nd Lieutenant Thomas Grosvenor of the 3rd Connecticut regiment, with his Negro attendant Peter Salem; Yale owns a preparatory oil sketch for these two figures. The picture was painted in Benjamin West's London studio in 1786 and was engraved in Stuttgart, Germany, the subject being naturally unsympathetic to Britons. The fresh, brilliant little picture was a preparation for the large, carefully finished canvas now in the Rotunda of the Capitol in Washington, D.C. Another version is owned by the Wadsworth Atheneum in Hartford, Connecticut. *The Battle of Bunker's Hill* is one of several related historical paintings by Trumbull in Yale's collection.

Trumbull was born in Lebanon, Connecticut, the son of Governor Jonathan Trumbull. A Harvard graduate, he served in the Revolutionary army and attained the rank of lieutenant colonel. For a short time he was aide-de-camp to General Washington. In 1780 he went to London; in 1787 and 1789 he was in Paris, where he knew Thomas Jefferson and met such prominent French painters as Jacques-Louis David. Returning to America, he painted a large number of portraits. In 1816 he settled in New York, where he remained for the rest of his life except for an interval of four years in New Haven, 1837–41. In 1831 he presented his pictures to Yale College in exchange for an annuity, which the College, doubtless to its dismay, was obliged to go on paying for twelve years. In 1832 the Trumbull Gallery, which he designed, was opened on the Yale campus; that building no longer exists. The painter and his wife are buried beneath the present Art Gallery.

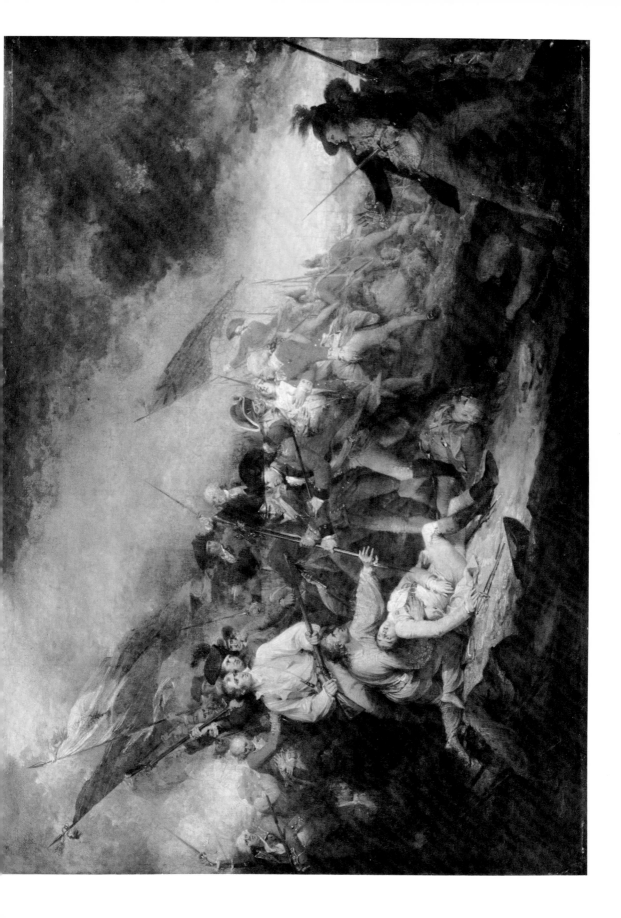

## 44. JOHN TRUMBULL

American, 1756–1843

*The Death of General Mercer at the Battle of Princeton, January 3, 1777,* 1789–before 1797

Oil on canvas

$20\frac{1}{2}$ x $29\frac{7}{8}$ in.

Purchased from the artist

1832.6

The battle of Princeton was fought on January 3, 1777. In the center of the composition Trumbull has placed General Washington directing his troops. In front of him, leaning against his wounded horse, the fallen General Mercer tries to fend off the bayonet of a British soldier. British banners fly at the right; at the far left the Stars and Stripes can be seen above the mounted figure of Brigadier General Thomas Mifflin of the Continental army.

Yale owns an oil sketch for this painting, and several preparatory drawings for the composition; other drawings are now in the possession of Princeton University. Like *The Death of General Warren at the Battle of Bunker's Hill* (No. 43), this was intended as one of a series of historical paintings which Trumbull planned to have engraved for public sale. The paintings themselves were finished in London.

Although he was a prolific portrait painter, Trumbull's chief importance lies in his historical compositions. As America's first systematic recorder of great moments in the development of the young republic, he made careful studies of the individuals involved and of pertinent factual detail. A pupil of Benjamin West in London, and an admirer of the Neoclassic art of his day, Trumbull built his compositions on approved academic patterns and adapted poses and gestures from antique sculpture and old master paintings. He did, however, insist on accuracy of costume and accessories. In his best historical pictures, such as this one, he evokes a vivid sense of the event itself in spite of the formal, consciously theatrical arrangement which was, of course, deliberately chosen to emphasize the greatness of the historical moment, the lofty theme of high tragedy and noble achievement.

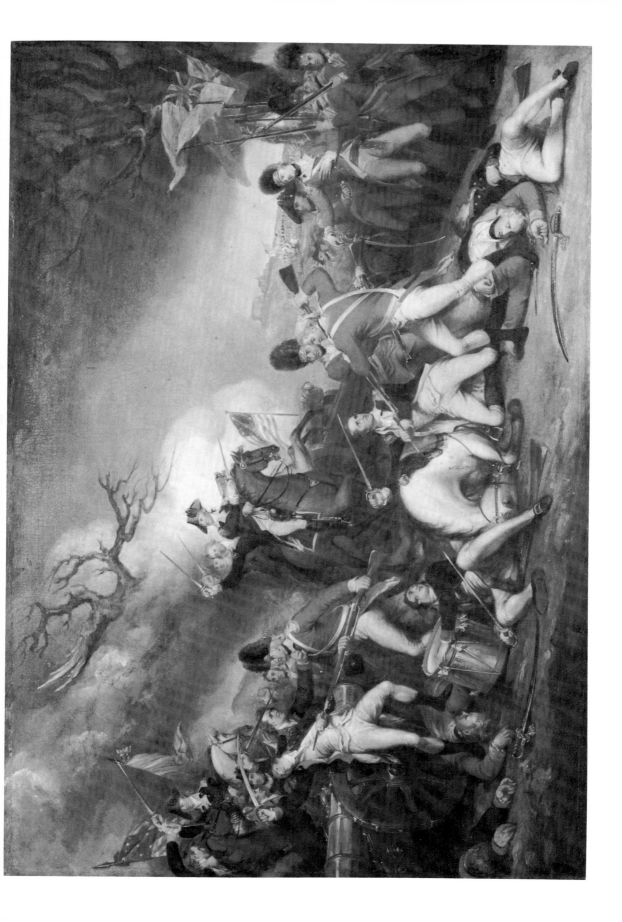

## 45. JOSEPH HIGHMORE

British, 1692–1780

*Henry Wyndham,* 1743

Oil on canvas

50 x 40 in.

John Hill Morgan, B.A. 1893, Fund

1964.42

This benevolent gentleman sums up, in his person and in his setting, the character of aristocratic England in the mid-eighteenth century. His pose and expression are typical for the time, embodying self-confidence, affability, and a lively satisfaction with the taste and culture implied by his handsome Georgian house, his elegant costume, and the classic column. Henry Wyndham, as a grandson of Sir Wadham Wyndham, Knight, of Norrington, Wiltshire, and Orchard Wyndham, Somerset, was entitled to bear heraldic arms; hence the title *Armg.* (Armiger) written after his name at the upper left corner of the picture.

Joseph Highmore is probably best known for his charming paintings illustrating Richardson's *Pamela* (1740–41). He is outstanding in an age of competent recorders of British life among the well-to-do; the popular "conversation pieces" constitute well-bred accounts of prosperous families, proud and jealous of their social standing. But Highmore was also a distinguished portrait painter. *Henry Wyndham,* one of his finest canvases, belongs to the period of Hogarth's most brilliant social criticisms in paint, and of the great operas and oratorios of Handel, then resident in London.

Born in London, the son of a coal merchant, Highmore studied under Sir Godfrey Kneller, and later set up a studio in Lincoln's Inn Fields. A great admirer of Rubens, he went to Antwerp in 1723 to study the master's work, and he also visited Holland and Germany. When the Order of the Bath was revived in 1725, he furnished drawings for John Pine's engraved portraits of the knights. This led to direct commissions for portraits, ultimately from George II and members of the royal family. Highmore also wrote several books on art and religion. He retired, wealthy and successful, in 1761, dying in Canterbury nineteen years later.

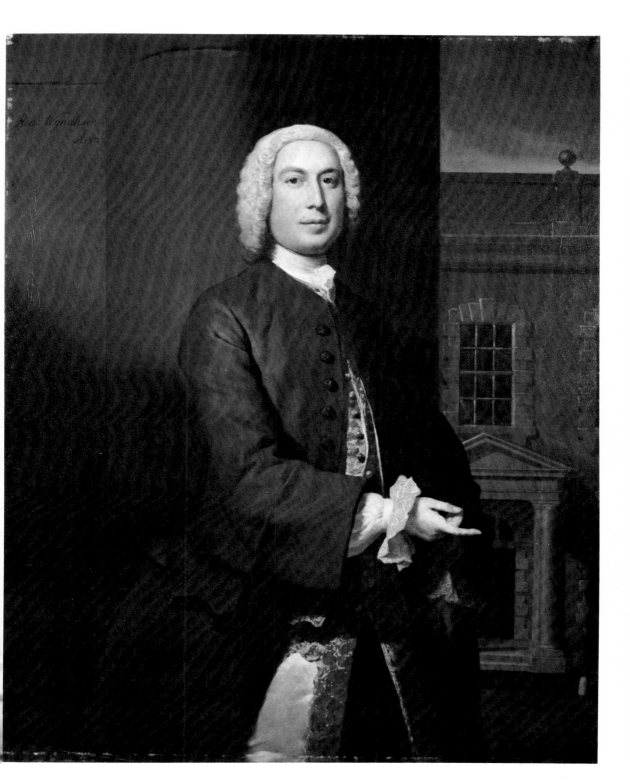

## 46. ARTHUR DEVIS

British, 1711–1787

*Robert Gwillym of Atherton and William Farington of Werden,* 1743

Oil on canvas

30 x 36⅞ in.

Gift of Mr. and Mrs. James W. Fosburgh, B.A. 1933

1958.60

This type of portrait, small in scale, is related to the so-called conversation pieces which were popular in eighteenth-century England. Members of a family, or a group of friends, would be posed in more or less stereotyped attitudes, either indoors or in an outdoor setting suggestive of their tastes, personal possessions, and standing in society. A Queen Anne or Chippendale chair effortlessly became a grassy bank or a stony outcrop for the gentleman seated upon it, and his companion might lounge as gracefully against a tree trunk or a bit of garden sculpture as beside a Georgian chimney piece. Thus the Englishman's desire for a faithful likeness could be satisfied along with his fashionably romantic yearnings for wild landscapes adorned with melancholy ruins—sometimes constructed on purpose, when originals were lacking.

A pupil of the Dutch painter Pieter Tillemans, Devis, like Joseph Hayman and others of his day, tended to paint his figures flatly, with crisp outlines. Landscape settings have the effect of backdrops spatially and atmospherically unrelated to the human beings occupying them. One is reminded of Alexander Pope's neatly turned couplets, or of Horace Walpole savoring the joys of his sham "Gothick" at Strawberry Hill. The ruined buildings in Devis's canvas are more likely to have been inspired by medieval structures than by souvenirs of the Roman Campagna such as Devis might have borrowed from engravings.

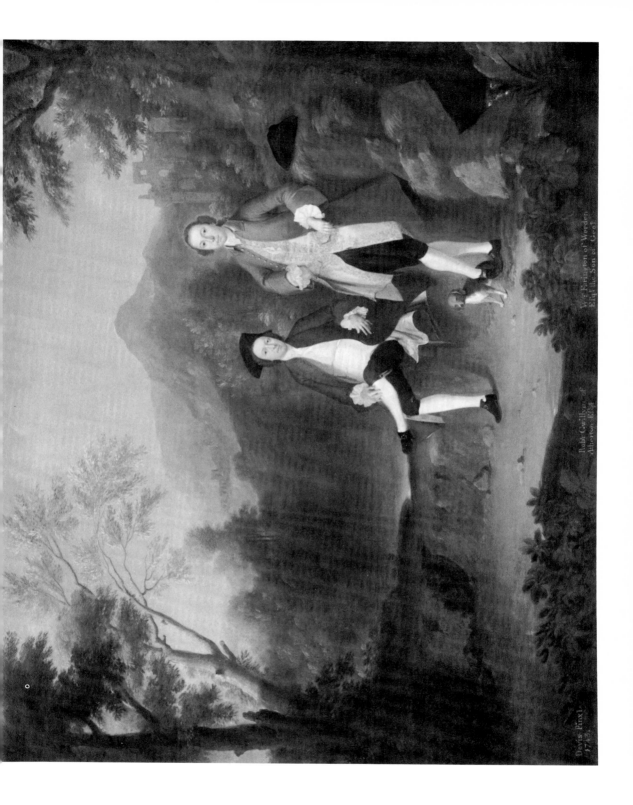

Devis Pinxt.
1743.

Robt Gwillym of
Atherton. Esq

W: Farington of Werden
Esqr. his Son or Grd?

## 47. SIR JOSHUA REYNOLDS

British, 1723–1792

*Mr. and Mrs. Godfrey Wentworth,* 1763

Oil on canvas

56¼ x 61 in.

University purchase, Leila A. and John Hill Morgan, B.A. 1893, Fund 1959.46

In the years before the founding, in 1768, of the Royal Academy of Art of which he became first president, Reynolds's portraits often show a directness and a lack of the theatricality and flourish which characterize so many of his later works. In Ellis Waterhouse's apt phrase, Mrs. Wentworth represents "domestic virtues rather than the public style of a great lady of the eighteenth century." Clearly prosperous and well content, the Wentworths do not attempt to dazzle the observer or impress him with their social importance; nor does their representation suggest the painter's classical taste and learning. Although many of Reynolds's canvases have lost or changed color through chemical change in the pigment, in this case the cool, silvery tonality seems to have been intentional.

Reynolds was the son of a Devonshire clergyman who headed Plympton Grammar School. He was apprenticed in 1741 to the painter Thomas Hudson, with whom he worked for two years. In 1749 he went to Italy, spending two years in Rome and visiting Florence and Venice, where he copied Titian, Tintoretto, and Veronese. The work of Raphael and Michelangelo most strongly influenced the formation of his ideal "grand style" in painting; his theories were eloquently set forth in his famous *Discourses on Painting* delivered yearly before the Royal Academy. From 1753 until his death he lived in London, where he enjoyed enormous success as a fashionable portrait painter. After 1789 failing eyesight forced him to give up painting.

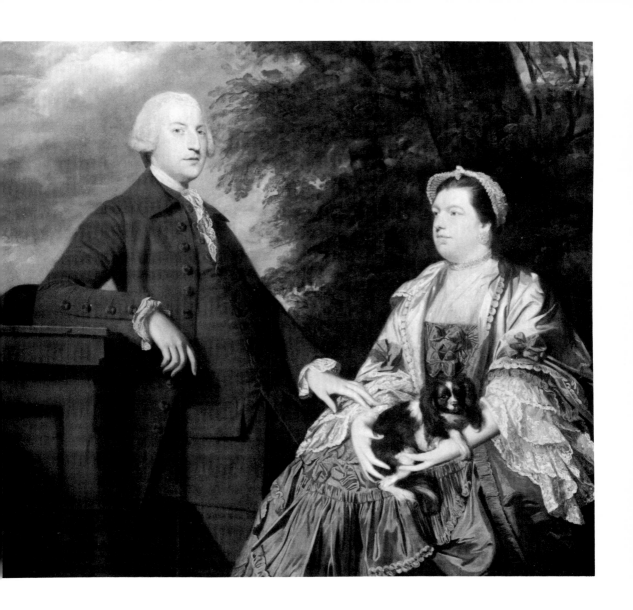

48. SIR JOSHUA REYNOLDS

British, 1723–1792

*Omai,* ca. 1774

Oil on canvas

$23\frac{3}{4}$ x $20\frac{3}{4}$ in.

Gift of the Yale University
Art Gallery Associates

1936.128

Omai (sometimes called Omiah) was an Otaheitan chieftain, one of two natives of the Society Islands who sailed for England in 1774 in the *Adventure,* consort of the *Resolution* which carried Captain Cook on his second voyage to the Pacific. Omai's companion died during the trip, but he himself reached London, where he became a sensation as the first native of the Pacific islands ever to have been seen in England. The prevailing interest in the "noble savage" or primitive man contributed to the success of Omai, who seems to have charmed the court of George II and the social and literary aristocracy to which he was introduced. He returned to the Society Islands in 1776.

While in London Omai posed for a full-length portrait by Sir Joshua Reynolds, the so-called Castle Howard portrait. Yale's picture is in all probability a study for this. It is a freely painted, informal likeness of an essentially modest, attractive personality of whom Chauncey B. Tinker has written, "The South Sea Islanders were happy in their choice of this unofficial ambassador to Great Britain."

## 49. GEORGE STUBBS

British, 1724–1806

*Lion Attacking a Horse,* 1770

Oil on canvas

38 x 49½ in.

Gift of the Yale University
Art Gallery Associates

1955.27.1

Colorplate 10

Best known for his smoothly finished likenesses of horses, Stubbs turned now and then to themes less documentary in character. Among these a favorite was that of a horse attacked by a lion, which he is said to have witnessed in north Africa about 1755. An account published in 1808 in *The Sporting Magazine* describes this killing of a white Barbary horse by a lion which emerged by moonlight from some distant cliffs to stalk its prey. Stubbs painted several versions of this subject. In the Yale example, dramatic forms of rock and storm cloud are echoed in the curves of the animals in their death struggle. This kind of picture has been called proto-Romantic; it anticipates Eugène Delacroix, the great leader of the early nineteenth-century Romantic movement in France, who often, like the sculptor Barye, represented animals in combat. Delacroix may have seen engravings of one or another of Stubbs's horse and lion compositions, which circulated on the Continent as well as in England. An oil sketch in the Louvre, attributed to Delacroix, is very close to the Yale picture in reverse, as though derived from a print. A more ancient source for all of these may be the sculptured group now in the Palazzo dei Conservatori in Rome; a variation of this is depicted in Yale's painting by Panini illustrated in this book (No. 54).

It has been suggested that in *Lion Attacking a Horse* Stubbs was consciously aiming at the imaginative or "sublime" type of picture so highly esteemed by Sir Joshua Reynolds and the Royal Academy, to which Stubbs was elected as an Associate in 1780 and for which his factual animal paintings hardly qualified him. The inherently painful subject of the Yale picture has been transmuted into a genuinely "noble tragedy" of academic art, and there is real excitement and beauty in the form of the white horse gleaming against the dark, threatening landscape.

Born in Liverpool, Stubbs spent some time in York. After traveling in Italy, he returned to Liverpool, and in 1766 published his monumental work, *The Anatomy of the Horse,* which enjoyed a high reputation in England and on the Continent.

50. HENRY FUSELI

Anglo-Swiss, 1741–1825

*Mother and Child: A Mythological Subject,* ca. 1790

Oil on canvas

39⅞ x 50 in.

Gift of the Yale University
Art Gallery Associates

1958.65

What tragic tale is enacted here? A woman bends sorrowfully over her sleeping, or dead, child, her left hand touching a dagger. In the distance a man (or god?) with flying hair drives a golden chariot over tossing waves. One thinks of Medea, or of Hagar and Ishmael in the desert, but so far the scene has not been identified. Is it Apollo in the chariot, or Neptune? Or are we dealing with an allegory? The melancholy mood and stormy setting are unmistakably in the spirit of the Gothic novel, but the bare-shouldered driver seems certainly to belong to classical mythology. Whatever the meaning, the atmosphere of mystery is typical of the painter's work.

Henry Fuseli (actually, Johann Heinrich Füssli) was born and educated in Zurich. Through his friendship with the Swiss preacher and theologian Johann Lavater he became interested in physiognomy and mystical speculation, later influencing William Blake in England. While there he was encouraged by Sir Joshua Reynolds, whose influence is suggested in the figure of the woman in Yale's picture. After an eight years' stay in Italy, Fuseli returned, in 1778, to England. He painted illustrations for Shakespeare's plays and the poems of Milton, and composed poetry of his own. In 1788 he was elected an Associate of the Royal Academy, attaining full membership two years later. He was appointed Professor of Painting and Keeper of the Academy. Some of his drawings were engraved by Blake, who held him in high esteem.

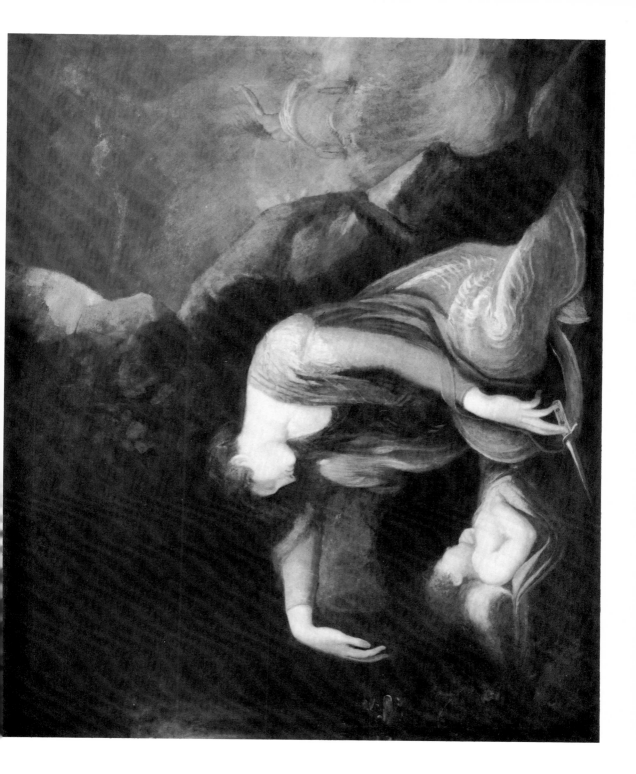

51. JEAN-BAPTISTE PATER

French, 1695–1736

*Courtly Scene in a Park (Scène galante dans un parc)*, ca. 1733–34

Oil on canvas

20¾ x 27⅛ in.

Gift of Mrs. André Blumenthal in memory of her mother, Annie C. Wimpfheimer

1957.28

Colorplate 8

This delightful little picture, probably painted in the 1730s, is an example of the so-called *École galante* characteristic of the Regency period in France following the death of Louis XIV in 1715. Court life became relaxed and frivolous; sophisticated taste ran to the lively, decorative, and playful style known as rococo.

Yale's picture is a variant of a painting, *La Danse*, in the Wallace Collection in London; stylistically it is close to two dated pictures by Pater, *La Fête de la Foire de Bezons* (1733) and *Concert Champêtre* (1734). At the extreme left of the composition are two musicians, one with his back to the observer, playing a viol, the other playing a hurdy-gurdy—a stringed instrument operated by means of a crank, plebeian in origin but much favored by the aristocracy in the eighteenth century.

Like Watteau, Pater was born in Valenciennes, son of a picture dealer who also did decorative sculpture. He worked for a time in Watteau's Paris studio. After returning for a short time to Valenciennes, where he made unsuccessful attempts to defy the local Guild of St. Luke, he went back to Paris, remaining there until his death in 1736.

Pater's work, like Watteau's, reflects the influence of the theater. It has a musical comedy lightness and gaiety, whether the subject is one of the country fairs popular at the time, a scene of military encampment brightened by the presence of ladies, or the endless variations on the themes of the picnic, the dance, and the courtly flirtation. We find an exact musical parallel for these little paintings in the compositions of Rameau, Scarlatti, and Couperin.

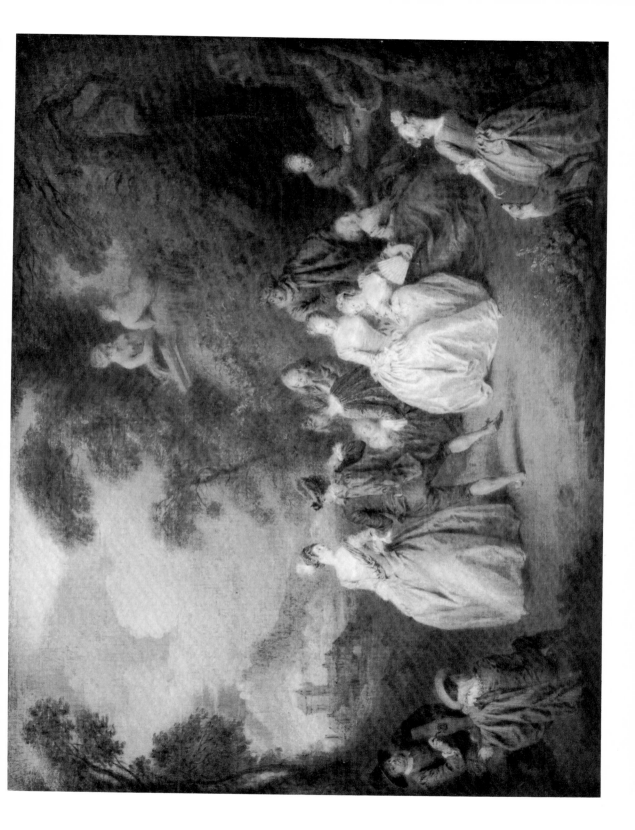

## 52. HUBERT ROBERT

French, 1733–1808

*The Old Bridge (Le Pont ancien,* or *Escalier monumental sous un pont orné de statues),* ca. 1760

Oil on canvas

30 x 39½ in.

Gift of Mr. and Mrs. James W. Fosburgh, B.A. 1933

1957.34.1

Colorplate 9

Hubert Robert was one of those travelers to Italy who saw and remembered that artists' paradise through rose-colored glasses. In contrast to certain of his painter contemporaries such as Canaletto and Bellotto, whose approach to landscape was topographical, he used buildings and antique sculptures like pieces in an unorthodox game of architectural chess, rearranging and combining them in defiance of geographical fact. Like many designs by Panini and Piranesi, his compositions often suggest baroque stage settings. As in the Yale picture, scale may be distorted to heighten the dramatic or emotional effect. Robert's is a world of romantic imagination, in which the beguiled spectator is rarely moved to wonder how the little human figures ever managed to arrive at the improbable places they occupy.

Born in Paris, Hubert Robert studied for a time with the sculptor Michel-Ange Slodtz. He went to Rome in 1754 with the Comte de Stainville, later Duc de Choiseul. In Rome he met Fragonard, who became his close friend and fellow protégé of the Abbé de Saint-Non. In 1760 the Abbé took him to Naples and Herculaneum, where excavations had been under way since 1738.

Hubert Robert's work is chiefly decorative. His lightly brushed, fancifully devised compositions are perfectly suited to the eighteenth-century rococo salons and music rooms for which he designed wall panels.

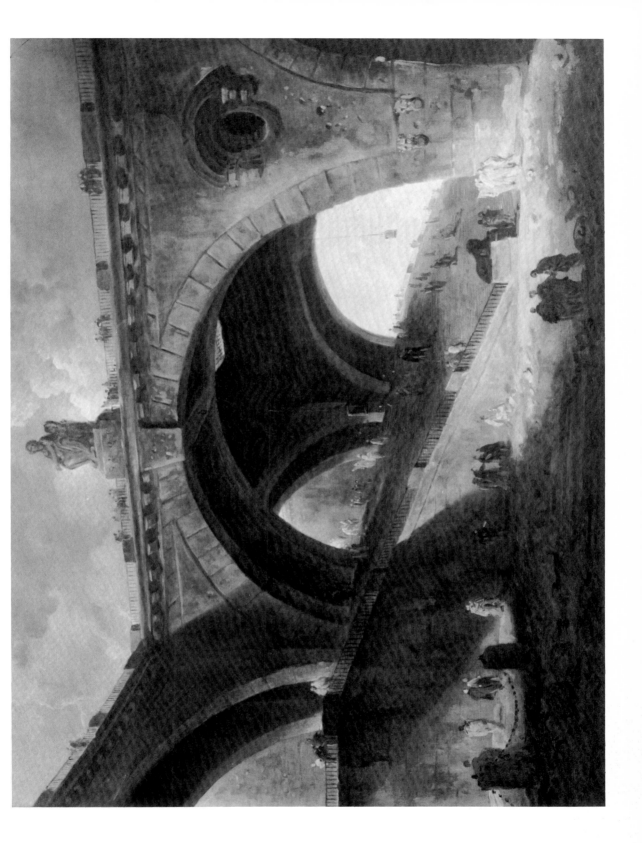

53. ALESSANDRO MAGNASCO

Italian, 1667–1749

*Seascape with Fishermen Pulling out Nets*

Oil on canvas

$45\frac{1}{2}$ x $68\frac{1}{4}$ in.

The Maitland F. Griggs, B.A. 1896, Collection

1945.142

In contrast to the sunlit, detailed townscapes of Bellotto and the nostalgic classical ruins of Panini, Magnasco's landscapes are romantic expressions, sometimes exaggerated to the point of caricature, of the uncontrollable forces of nature. Even when his horizons are bathed in sunshine, as in this picture, his canvases are essentially stormy, filled with tempest-tortured waves, straining branches, and scudding clouds lit as though by lightning flashes. Human figures, relatively small in proportion to their surroundings, are elongated and distorted in a manner recalling El Greco. They seem always to be battling the elements; every act takes on the character of an emergency, as though the day of doom were at hand. In this scene of fishermen beaching their nets, a specific note of the supernatural occurs in the scaly sea monster glaring above the waves in the middle distance. Magnasco's characteristic brush strokes, rapid and splintery, are visual symbols of speed and terror.

Born in Genoa, Magnasco worked for some years in Milan, and in Florence, ca. 1703–10, for Gian Gastone, the last of the Medici grand dukes. From 1711 to 1731 he was in Milan, finally returning to Genoa where he died.

## 54. GIOVANNI PAOLO PANINI

Italian, 1691–1764/68

*A Capriccio of Roman Ruins and Sculpture with Figures,* 1741

Oil on canvas

67 x 86½ in.

Stephen Carlton Clark, B.A. 1903, Fund

1964.41

A capriccio is a fantasy or scene formed in the imagination. Panini's paintings in this category tend to be combinations of guidebook and scrapbook. Although he is sometimes topographically accurate, he often rearranges actual buildings on an identifiable site and introduces structures or sculptures borrowed from other locations. Allowing for these liberties taken with fact, his canvases provide useful evidence of what towns looked like in the eighteenth century. Peasants, tourists, and local or visiting dignitaries help to dramatize a scene. Among classical ruins, historians and archaeologists search for evidences of earlier civilizations; philosophers and poets meditate on the melancholy and brevity of life, the transitoriness of imperial power, and the certainty of decay; peasants, unconcerned with the past, hang their laundry in the shadow of an emperor's arch of triumph. The result is like a stage setting, picturesquely composed.

Panini studied architecture and perspective in his birthplace Piacenza, perhaps with Ferdinando Galli Bibiena, the most famous member of a family of designers for court festivities and the stage. About 1717 he went to Rome, where he was influenced by Salvator Rosa and by painters of classical ruins. In 1729 the French ambassador, Cardinal Polignac, commissioned him to paint decorations in honor of the birth of the dauphin. Three years later he was made Fellow of the French Academy in Rome, where he taught perspective.

The Yale *Capriccio* shows the Roman Forum as seen from the west. Several of the buildings are placed as they stood in the eighteenth century or stand today, for example the Arch of Titus (before modern restoration) in the distance, the Temple of Castor and Pollux (three Corinthian columns in the center of the composition), and the Temple of the Divine Vespasian, the tallest building on the right. The sculpture, on the other hand, has been transferred from a variety of sites and museums. The stone lion attacking a horse, in the right foreground, is taken from the piece now in the Palazzo dei Conservatori in Rome, which in turn is the probable source of George Stubbs's painting of the subject owned by the Yale Gallery (see No. 49).

## 55. GIOVANNI BATTISTA TIEPOLO

Italian, 1696–1770

*Apotheosis of a Saint (Saint Roch between Angels)*

Oil on canvas

$16\frac{1}{8}$ x $13\frac{3}{8}$ in.

The Maitland F. Griggs, B.A. 1896, Collection

1937.88

Tiepolo is perhaps the greatest Italian exemplar of the essentially decorative eighteenth-century style known as Rococo. Whether for ecclesiastical or secular purposes, his work has the lively design and festive mood primarily associated with ballrooms, music salons, and the theater. His finished compositions, such as the ceiling panel *Flora and Zephyr* in the Yale Gallery, preserve the lightness and freedom of his preparatory studies, of which the *Apotheosis of a Saint* is an example.

Saint Roch (Rocco in Italian), patron of the plague-stricken, is shown being carried aloft by angels who hold his identifying attributes, the tall pilgrim's staff with a purse attached, and the broad-brimmed hat decorated with a cockle shell. His faithful dog, usually included in pictures and statues of Saint Roch, is not present here; there is a pleasant legend to the effect that the saint declined to enter heaven unless his dog were admitted as well. On the old stretcher of this canvas were the words "Scuola di San Rocco," which would reinforce the identification of the subject. The small painting illustrates Tiepolo's brilliant foreshortening and rapid, sketchy rendering of form.

Tiepolo, whose son Giovanni Domenico was also a distinguished painter, was a Venetian, much influenced by Veronese, Ricci, and Piazzetta. Popular in his lifetime, he was in constant demand for the decoration of churches, palaces, and villas on the Venetian mainland, in Bergamo, Vicenza, Milan, and elsewhere, in addition to Venice itself. He did important work in Germany and Spain, where he painted for Charles III in the royal palaces at Madrid and Aranjuez. Goya was strongly influenced by him.

## 56. BERNARDO BELLOTTO

Italian, 1720–1780

*The Lock at Dolo*

Oil on canvas

29 x 42¾ in.

Gift of Duncan Phillips, B.A. 1908

1929.5

Dolo, a small mainland community on the Brenta near Venice, was much favored as a vacation spot by eighteenth-century Venetians. Bellotto has recorded this particular view with topographical accuracy. The canvas acquires special distinction through the painter's use of striking contrasts of sunlight and a characteristic inky shadow, which are combined with the architectural arrangement to produce a clear-cut, attractive design.

Like his uncle Antonio Canale, called Canaletto, who adopted him and whose nickname he sometimes used as a signature, Bellotto won an international reputation as a landscapist. He worked in Rome and in northern Italy; later he went to Munich, and about 1746 he settled in Dresden, where he was appointed court painter. In 1766 he was in St. Petersburg, and was active in Pirna and in Warsaw, where again he became court painter. His views of European towns are reliable records of eighteenth-century buildings and their relative locations. Like good guidebooks or modern photographs, they tell us clearly what the traveler on the Grand Tour would have seen and admired.

57. EDWARD HICKS

American, 1780–1849

*The Peaceable Kingdom of the Branch,* ca. 1825–30

Oil on wood

36¼ x 44⅞ in.

Gift of Robert W. Carle, B.A. 1897

1958.12

Painted as a fireboard, this *Peaceable Kingdom* is one of over eighty paintings of this theme executed by the artist. Like many another early American craftsman, Hicks worked first as a painter of tavern signs and other utilitarian objects. Oliver Larkin remarked in his *Art and Life in America* that "the lion which lies down beside the lamb in these kingdoms . . . is of the same species that swung on boards above taverns throughout the country; and the lettered bands which frame Hicks' allegories are the device of the sign-maker's craft."

The subject represented is taken from Isaiah 11.6–8. Hicks himself put the passage into verse:

> The wolf shall with the lambkin dwell in peace,
> His grim carnivorous thirst for blood shall cease,
> The beauteous leopard with his restless eye,
> Shall by the kid in perfect stillness lie;
> The calf, the fatling, and young lion wild,
> Shall all be led by one sweet little child.

Born in Pennsylvania, apprenticed to a coach maker, Hicks became a devout Quaker and gradually grew famous for his evangelical preaching. Disapproving of painting as an activity, he nevertheless employed his talents to create images of morality. The *Peaceable Kingdoms* usually include, as in Yale's picture, a distant view of William Penn's treaty with the Indians. The stone arch framing the group is based on the Natural Bridge of Virginia. Yale owns two additional versions of the subject by Hicks.

The peaceable KINGDOM of the branch. The wolf also shall dwell with the lamb,& the leopard shall lie down with the kid:& the young lion & the fatling together;a little child shall lead them.

## 58. SAMUEL FINLEY BREESE MORSE

American, 1791–1872

*Alexander Metcalf Fisher,* 1822

Oil on canvas

$44\frac{1}{8}$ x $34\frac{11}{16}$ in.

Gift of Professor Fisher's colleagues in office

1822.1

Alexander Fisher (1794–1822) was professor of mathematics and natural philosophy at Yale College, where he received his B.A. degree in 1813 and his M.A. three years later. He was lost at sea during a storm off the coast of Ireland. Some of his academic colleagues commissioned Morse to paint this posthumous portrait, the head being a copy of a likeness executed from life by Lucius Munson. The sitter, in accordance with the taste of the time, is presented as a melancholy, romantic individual rather than as a confident, self-assured man of learning. The stormy background, in which lightning strikes the foundering ship, is Morse's own reference to the tragic death of the young scholar.

Best known for his part in the invention of the telegraphic code which bears his name, Morse was a painter of genuine distinction, having from his early youth made painting his chosen career. After receiving his B.A. from Yale in 1810, he sailed for England with Washington Allston, who taught and influenced him during the next four years. He also worked at the Royal Academy in London. On returning to America he became a successful portrait painter and at the same time pursued scientific research. He was the first president of the National Academy of Design, founded in 1826 as a rival to the American Academy of Fine Arts in New York, which was ruled with an iron hand by the aging John Trumbull. Yielding to the growing industrial age, which encouraged his scientific activities, Morse finally gave up painting altogether.

Morse painted some subject pieces (though without much success), among them *The Dying Hercules* owned by Yale. The Gallery also owns a plaster cast of the clay model Morse made for the *Hercules* (see No. 129).

59. THOMAS COLE

American, 1801–1848

*Scene from* Manfred, 1833

Oil on canvas

50 x 38 in.

John Hill Morgan, B.A. 1893, Fund

1968.102

The scene depicted is from Byron's long dramatic poem *Manfred* (Act 2, Scene 1), in which the hero, disillusioned with life and seeking enlightenment in solitude, stands before a cataract in an Alpine valley and summons the Spirit or "Witch" of the Alps, who appears in the form of a radiantly beautiful woman standing beneath a rainbow.

>          No eyes
> But mine now drink this sight of loveliness;
> I should be sole in this sweet solitude,
> And with the Spirit of the place divide
> The homage of these waters.

The enraptured Manfred himself does not appear in the picture; what we see is the vision which rose before his eyes.

For Cole, landscape was less a description of a locality (although he could on occasion be topographically accurate) than a metaphor symbolizing a philosophical or moral idea: divine power, the forces of Nature, the destiny of man since the fall of Adam. This romantic attitude came more and more to color an art which began by being objectively descriptive, recording the appearance of New England and New York state regions in the style of the Hudson River school to which Cole's work is related. He often chose subjects from the Bible and romantic literature.

Cole was born in England and came to America at the age of seventeen. He was a close friend of the poet William Cullen Bryant and of James Fenimore Cooper, whose novels furnished some of his subjects. Several of his pictures were commissioned by Daniel Wadsworth, founder of the Wadsworth Atheneum in Hartford to which he bequeathed them. Cole preferred scenes of natural grandeur and the wilderness such as he found in the Catskills and the White Mountains; these he often made the setting—as in Yale's *Manfred*—for supernatural visions and allegories of human destiny.

## 60. ROBERT WALTER WEIR

American, 1803–1889

*The Microscope,* 1849

Oil on canvas

30 x 40 in.

John Hill Morgan, B.A. 1893, Fund and Olive Louise Dann Fund

1964.15

Zacharias Janssen, a Dutch inventor and spectacle-maker, is credited with the invention of the compound microscope around 1590 (also attributed to Galileo, 1609–10.) The costumes and furniture in Weir's picture belong to the late sixteenth and early seventeenth centuries, a period the artist studied intensively while working on his most famous commission, *The Embarkation of the Pilgrims* (1843) for the Rotunda of the Capitol in Washington, already adorned by John Trumbull's historical murals. Weir may have intended *The Microscope* to represent Janssen and his family. The suggestion of a story, presented in smoothly finished detail, was a sure road to popular approval in the mid-nineteenth century. The strong contrasts of candlelight illumination in surrounding darkness, with the actual source of light blocked by a figure placed in front of it, is in the tradition of Honthorst and the Le Nains, deriving ultimately from Caravaggio.

Robert Weir, of Scottish descent, studied at the National Academy of Design in New York, of which Trumbull was head, and at the Medical School of New York University, where he studied anatomy. After some years in Italy, where he became a close friend of the American sculptor Horatio Greenough, he was appointed professor of perspective at the National Academy of Design. From 1834 to 1876 he taught perspective at the United States Military Academy, West Point, retiring with the rank of colonel. Two of his sons had artistic careers. One of these, John Ferguson Weir, became professor and dean of the newly created Department of Fine Arts at Yale, serving for 44 years. John's half brother, Julian Alden Weir, was associated with American Impressionism and exhibited in the Armory Show of 1913.

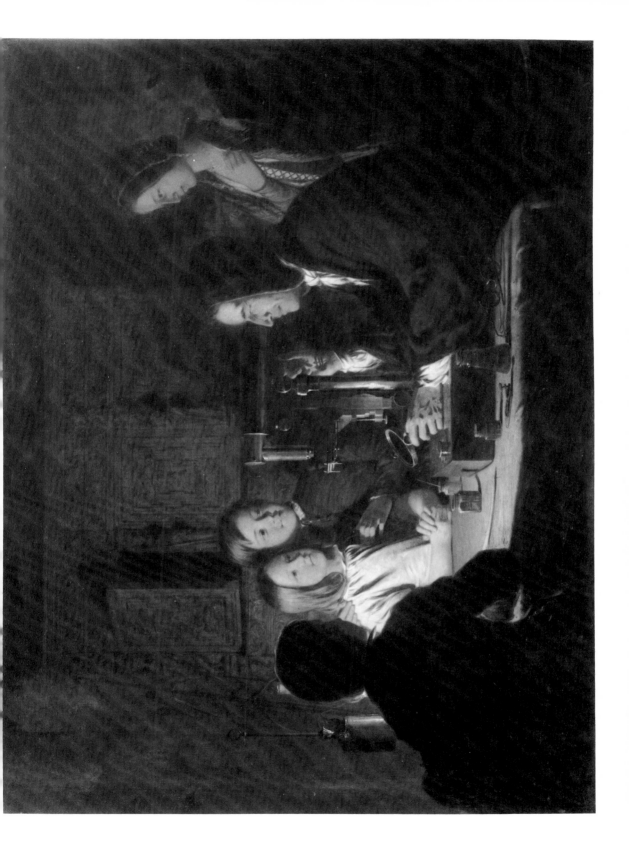

## 61. GEORGE INNESS

American, 1825–1894

*Landscape,* 1891

Oil on canvas

30 x 45 in.

Bequest of Blanche Barclay

1949.234

This quiet corner of a forest recalls Corot and other Barbizon painters, whose work Inness had studied in Europe in 1850. But there is a free, vaporous touch which is Inness's own; one would never take him for a French artist. Again, the sketchy manner is not that of the Impressionists, although Inness had a comparable eye for fact observed in an instant under given conditions of light and atmosphere. The scene is uncontrived, without pretensions in design (though by no means without design): an intimate record of a place seen and loved. In the 1860s Inness had come under the influence of Swedenborgianism, which intensified his innately mystical attitude toward nature; it has been said that he viewed his artistic gifts as a manifestation of divine power. This sense of God in all creation comes closer to the poetry of Wordsworth than to the grandiose romanticism of Thomas Cole. In late works such as the Yale picture, the handling is veiled as though physical vision were dominated by spiritual experience.

Inness was born in Newburgh, New York, where his first links were with the Hudson River school. Apart from a short period of study in Brooklyn with the painter Regis Gignoux, he was self-taught. In 1847 he went to London and Rome, where he studied the landscapes of Claude, Poussin, Constable, and Turner. After his 1850 trip to Paris, he worked in New Jersey and Massachusetts, going abroad regularly. By the 1870s he was firmly established in his profession. He died in Scotland during his last foreign tour.

Inness is an important and appealing figure in the history of American landscape painting. Like Constable in England and Corot in France, he could communicate with nostalgic charm the special qualities of place, weather, and season.

S. Guiness 1871

## 62. FREDERICK EDWIN CHURCH

American, 1826–1900

*Mount Ktaadn (Katahdin),* 1853

Oil on canvas

36 x 55 in.

Stanley B. Resor, B.A. 1901, Fund

1969.71

A pupil of Thomas Cole during the latter's last years, Church turned from his teacher's visionary and sometimes moralizing romanticism to painstaking realism in detail. His canvases are panoramic in scope, but everything is represented with close-up exactitude. Associated with the Hudson River school (his extraordinary "provincialized Persian" palace, Olana, overlooking the Hudson, is now a public monument open to visitors) he achieved great popularity and was regarded in his own day as America's leading landscape painter. He traveled to South America and to the far north, studying geology, meteorology, and botany with a scientist's passion for data.

*Mount Ktaadn,* a breathtaking sunset over Maine's highest peak, is a fine example of Church's mature style. Here he celebrates the glory of the American wilderness which lies beyond the settlements of man—a wilderness which, unlike the terrain of the early settlers, hides no threat of hostile Indians, or unlike some Romantic landscapes, embodies no pious allegory, but instead is meant to stir the patriotic American's heart to pride in the beauty of his country. Yet a note of Romantic contemplation is struck in the figure of the boy seated under an elm tree at the left, and in the snug homestead at the foot of the awesome mountain. Church has achieved a balance between fact and sentiment well calculated to win sympathy and to gain popular currency via the prints of Currier and Ives.

In spite of a tendency to showmanship, Church must be given credit for real brilliance in the rendering of light. As Theodore Stebbins has written, "this picture foretells the whole style of American luminism of the following decades."

63. ALBERT BIERSTADT

American, 1830–1902

*Yosemite Valley*

Oil on canvas

54 x 84¾ in.

Gift of Mrs. Vincent Ardenghi

1931.389

As Thomas Cole was the poet and philosopher of New England and the Hudson River landscape, so Bierstadt became the apostle of scenic grandeur in the Far West— the Rocky Mountains and the wild vistas of Oregon and northern California. His huge canvases, built up in the studio from sketches and studies made on the spot, have a scale and magnificence which, while frankly theatrical, show a sensitivity to light and atmosphere comparable to that of Frederick Church. As Cole and other members of the Hudson River school loved to stress the beauties of nature untouched by modern industrial man, so Bierstadt depicted the wilderness and its animal denizens as existing in an ideal state. These landscapes are awesome in spirit in spite of their deliberate romanticism, and, sometimes, a showmanship that reminds one of the gilded prose of the travel agent. Yale's picture, relatively small and intimate, shows characteristically tiny travelers on horseback or afoot; late afternoon sunshine turns the river to silver and accents the rocks and shadows along the dangerous trail.

Bierstadt was born in Germany, near Düsseldorf. Brought to America as a small child, he returned to Düsseldorf in 1853, studying at the Academy there under Lessing and Emanuel Leutze. He spent the winter of 1856–57 in Rome. Back in New England, he took a studio in New Bedford, Massachusetts, where he worked up his immense canvases from studies brought from abroad. His first trip to the Rockies, in 1858, was followed by a second in 1863, when he reached San Francisco and made studies of the Yosemite. He came east in 1866, occupying a house at Irvington-on-Hudson, but made several trips to Europe thereafter. His work achieved great popularity abroad as well as in the United States, and the French government made him a Chevalier of the Legion of Honor.

## 64. WINSLOW HOMER

American, 1836–1910

*The Morning Bell,* 1866

Oil on canvas

24 x 38⅛ in.

Bequest of Stephen Carlton Clark, B.A. 1903

1961.18.26

Colorplate 11

Several young girls, dinner pails in hand, are seen on their way to work in one of the small factories that flourished in New England and eastern New York state during the mid-nineteenth century, turning out textiles, furniture, glassware, and so on. Homer's wood engraving based on this painting was printed in *Harper's Weekly* for December 13, 1873; several figures have been added, including a boy, a stoop-shouldered man, and two older women. The resulting mood of weariness and depression inspired an anonymous poem which was printed with the engraving. It reads, in part:

> . . . 'tis but the heavy factory bell,
> Which takes its tone from factory noise and din,
> And wearily responding to its call,
> Behold a day of hardship must begin!
>
> And slowly in the well-worn, toilsome path
> Go those whose paths seem ever cast in shade,
> While others reap the sunshine of their toil:
> By these the factory bell must be obeyed.

The painting, however, contains no hint of dismal thought, recalling instead Homer's pictures of country schools in spring or autumn weather. The sloping ramp which provides such an effective element in the composition implies the presence of the stream necessary for machine operation. The brilliant red of the girl's jacket is a splendid note of color against the dark trees and intermittent patches of early morning sunlight.

Homer spent his boyhood in New England. Apprenticed to a Boston lithographer, he made drawings for wood engravings to be used as magazine illustrations and sheet music covers. His early oils, such as *The Morning Bell,* and his Civil War drawings, reflect his experience as an illustrator. After trips to France and England in the 1870s and '80s he settled at Prout's Neck on the Maine coast, thereafter dividing his time between Maine and Bermuda or the Caribbean. Practically self-taught in oils, he later carried watercolor to a point of unsurpassed technical and expressive brilliance.

## 65. THOMAS EAKINS

American, 1844–1916

*Girl with a Cat
(Katherine Crowell)*, 1872

Oil on canvas

62⅝ x 50 in.

Bequest of Stephen Carlton Clark,
B.A. 1903

1961.18.17

The subject of this portrait, Katherine Crowell, became engaged to Eakins in the same year in which she posed for him; the engagement lasted until her death in 1879. This picture shows her in the family house in Philadelphia, seated before a huge Victorian bookcase and playing idly with a kitten on her lap. Reds and browns predominate in the color scheme; the rose tone of the ribbon at her neck and bordering her fan becomes more intense in the flowered tapestry covering of the hassock under her left foot, and reappears, somewhat muted, in the plush upholstery of the carved mahogany armchair in which she sits. Eakins's signature and the date may be seen at the lower righthand corner, on the edge of the rug.

Much of the force of Eakins's portraits stems from his ability to catch characteristic attitudes and gestures. His subjects do not pose in self-conscious or currently fashionable ways, but seem often to be unaware of the artist or any other spectator. Apparently not strong physically, Katherine Crowell sits and moves her hands as though she had little energy or even interest; her face is largely in shadow. Yet one feels sympathy for this rather repressed young woman while one admires the artist's skillful handling of light and atmosphere. It is interesting to recall that at this very time—the 1870s—Degas was painting some of his somber, psychologically penetrating interior scenes. Both painters evoke the world of Henry James's novels.

## 66. THOMAS EAKINS

American, 1844–1916

*John Biglen in a Single Scull,* 1874

Oil on canvas

24⁵⁄₁₆ x 16 in.

Whitney Collections of Sporting Art,
given in memory of
Harry Payne Whitney, B.A. 1894,
and Payne Whitney, B.A. 1898, by
Francis P. Garvan, B.A. 1897

1932.263

The brothers John and Barney Biglen were professional oarsmen, often seen racing or training on the Schuylkill river in Philadelphia, which was the national course for oarsmen at that time. Eakins, always fascinated, like his contemporary Degas, by the human body in motion, painted a number of racing pictures. He told a pupil of his: "When I came back from Paris [in 1870] I painted those rowing pictures. I made a little boat of a cigar box and rag figures, with the red and white shirts, blue ribbons around the head, and I put them out into the sunlight on the roof and painted them, and tried to get the true tones."

All of Eakins's skill in recording physical appearance is evident here: the dynamic pose, taut muscles, and sunburned skin of the rower, the clear light broken by the ripples on the water, the color brought to sharp focus in the red head cloth. Although this canvas suggests a close-up detail of one of the larger rowing pictures, it is complete in itself, and creates a similar impact. Theodore Sizer has written: "His preoccupation with the problems of form, anatomy, and human dynamics and his interest in mathematics remind one strikingly of a fifteenth century Florentine painter of the scientific group." But Eakins's scientific concerns never led to abstraction; his work always communicates an intensely human experience.

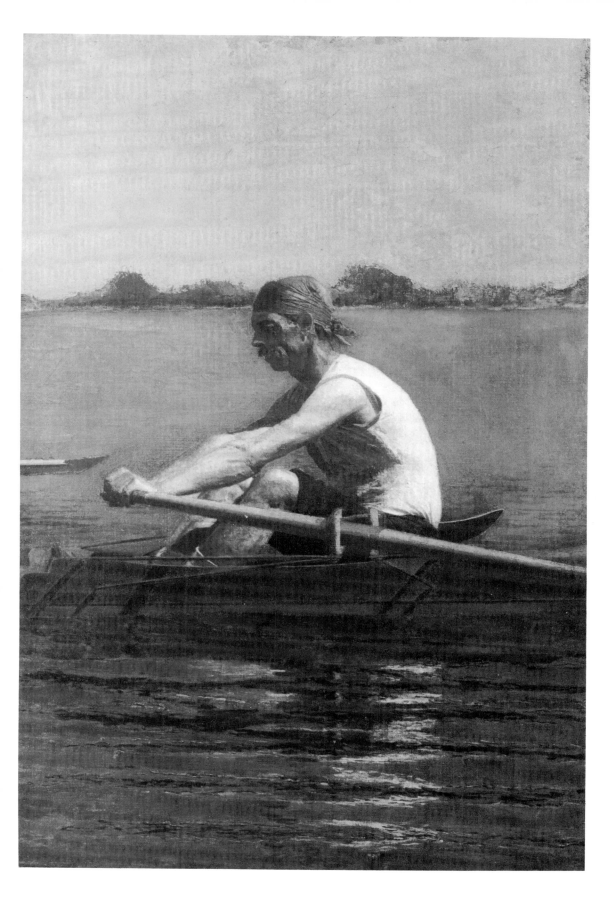

## 67. THOMAS EAKINS

American, 1844–1916

*Will Schuster and Blackman
Going Shooting for Rail,* 1876

Oil on canvas

$22\frac{1}{8}$ x $30\frac{1}{4}$ in.

Bequest of Stephen Carlton Clark,
B.A. 1903

1961.18.21

Colorplate 18

Eakins approached his art like a scientist in a laboratory. His concern was not with traditional ideals of beauty but with unvarnished physical truth. He studied anatomy and watched surgical operations, even, for a time, considering medicine as a career. Keenly interested in photography, he made pioneer experiments in photographing animals and human beings in motion which contributed indirectly to the development of moving pictures. An accomplished sportsman, he used the themes of rowing and hunting as points of departure for painstaking studies in linear perspective and in the muscular tensions involved. But in contrast to George Bellows, who was fascinated by the dynamic rhythms of movement, Eakins analyzed and described exact appearances, so that his figures often seem to have halted at the precise moment depicted. In *Will Schuster and Blackman* there is no suggestion that either man will move. The strong red of Schuster's shirt blazes dramatically against the dark tones which dominate the picture.

Born in Philadelphia, Eakins studied at the Pennsylvania Academy of the Fine Arts and attended courses in anatomy and dissection at Jefferson Medical College. He worked at the École des Beaux-Arts in Paris under the academic painter Jean Léon Gérôme, whose influence on him was strong and lasting. In Spain he greatly admired the work of Velazquez and Ribera. As a teacher of painting at the Pennsylvania Academy he shocked his contemporaries by insisting on the use of completely nude models in his classes when women were present. Dismissed from his post, he went on teaching the many students who followed him after his dismissal. At the time of his death, his work was owned by no more than three museums; today the Yale University Art Gallery possesses eleven of his paintings.

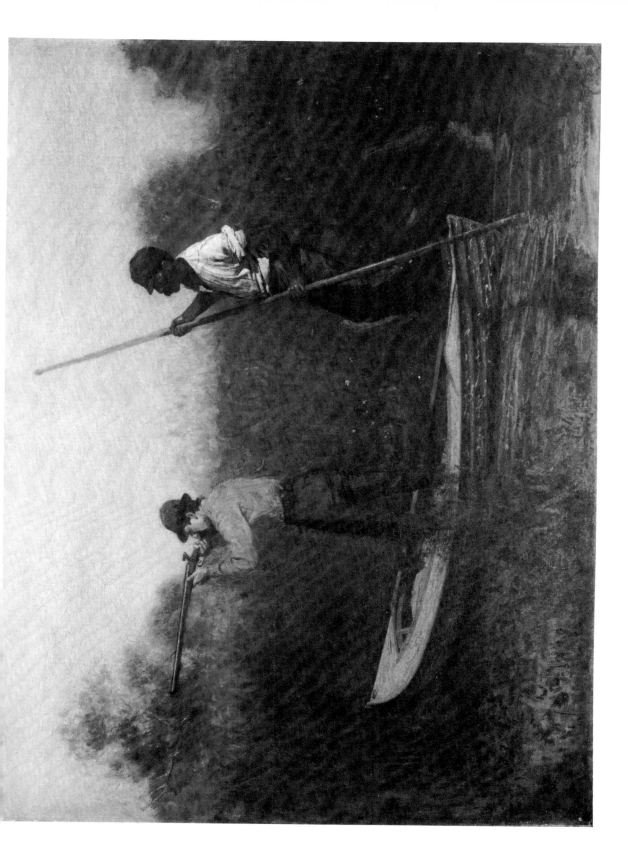

## 68. THOMAS EAKINS

American, 1844–1916

*Taking the Count,* 1898

Oil on canvas

96⁵⁄₁₆ x 84⁵⁄₁₆ in.

Whitney Collections of Sporting Art,
given in memory of
Harry Payne Whitney, B.A. 1894,
and Payne Whitney, B.A. 1898, by
Francis P. Garvan, B.A. 1897

1932.262

Eakins has shown this bout taking place in the Arena (now demolished) at Broad and Cherry Streets, Philadelphia. He used the same setting for *Between Rounds,* painted in the following year; the same theatrical posters hang from a balcony in each. All the figures, including the members of the audience, are known to be portraits; the standing boxer is the famous Charlie McKeever, his crouching opponent is Joe Mack, and H. Walter Schlichter is the referee.

The composition, like many of Eakins's canvases, has a static quality; as in Greek sculpture (Myron's *Discus Thrower,* for example) the moment chosen is one of repose between two of movement. In this case of course there is the element of suspense, but Eakins does not dramatize it; he gives the pertinent facts, as one might state a mathematical problem. Describing this picture in his book *Eakins,* Sylvan Schendler has written: "Vision coerces the epic moment to a monumental stillness before life bursts loose again. . . . The posed and poised figures have been brought to a stop, and the elemental meaning each represents is defined in that mood of quiet yet forceful tension that flows beneath so much of his work." Yale owns a preparatory study for this painting.

## 69. WILLIAM MICHAEL HARNETT

American, 1848–1892

*Still Life with Flute,
Vase, and Roman Lamp,* 1885

Oil on gessoed mahogany wood panel

$13\frac{13}{16}$ x $10\frac{1}{4}$ in.

Christian A. Zabriskie Fund

1970.114

Admired during his lifetime for their astonishing accuracy of detail, Harnett's still lifes soon went out of fashion, to be rediscovered in the 1930s when "Magic Realism" was developed in the United States. Harnett himself seems to have had no thought of suggesting more than was visually represented, but his silent, beautifully balanced groups of old books, musical instruments, or trophies of the hunt (once described as "bachelor still lifes") do exert a fascination beyond the uncanny realism of their tactile and visual details. An amateur flutist, Harnett often painted musical instruments and sheet music; in this panel the large sheet, in modern notation, is labeled as a passage from Meyerbeer's opera, *Le Pardon de Ploermel (Dinorah),* published in 1859. The Roman lamp and the inkwell, like the books (one of these is dated 1507), were studio properties bought for the purpose and used repeatedly in the painter's compositions. Early in his career he could not afford living models, and he was never successful in his attempts at portraiture. An admirer of Dutch seventeenth-century still life, he seems also to have been influenced by the paintings of Raphaelle and Rembrandt Peale, which he may have seen in the Pennsylvania Academy of the Fine Arts. Yale's picture once belonged to Warren A. Kohler, who took over Theodore Stewart's famous New York saloons after the latter's death in 1887; Stewart had decorated them with his collection of paintings, including Harnett's masterpiece *After the Hunt,* executed in Paris in 1885 and exhibited at the Salon of that year. The Yale panel may be dated from an existing photograph inscribed by Harnett: "Paris, 1885."

Harnett was born in County Cork, Ireland, coming to Philadelphia as a child. He studied engraving, specializing in work on silver and attending night classes at the Pennsylvania Academy of the Fine Arts. By 1875 he was working exclusively in painting. From 1880 to 1886 he lived in Europe, chiefly in Munich, by which time he had achieved great success, and his signature began to be forged by imitators and dealers. Outstanding among his many followers was his friend John Frederick Peto.

70. GEORGE SAMUEL

British, active 1786–1823

*View of London from Greenwich Park,* 1816

Oil on canvas

$54\frac{3}{8}$ x $72\frac{1}{8}$ in.

John Hill Morgan, B.A. 1893, Fund
1961.29

Like Wordsworth in his sonnet on Westminster Bridge (composed in 1802) George Samuel has celebrated the beauties of London seen through the eyes of a poet-painter:

> This City now doth, like a garment, wear
> The beauty of the morning; . . .

In the middle distance appears the Queen's House, designed in 1618–35 by Inigo Jones for Anne of Denmark, wife of James I; to the right of it rise the twin towers of Wren's Greenwich Hospital, built some thirty years later before the completion of his masterpiece, St. Paul's, visible across the river.

But the charm of the painting lies not so much in its careful topography as in its fresh color, fine treatment of light, and the very English sense of joy in nature. The figures in the foreground, informally posed in fête champêtre fashion, include a young officer in a red coat and a young civilian. The ladies wear yellow and white, with blue hats trimmed with plumes. They are like characters from Jane Austen, whose *Emma* was published in 1816, the precise year of Samuel's painting. Tame deer can be seen under the trees at the right. Greenwich Park has, indeed, all the pleasing features of a gentleman's country estate.

Almost nothing is known of the painter except the melancholy circumstances of his death: he was crushed by a falling wall while working on one of his landscapes. A Londoner, he traveled widely in England and Wales and regularly exhibited his landscapes at the Royal Academy and the British Institution. Although apparently popular in his day, he was soon forgotten. M. H. Grant has written of him, "The wall fell upon poor Samuel more cruelly than he knew, burying, too, his very name."

71. JOHN CONSTABLE

British, 1776–1837

*Landscape—Hampstead Heath,*
ca. 1830

Oil on canvas

$12\frac{7}{8}$ x $19\frac{3}{4}$ in.

Bequest of Blanche Barclay;
the George C. Barclay Collection

1949.235

Sir George Beaumont, while he was the proud possessor of Rubens's great landscape, *The Château de Steen,* placed it for repairs in Benjamin West's studio in London. Some years later, in 1815, it was exhibited at the British Institution. At one or both of these places it must have been seen by John Constable, whom as a young man Sir George Beaumont had encouraged to go to London to study painting. Yale's small canvas, with its fine sense of space and its sparkling brushwork, may well owe something of its technical skill and beauty to a knowledge of Rubens, although as a late work it illustrates Constable's fully developed personal style—a style which, in contrast to the dazzling rhetoric of Turner, has the quality of sound, convincing prose.

Born in East Bergholt, Suffolk, the son of a prosperous miller who owned Flatford mill, Constable worked there for a time, sketching whenever he could. He was admitted to the Royal Academy schools in London in 1799. Not until he was in his forties did he have much success in selling his pictures, but he was always comfortably off financially. His *Hay Wain,* shown in the Paris Salon of 1822, had a marked influence on Delacroix. Although his most ambitious canvases are perhaps too elaborately worked up from his brilliant smaller studies, no painter has seen and interpreted the English countryside with more affectionate understanding or clearer vision. *Hampstead Heath* is a delightful evocation of rolling ground and moisture-filled clouds. Tiny flicks of the brush have translated pigment into miniature figures on the horizon, fresh and vividly alive.

72. VINCENT VAN GOGH

Dutch, 1853–1890

*Night Café (Le Café de nuit)*, 1888

Oil on canvas

28½ x 36¼ in.

Bequest of Stephen Carlton Clark, B.A. 1903

1961.18.34

Colorplate 13

*Night Café,* one of Van Gogh's best known pictures, was painted two years before his death. It shows the Café de l'Alcazar in Arles, shortly after midnight, in the glare of gaslight: brilliant, shocking colors hold in suspension the materials of pleasure—the billiard table, wine bottles, and glasses—bitterly contrasted with the few human beings absorbed in their individual loneliness and despair. Only the couple seated near the door suggest sympathetic communication. Van Gogh wrote of this painting in a letter to his brother Théo: "In my picture of the *Night Café* I have tried to express the idea that the café is a place where one can ruin one's self, go mad or commit a crime." Elsewhere he wrote, "I have tried to express the terrible passions of humanity by means of red and green. The room is blood red and dark yellow with a green billiard table in the middle; there are four citron-yellow lamps with a glow of orange and green. Everywhere there is a clash and contrast of the most disparate reds and greens in the figures of little sleeping hooligans, in the empty, dreary room, in violet and blue."

Born in Holland, the son of a Protestant pastor, Van Gogh worked for the picture dealing firm of Goupil in the Hague, London, and Paris. Dismissed from his post, he began theological training in Holland and spent several months as a lay preacher in the mining region of the Borinage in Belgium. Again dismissed, he turned to painting as a profession, supported by his brother Théo in Paris, where he met Gauguin, Pissarro, Seurat, and Toulouse-Lautrec. Later he went to Arles and S. Rémy. Having suffered intermittent attacks of insanity, he committed suicide in Auvers while under the care of his sympathetic admirer Dr. Gachet.

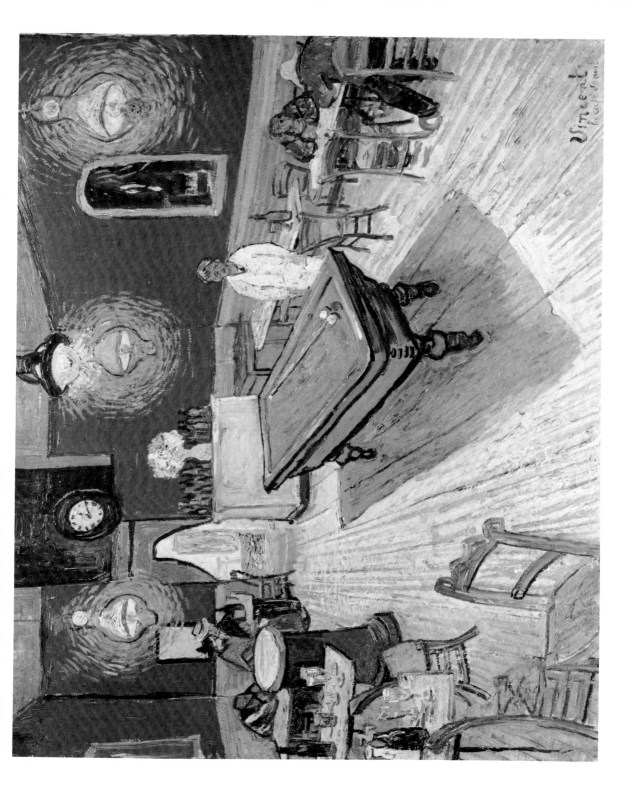

73. JEAN-BAPTISTE CAMILLE
    COROT

French, 1796–1875

*The Harbor of La Rochelle
(Le Port de la Rochelle)*, 1851

Oil on canvas

$19\frac{7}{8}$ x $28\frac{1}{4}$ in.

Bequest of Stephen Carlton Clark,
B.A. 1903

1961.18.14

Colorplate 14

This view of the harbor of La Rochelle, on the Bay of
Biscay, harks back to Corot's earlier style in its arrangement
of architectural masses illuminated and solidly modeled by
sunlight. Painted in the summer of 1851, it belongs
chronologically to the period of the feathery gray landscapes
which he had begun to paint two or three years earlier, and
which brought him his greatest popularity. This canvas,
recording the view from the second story window of a
house on the Quai Vallin, shows something of the classic
order and serenity that Corot drew from his study of
Poussin and Claude. A favorite of his, often exhibited, it
was his first out-of-doors view of a French site to be shown
to the public.

Corot devoted most of his life to painting, which he took
up seriously at the age of twenty-six. Having money from
his father, he could afford to wait until he was over forty
for his first sale of a picture. By mid-century he was famous
(he received the Legion of Honor in 1846) and his work
began to be in such demand that forgeries appeared on the
market. He was much interested in photography, which
had a marked influence on his later work. A serene and
contented individual, he was modest and always generous
to his fellow artists.

## 74. JEAN FRANÇOIS MILLET

French, 1814–1875

*Starry Night (Nuit etoilée),* ca. 1850–51

Oil on canvas, mounted on wood

25¾ x 32⅛ in.

Leonard C. Hanna, Jr., B.A. 1913, Fund

1961.22

Both the title and the general composition of this painting bring to mind Van Gogh's dramatic picture, *Starry Night.* Quite possibly Van Gogh had seen this very canvas, which was bought by Goupil in Paris at the studio sale just after Millet's death in 1875, while Van Gogh was in Paris. His admiration for Millet's work is well known. Both men had a deep reverence for nature; in this small painting one feels awe and joy in the drama of stars and flashing meteors above the dark fields. No human actors are needed. It seems fitting that Millet, like Van Gogh, was brought up on the Bible, and was also a lover of Virgil. Henri Focillon has called him "a man of '48, not by doctrinal affirmations or by humanitarian dreams, but by his broad feelings for humanity itself."

Millet was born in Gruchy, near Gréville in Normandy. The son of a peasant farmer, he grew up close to the soil, and made the daily life of the peasants his major concern as a painter. Fond of drawing from early childhood, he showed such promise that some citizens of Cherbourg raised money to send him to Paris in 1838. He became a pupil of Paul Delaroche, but finding himself totally out of sympathy with his teacher, he left the studio and spent some difficult months on his own, even painting signs to earn a living. Returning to Normandy, he married and went back to Paris, but when his wife died soon thereafter he went home once more, remarried, and had his first, if brief, success with an exhibition at Le Havre. A third visit to Paris was a failure. In 1848 the revolution and an outbreak of cholera drove him and his family to Barbizon, where he lived like a peasant and produced his most famous canvases: *The Sower* (accused of being socialist), *The Angelus, The Gleaners,* and quite probably Yale's *Starry Night* as well. Finally, in 1867, nine of his paintings were accepted for the Paris Exposition Universelle, and he won a first class medal; he was elected a Chevalier of the Legion of Honor a year later. The Franco-Prussian war drove him back to Cherbourg in 1870. A commission to paint some decorations for the Panthéon in Paris was never carried out owing to the illness which resulted in his death in 1875.

75. GUSTAVE COURBET

French, 1819–1877

*Hunter on Horseback*
*(Chasseur à cheval)*, 1867

Oil on canvas

46¹³⁄₁₆ x 38 in.

Gift of J. Watson Webb, B.A. 1907,
and Electra Havemeyer Webb

1942.301

*Hunter on Horseback* was painted during the winter of
1867 at Ornans, in preparation for Courbet's one-man
exhibition organized in competition with the Paris Exposi-
tion Universelle of that year. At the same time he was
working on a large composition, *Sounding the Kill of the
Stag in the Snow,* in which huntsmen and hounds are
grouped triumphantly around the dying quarry. In contrast
to that victorious scene, *Hunter on Horseback* strikes a note
of melancholy and disillusionment quite unusual in
Courbet's work. The tired horse sniffs indifferently at the
bloody tracks in the snow; his rider seems equally weary
and disheartened. It is near sunset; long shadows lie across
the new snow. As William Kane has pointed out in an
article in the *Yale University Art Gallery Bulletin* (March
1960), this may well be a self-portrait of the artist. But the
tilt of the head, which in Courbet's self-portraits is so often
a mark of self-confidence and even aggressiveness, here
seems to imply a sense of futility and despair.

The canvas is brilliantly painted in terms of the material
world; one feels the chilly dampness of the air and perceives
the exact rendering of figures which, seen against the light,
lose their solidity and become somber silhouettes. Courbet
once wrote: "The hunter is a man of independent character
who has a free spirit or at best a sense of liberty. His is a
wounded soul, his heart moves to encourage his languor in
the billows of the sea and in the sadness of the forest." Kane
calls the picture "an essential document of Courbet's career
and a clear expression of his mind and heart."

Courbet was born in Ornans near the Jura mountains. An
admirer of Rembrandt and the Spanish seventeenth-century
masters, he won his first medal at the Salon of 1849.
Thereafter he began showing his Realist canvases, which
shocked Paris and brought upon him accusations of
dangerous socialism. During the civil war of 1871 he was
unjustly held responsible for the destruction of the
Vendôme column, imprisoned, and ordered to pay for the
reconstruction of the column. His career and finances
ruined, he died, disillusioned and embittered, an exile in
Switzerland.

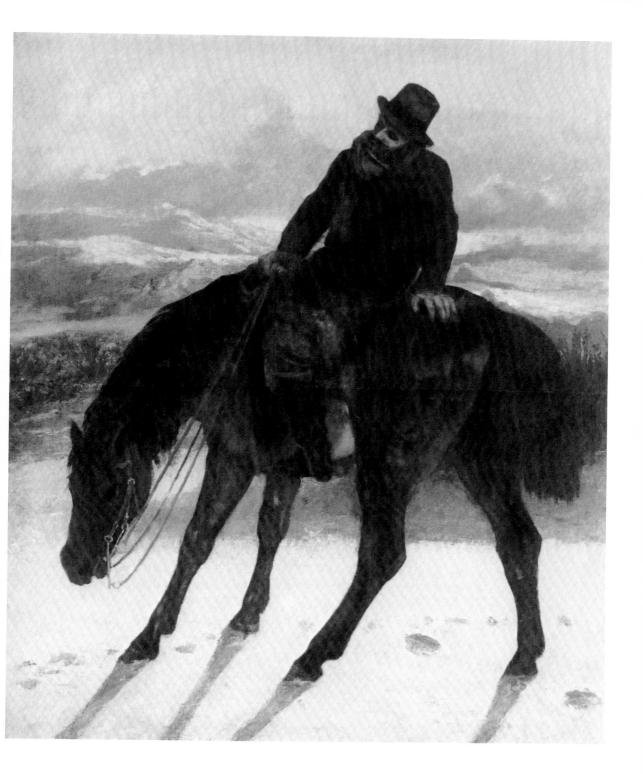

## 76. PIERRE PUVIS DE CHAVANNES

French, 1824–1898

*The Pleasant Land (Doux pays),*
ca. 1882

Oil on canvas

10⅛ x 18⅝ in.

University purchase, Mary Gertrude Abbey Fund

1958.64

Colorplate 15

This small canvas is a finished study for a wall painting commissioned by Puvis's friend, the painter Léon Bonnat, for his Paris house. The world of classical antiquity, derived from Poussin and the French classical tradition, is reborn here in terms of poetry rather than archaeology or history: a sensitive image of serenity and repose. In mood and visual pattern this art is reflected in the work of such different masters as Gauguin and Seurat.

Puvis de Chavannes was born in Lyon and died in Paris. He studied briefly in the studios of Delacroix and Thomas Couture, but the real formative influence on his work came from the Italian primitives whom he studied during two years in Italy. In 1851 he established himself in the Rue Pigalle, where he remained until his marriage forty-five years later with the princess Cantacuzène. Associated with the Symbolists, he was admired by Théophile Gautier and Baudelaire, and had considerable influence in the development of Art Nouveau. Among his commissions were murals for Lyon, Marseilles, Poitiers, Rouen, Paris (notably the St. Geneviève series in the Panthéon) and the stairway decorations for the Public Library, Boston. His cool, pale color and flat design are admirably suited to wall spaces, though his compositions have not always been happy in their architectural settings.

Critical opinion of Puvis was sharply divided during his lifetime. Among his ardent admirers was Van Gogh, who referred to *The Pleasant Land* in a letter of 1888 to his brother Théo: "When you have seen the cypresses and the oleanders here . . . then you will think even more often of the beautiful *Pleasant Land* by Puvis de Chavannes, and many other pictures of his."

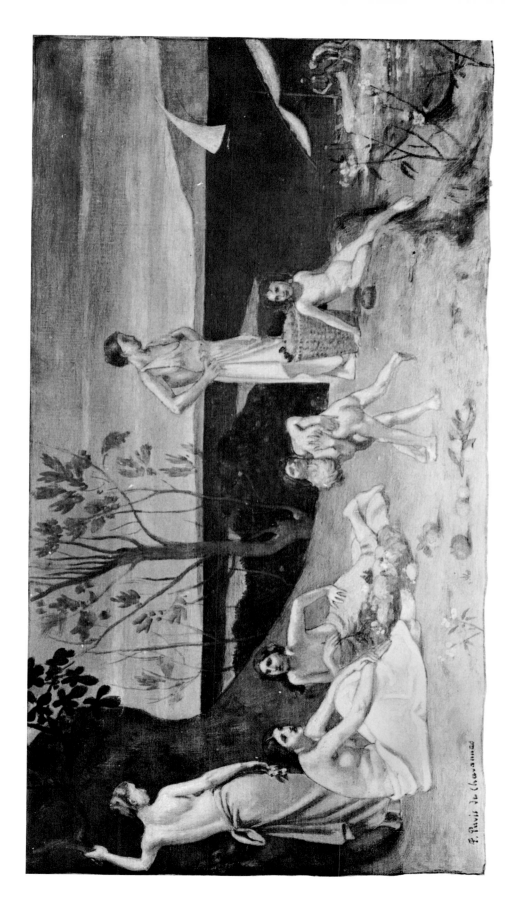

P. Puvis de Chavannes

77. JEAN LÉON GÉRÔME

French, 1824–1904

*"Hail, Caesar! We Who Are About
to Die Salute You" ("Ave Caesar!
Morituri Te Salutant"),* 1859

Oil on canvas

36⅝ x 57¼ in.

Gift of C. Ruxton Love, Jr.

1969.85

A group of Roman gladiators, armed with swords, shields, and heavy helmets, and their intended opponents carrying nets and tridents, offer the traditional salute to the emperor Vitellius, enthroned in the royal box with a number of Vestal Virgins at his right. Victims of earlier combats in the day's program lie dead or dying on the blood-stained sand, or are dragged toward the exits by attendants. Above the crowded stands is stretched a great awning decorated with silhouettes of circus animals. Historically this amphitheater cannot be the Colosseum, which was dedicated in A.D. 80 by the emperor Titus, son of Vespasian who succeeded Vitellius in A.D. 69.

*"Hail, Caesar!,"* exhibited in the Paris Salon of 1859, was, with its well-known companion piece *"Pollice Verso" ("Thumbs Down"),* regarded by Gérôme as his best work. Academic in its balanced design, careful drawing, and choice of subject—all in the Neoclassic tradition—it shows an archaeologist's interest in historical detail. Relatively small in size, it is conceived in monumental terms. In spite of the meticulous rendering, the canvas has considerable dramatic force, and is beginning to re-evoke today something of the enthusiasm that it aroused in its own time.

Gérôme was a pupil of the successful academicians Paul Delaroche and Charles Gleyre. He became a professor at the École des Beaux-Arts, was awarded several important medals, and was elected to membership in the Institut de France. He was also an honorary member of the Royal Academy in London. Basically an academician, he sometimes seems closer to the Romantic or Realist painters of the mid-nineteenth century. As a teacher he strongly influenced Thomas Eakins, who once adopted the "Hail, Caesar!" theme for a painting of modern boxers in the prize ring.

## 78. EDOUARD MANET

French, 1832–1883

*Young Woman Reclining in Spanish Costume (Jeune Femme couchée en costume espagnol),* 1862–63

Oil on canvas

37¼ x 44¾ in.

Bequest of Stephen Carlton Clark, B.A. 1903

1961.18.33

Colorplate 12

This picture was exhibited, with thirteen others, in Manet's one-man show at the Galerie Martinet in Paris in March 1863, the year of the famous Salon des Refusés. The exhibition met with violent abuse and ridicule. During the early 1860s Manet was deeply interested in Spanish painting and costume. The model seen here is generally considered to be Victorine Meurend, who posed for the *Déjeuner sur l'herbe,* but it has been suggested that she may, instead, be a friend of the photographer Nadar, to whom Manet presented the painting (note the inscription at the lower right). The theme and composition have been compared to Goya's *Maja Vestida.*

Stylistically the painting illustrates superbly the artist's ability to suggest firmly rounded forms by means of broad, smooth areas of paint. Creamy pink, silver, and black are set against the dull rose red of the sofa and the unexpected orange of the fruit on the floor.

Born in Paris, Manet grew up determined to become a painter; he made a sea voyage to Rio de Janeiro rather than study law according to his parents' wish. He met with little sympathy in the Paris studio of Thomas Couture, who once described him (certainly not intending to flatter) as "the Daumier of your time." Generally regarded as the founder of Impressionism, Manet altered his broad early style, seen in the Yale canvas, to a system of short, splintery brush strokes suggesting the influence of Monet.

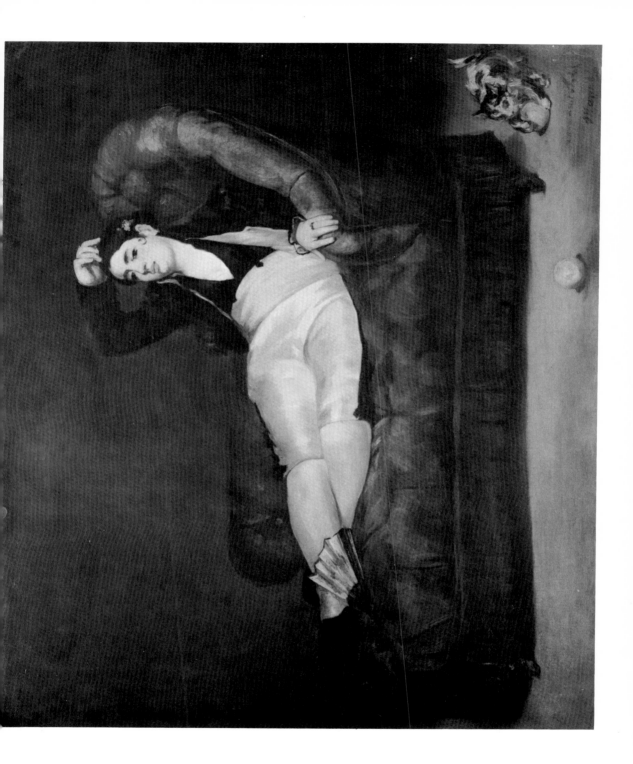

79. EDGAR HILAIRE
GERMAIN DEGAS

French, 1834–1917

*Ballet Rehearsal (La Salle de danse),*
ca. 1891

Oil on canvas

$14\frac{1}{8}$ x $34\frac{1}{2}$ in.

Gift of Duncan Phillips, B.A. 1908

1952.43.1

For over thirty years Degas pursued the theme of ballet
dancers: on stage, taking a curtain call, standing in the
wings awaiting the cue. He followed them to the rehearsal
rooms, where he studied their postures at the practice bar
or sitting in various attitudes of relaxation or weariness. His
brilliant drawing and design never entirely overshadow
his feeling for the girls as human beings, tired, disillusioned,
often plain-featured—but it is difficult to say whether his
eye is sympathetic or ironical.

The post which cuts this canvas into two distinct parts
emphasizes the contrast between the group in the distance
at the left, at the practice bar (one can make out several
alterations in the positions of arms and legs), and the four
girls resting at the right, brought into the foreground by
Degas's familiar diagonal arrangement. One might almost
take them for the same quartet during a break following the
practice session. All wear the same shade of blue-white,
with deeper blue sashes. The blue tone is carried throughout
the composition: dark in the curtain, lighter in the mirror,
and played against warm red-browns which blend in broken
impressionist strokes with the pervading blue of wall and
floor. The carrot-colored hair of one of the seated dancers
is a vibrant note in the midst of the beautifully studied
light falling across the room from the open door.

The painting was presented to Yale in 1952, the Uni-
versity's 250th anniversary, to commemorate the laying
of the cornerstone of the new wing of the Art Gallery and
Design Center. Two similar versions exist, one in the
Courtauld Collection in London, and the other, part of
the Joseph Widener Collection, in the National Gallery in
Washington, D.C.

Degas was the son of a French banker and a Creole mother
from New Orleans, where he visited relatives during
1872–73. He left the study of law to work at the École des
Beaux-Arts in Paris in 1855. An intense admirer of Ingres,
whom he once met, he followed the classic tradition of
careful draughtsmanship and the use of subjects taken from
ancient history and literature. In Italy he studied the early
Renaissance masters. During the early 1860s he met Manet
and other Impressionists, subsequently altering his style and
turning, like them, to contemporary, everyday scenes for
subject matter. Always a rather aloof and solitary figure,
he stopped exhibiting his pictures after 1886, selling them
on contract through Durand-Ruel.

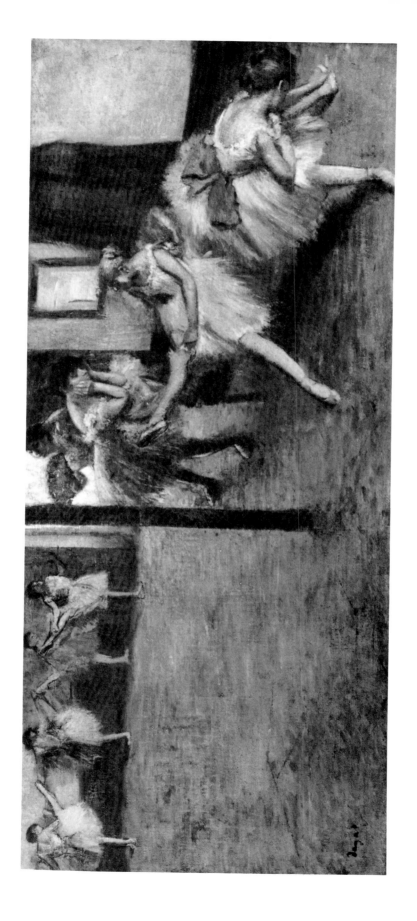

80. EDGAR HILAIRE
GERMAIN DEGAS

French, 1834–1917

*Woman Drying her Hair
(Femme s'essuyant les cheveux)*
ca. 1900

Pastel

31 x 43¼ in.

Leonard C. Hanna, Jr.,
B.A. 1913, Fund

1971.25

Degas's concern as an artist was first and foremost with the human figure. His best portraits are unsurpassed both as human documents and as examples of flawless design. Equally great are his studies of contemporary activity—ballet dancers, jockeys, laundresses, milliners, or the unforgettable "interiors" in which human relationships are set forth with the accuracy and penetration of a novelist. But perhaps most fascinating of all are his nudes—never classical Venuses, but ordinary women in the ordinary business of washing and drying themselves. One sees the model as Degas, and Rodin, saw her, in unstudied, often awkward attitudes—the direct opposite of the traditional poses struck on the model stand in the art school. What is awkward and unbeautiful by academic standards becomes the perfect integration of natural movement with coherent, balanced (though asymmetrical) design; the subject is seen from unexpected angles and at levels of observation that reveal new delights in composition. "Angle shots" of this kind suggest the influence of Japanese prints, which strongly affected Degas's way of organizing a picture. But physical truth is never sacrificed to interest of design; there is always the underlying structure of anatomical knowledge and disciplined drawing, at the service of an unerring and imaginative eye.

Yale's pastel, the only example in that medium illustrated in this book, has been included because of its interest and importance for an understanding of Degas's art. It belongs to his late period, when failing eyesight was turning him increasingly to the use of pastel. In its large scale, though not in its style, this study recalls the Renaissance cartoons made in preparation for panel paintings, which Degas constantly studied. Only an artist with complete knowledge of the human figure could have carried off so bold a piece of foreshortening. There is marvelous sureness in this statement in black, blue, brown, and white strokes on the beige paper. Weight, volume, and muscular tensions are coordinated within the restricted space, convincingly indicated in a minimum of strokes. One sees the painter's ideas changing as he corrects the lines of the couch behind the figure, yet the total impression is of a finished composition—dynamic, alive, momentary, but stable, like the ancient Greek sculptures which he admired. In Degas's own words to Paul Valéry, "Drawing is not form, it is a way of seeing form."

81. ALFRED SISLEY

French, 1839–1899

*The Seine at Bougival,* 1872

Oil on canvas

20 x 25 in.

Gift of Henry J. Fisher, B.A. 1896

1926.54

Sisley's work is perhaps the most immediately attractive of any in the Impressionist group. His brushwork and muted color, close to that of the early Monet, have a freshness and sureness which are pleasurable in themselves, and his sense of place and weather is sometimes even more intimate and immediate than Monet's. For a lover of the French countryside a Sisley landscape has a nostalgic poignancy clearly felt in Yale's canvas.

Bougival, a village on the Seine outside of Paris and a favorite resort of the Impressionists, provided them with the simple elements of river, willows, boats, and farmhouses which caught and reflected the light, the basis of their studies. In this painting one is haunted by echoes of Corot, but the younger painter is less consciously lyrical and dreamy; Sisley's daylight moment in time and place evokes its own poetry.

Sisley was the son of English parents. Born in Paris, he became a close friend of the future Impressionists Monet, Renoir, and Frédéric Bazille when the four were working in the studio of the academic Swiss painter Charles Gleyre. Like Monet, Sisley was primarily a landscape painter, living and working in Bougival, Argenteuil, and Louveciennes—country communities on the Seine where he could observe and record familiar surroundings from season to season. At first influenced by Corot, he gradually adopted a brighter palette without, however, achieving the intense color of the later Monet or, at times, Pissarro.

## 82. PAUL CÉZANNE

French, 1839–1906

*The White House (La Maison blanche, environs d'Auvers),* ca. 1872–74

Oil on canvas

15 x 18½ in.

Bequest of Kate Lancaster Brewster

1948.120

Sometimes called *Le Chemin du Village,* this small painting takes its present title from an inscription written on the back of the canvas. It is believed to have been painted about 1872–74, when Cézanne was working with Pissarro at Pontoise, near Paris. A number of his pictures of this period center on village streets as their principal theme. The color scheme is generally subdued: subtle greens, blues, oranges, and grays, suggesting the palette of the early Monet or Sisley. The brighter coloring of later Impressionist work was adopted in due course by Cézanne in the pursuit of entirely different ends. This comparatively early painting, although it clearly asserts Cézanne's sense of solid form, has a gentle, even intimate mood very unlike the majestic power of his later great landscapes, still lifes, and portraits.

Cézanne was born and died in Aix-en-Provence, where he first knew the novelist Émile Zola, a kindred spirit in revolutionary thinking, although their areas of rebellion were different. The work of both men shocked, baffled, and sometimes outraged their contemporaries. Cézanne studied law but decided on a career in painting and went to Paris in 1863, supported by an allowance from his banker father. He met the leading Impressionists and very occasionally exhibited with them, but in general he was so unsuccessful that he returned to the south of France and thereafter spent most of his time in Aix. He had become increasingly dissatisfied with the aims and methods of the Impressionists, devoting himself instead to a painstaking study of color as a means of defining form in space, without regard to accidents of light or the traditional rules of linear perspective. He did not achieve recognition until the 1890s, when the dealer Ambroise Vollard and the critic Gustave Geoffroy first took an interest in his work. Far in advance of his time, he became one of the most powerful influences in the development of twentieth-century painting.

In addition to *The White House,* Yale owns a second oil painting by Cézanne, *Landscape with Water Mill,* and two distinguished watercolors, *The Pont Royal* and *Flowers.*

83. ODILON REDON

French, 1840–1916

*Apollo,* 1907–10

Oil on canvas

28¾ x 21⅜ in.

The Philip L. Goodwin Collection,
gift of James L. Goodwin, B.A. 1905,
Henry Sage Goodwin, B.A. 1927,
and Richmond L. Brown, B.A. 1907

1958.20

Although a contemporary of the Impressionists (he was born in the same year as Monet), Redon carried his art in a wholly different direction. Instead of observing and recording his physical surroundings, he looked inward to the world of mystery and imagination, and expressed it in the language of symbolism. His richly opalescent color is evocative rather than descriptive; his forms are blurred and feathery, like objects seen in dreams.

*Apollo* is not a quotation from classical mythology; rather, the horses plunging upward at the edge of the abyss are a metaphor of light itself—the power of the sun which literally as well as figuratively dwarfs the god in his chariot. The flecks of brilliant color have the effect of pastel, which Redon could handle so magnificently. One thinks of Shelley's luminous verbal imagery.

Apollo and his sun chariot appear in several of Redon's works in oil, pastel, and lithography. Redon admired Delacroix's painting of the subject on the ceiling of the Galerie d'Apollon in the Louvre, and was impressed by Gustave Moreau's *Phaeton.* Of the Delacroix he wrote, "It is a triumph of light over darkness . . . the joy of full daylight opposed to the sadness of the night and of the shadows . . . it is like the joy of a better feeling after anguish."

Redon was born in Bordeaux, where he admired and copied paintings by Delacroix in the local museum. He was also influenced by Dürer, Leonardo, Corot, and Rembrandt. Having failed in his early architectural studies, he took up the graphic arts, especially black and white lithography. In 1895 he began working in color, using oil and pastel. He was associated with the Symbolists such as Mallarmé and Huysmans, and with the Nabi group which included Bonnard, Vuillard, and Ker-Xavier Roussel. A special influence on his work and thinking was the botanist Armand Clavaud, whose interest in literature and philosophy made a strong impression on him. This influence is reflected in his many pastel and oil studies of flowers, among them Yale's *Capucine (Fleurs dans un vase).*

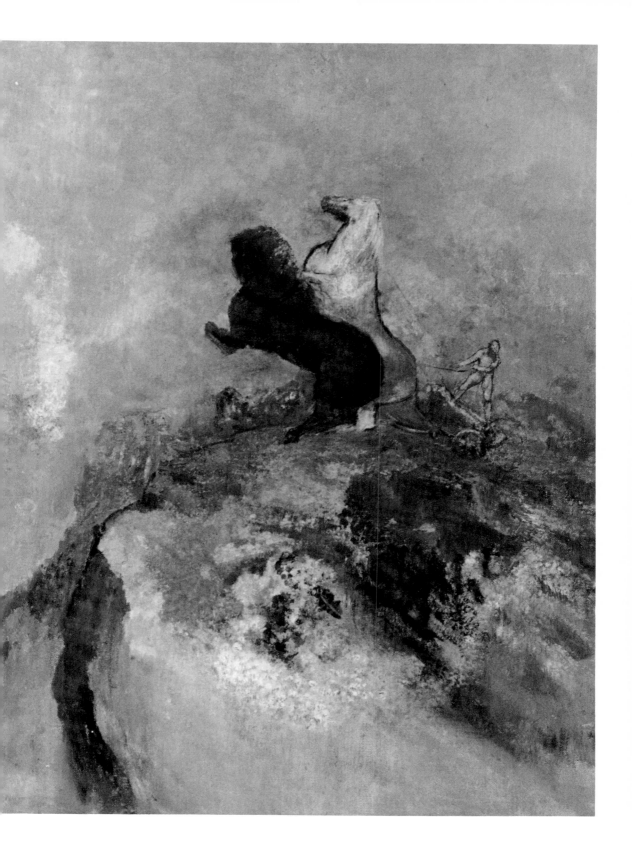

## 84. GEORGES SEURAT

French, 1859–1891

*Fisherman (Le Pêcheur),* ca. 1884

Oil on panel

6¼ x 9¾ in.

Bequest of
Edith Malvina K. Wetmore

1966.79.14

Colorplate 16

Seurat, the most theoretical and painstaking of the Post-Impressionists, prepared for every major canvas by painting numerous small studies in oil, such as this *Fisherman.* He also made hundreds of drawings in crayon and charcoal as a means of analyzing details and building up the final composition. Although his views on art were severely anti-Impressionist—like Cézanne he was seeking ordered geometric form and stability, not the fleeting moment—he often followed Impressionist procedure in his small sketches, looking for color values rather than line as a point of departure. These patches of color ultimately built up the form, much as do the tesserae in a mosaic or the stitches in needlepoint. But in the sketches the individual brush touches have not yet been precisely measured and disciplined; the result has a freshness and sparkle comparable to Impressionist work.

In connection with his *Baignade* of 1883–84 and the slightly later *Sunday Afternoon on the Island of the Grande Jatte,* Seurat spent much time in the Asnières-Courbevoie region making color studies of the river and of fishermen. Yale's picture is one of these. It once belonged to the painter's friend, the critic Félix Fénéon, who coined the term Neo-Impressionism to describe Seurat's art.

Seurat was born in Paris, where he studied at the École des Beaux-Arts and at the Louvre. At the age of twenty-one he took a studio where he worked day and night on the ambitious compositions he built up from his out-of-door sketches and drawings. Deeply influenced by Chevreul's color theories and by Charles Blanc's *Grammaire des arts du dessin,* he developed so precise a system of applying paint that he could work by gaslight. He died of pneumonia in Paris at the age of thirty-one.

## 85. EDOUARD VUILLARD

French, 1867–1940

*Interior,* ca. 1892–95

Oil on board

9½ x 13¾ in.

Bequest of
Edith Malvina K. Wetmore

1966.79.16

The son of a seamstress, to whom he was deeply devoted, Vuillard achieved a highly personal style in which one constantly recognizes the patterns of domesticity: printed fabrics, wallpaper, carpets, curtains, and small bright utensils. These he transcribed in broadly pointillistic terms subordinating effects of light and space to an overall tapestry of color. At the same time one is vividly aware of a homely, essentially French middle-class environment: the comfortable, multicolored clutter dear to the hearts of the bourgeoisie at the turn of the century.

Like another tiny Vuillard painting owned by Yale, *The Kitchen,* there is no subject here in the narrative sense. The pose of the woman suggests that of a seamstress at her sewing machine, so familiar to the painter, but what she is actually doing is neither clear nor relevant; she is simply one element in a rich harmony of textures and colors, in which the paint itself counts for much. The dark blue dress is contrasted with pale flesh tones; coral pink, red, turquoise brown, and gray-green make up a delicious whole.

As a shy, retiring young man in Paris, Vuillard was associated with the Symbolist group known as the Nabis (Hebrew for "prophets"), which included Bonnard, Roussel, Émile Bernard, and others. His work, rather limited in range, lacks the conscious mysticism of some of his associates. But no one has better expressed the peculiarly French intimacy and charm found in his domestic vignettes. His friend Paul Signac wrote of him, "He has a perfect understanding of the inner voices of things." This, with his relish for the painted surface itself, makes Vuillard, different though he is, a real descendant of Chardin.

## 86. PIERRE BONNARD

French, 1867–1947

*Place Pigalle, La Nuit,* ca. 1905–08

Oil on wood panel

$22\frac{5}{8}$ x $26\frac{15}{16}$ in.

Gift of Walter Bareiss, B.A. 1940

1955.23.1

Colorplate 17

The Place Pigalle is especially associated with the avant-garde painters and writers of Bonnard's generation, particularly the group calling themselves the Nabis. Situated on Montmartre, it was a center for those young enthusiasts who, in the 1880s and '90s, were reacting against Impressionism and evolving their new theories under the influence of Gauguin, Van Gogh, and Toulouse-Lautrec, and of the Symbolist poets.

Bonnard, whose studio on the Rue de Douai was near the Place Pigalle (at one time he shared a studio on the Place Pigalle with Vuillard and Lugné-Poë), produced paintings and lithographs which perhaps more than any others evoke the special aura of contemporary Parisian life—the theater, the shops, the parks where children and puppies play, and above all the fashionable young women in their huge hats and fluttering skirts who look so coquettish and decorative on Bonnard's posters, gay rivals of those by Toulouse-Lautrec.

Although Bonnard's oils are perhaps best known for their dazzling sunshine effects, his less frequent night scenes are equally evocative of a world sharply observed and happily remembered. In *Place Pigalle* the paint, impressionistically handled, brings a glow to the very darkness; the seemingly casual composition has a Degas-like immediacy and force.

Born at Fontenay-les-Roses, Bonnard studied law in Paris, but soon turned to painting, working at the École des Beaux-Arts and the Académie Julian where he met the Nabis Maurice Denis, Vuillard, Paul Ransom, and Paul Sérusier. Like others in the group he was much influenced by Gauguin, Toulouse-Lautrec, and Japanese prints; his colleagues nicknamed him "Le Nabi très japonard." He traveled widely in Europe and north Africa, and visited the United States in 1926. He died at Cannet, Switzerland.

## 87. GEORGE WESLEY BELLOWS

American, 1882–1925

*Lady Jean (Portrait of the Artist's Daughter)*, 1924

Oil on canvas

72 x 36 in.

Bequest of Stephen Carlton Clark, B.A. 1903

1961.18.7

Colorplate 19

Jean, the artist's younger daughter, was nine years old when she posed for this portrait. Like her sister Anne, she was adored by her father, who died only a year after the picture was painted.

One of Bellows's most popular pictures, *Lady Jean* is a splendid example of the artist's broad, free handling of paint, his sense of structure and design, and his liking for bold, clear colors. His favorite blues, seen in the dress, the Venetian blind, and the flower vase, are balanced by the bright red of the cupboard, muted in the rose tones of the reticule and rug, and by the pale yellow of the wall. The personality of the strong-willed, sensitive child is communicated without a trace of the sentimentality that so often goes with costume portraits of children.

From his boyhood, Bellows's two enthusiasms were sports and painting. He barely missed being a professional baseball player; prize fights form the subject of several of his paintings and lithographs. Born in Ohio of New England stock, he studied at Ohio State University but left before graduation to work in Robert Henri's New York studio. Elected to associate membership in the National Academy of Fine Arts in 1907, and to full membership in 1913, he was one of the founders of the Society of Independent Artists and the New York Society of Painters. For a time he taught at the Art Students League in New York. He was associated with The Eight, derisively known as the Ashcan School, which included Henri's pupils John Sloan, George Luks, William Glackens, and Everett Shinn.

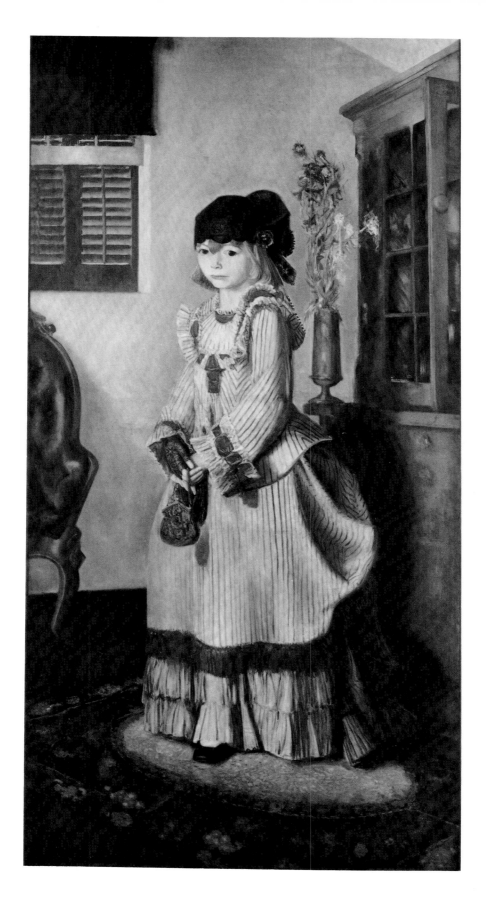

## 88. JOSEPH STELLA

American, 1877–1946

*Brooklyn Bridge,* 1917–18

Oil on canvas

84 x 76 in.

Collection of the Société Anonyme

1941.690

Colorplate 24

When Stella painted this picture the Brooklyn Bridge, opened to traffic in 1883, was over thirty years old. Conceived in 1857 as the daring design of John Roebling, who was fatally injured early in the project, the bridge was completed under the direction of his son Washington Augustus Roebling. Longer and higher than any of its predecessors, the steel cables of this suspension bridge were swung between two huge stone towers pierced by pointed "Gothic" arches—a dramatic feat of engineering and of the human imagination. To this day, superseded though it may have been by more modern constructional methods, the bridge remains one of the most deeply stirring sights along Manhattan's river boundaries.

Joseph Stella was born in Italy and came to the United States in 1900. An assignment by the *Survey Graphic* took him to Pittsburgh in 1908, where he made studies of industrial life. From 1909 to 1912 he was in France and Italy, where he came into contact with Futurism—that violent and iconoclastic art dedicated to the expression of speed, power, and energy in terms of the machine. Stella's large, brilliantly colored canvas, *Battle of Light, Coney Island* (now owned by Yale, Collection of the Société Anonyme), painted soon after his return to the United States, was exhibited in the Armory Show of 1913. *Brooklyn Bridge,* finished some five years later, is a more subtle achievement. Organized as a kind of perspective study of the bridge as one starts to cross it, it is only superficially a technical description. Suggestions of form—the pointed arches in the towers, the swinging cables, the roadway receding toward the vanishing point— all are perceived through a veil of glowing color—blue, red, green—luminous in the darkness and translucent as jewels. Technology is transformed into poetry; the machine assumes a human dimension. Stella took the Brooklyn Bridge as his subject on other occasions, but he never interpreted it more beautifully than in this example.

89. PATRICK HENRY BRUCE

American, 1880–1937

*Composition II*

Oil on canvas

34¼ x 51 in.

Collection of the Société Anonyme

1941.369

Born in Virginia of Scottish parents, Patrick Henry Bruce bore a name twice patriotic. He studied with Robert Henri in New York but ultimately settled in Paris, where he spent the rest of his life. He came in contact with the Cubism of Picasso and Braque, but he never wholly accepted their theories. His close friend Henri Pierre Roché (the only person, Bruce said, who liked his work) wrote after his death, "His effort was directed toward building paintings which would be supported mainly by their four sides, having a structural quality."

*Composition II* is built up with intensely colored, flat shapes organized on interpenetrating diagonals, giving the effect of opaque crystalline formations. One feels the thrust and counterthrust of these apparent solids, locked in a powerfully stabilized, balanced composition. Much of Bruce's work was done with the palette knife. His theory of color tended to parallel that of his contemporary Robert Delaunay, who maintained that color can be used to create effects of movement and space, the forms themselves being totally abstract.

Although Bruce influenced many younger painters, especially through discussions of art, he remained aloof as an individual. Roché wrote of him, "His isolation, his irascible modesty, his exclusiveness formed a wall. His slowness, his perseverance, his abrupt seriousness were unbelievable for Paris." But his paintings, as *Composition II* demonstrates, speak with boldness and authority. Yale owns five examples in addition to this one.

90. ARTHUR G. DOVE

American, 1880–1946

*Sunset, No. 3*

Oil on canvas

24⅞ x 35⅛ in.

Collection of the Société Anonyme

1949.3

"A primitive pantheism possessed him. There was worship of the sun and moon. He was aware of the cycles of life and death in nature, of decaying tree trunks returning to the soil while the wind blows and new life begins." So wrote Duncan Phillips in 1947, the year following Dove's death. The painter had been living on Long Island, close to the soil and to salt water; thirty years earlier he had raised chickens and fished for lobster in Westport, Connecticut, painting and illustrating in comparative solitude. He was one of America's first abstract artists, a pioneer in the search for modes of expression in vigorous opposition to traditional realistic painting.

Born in Canandaigua, New York, Dove studied at Hobart College and Cornell University. After a year in France and Italy, he was invited to join the "291" group of Alfred Stieglitz, who gave him a one-man show in 1912. A forerunner of the Abstract Expressionists, Dove searched out colors and shapes which would, he believed, communicate directly the emotional experience, and sometimes the sound of natural or man-made phenomena: foghorns, for example, or the sun at the horizon which he translates into concentric arcs of vibrating color surrounding a radiant center. Such compositions as *Sunset, No. 3*, less than three feet wide, is conceived on the grand scale of the sky itself, ablaze with color.

91. EDWARD HOPPER

American, 1882–1967

*Rooms by the Sea,* 1951

Oil on canvas

29 x 40⅛ in.

Bequest of Stephen Carlton Clark, B.A. 1903

1961.18.29

Like Eakins, whom he greatly admired, Hopper painted sharply, accurately, and unforgettably, the America of his own time. But unlike Eakins he generalized and simplified, arriving at forms that are types and symbols rather than individuals. His constant theme is silence. Clear geometric lines define spaces that are always uncrowded yet full of meaning and suggestion—a loneliness that is often peace rather than melancholy. His mastery of light, like that of so different a master as Vermeer, unifies the composition and determines its mood. *Rooms by the Sea,* painted when Hopper was nearly seventy, is one of his simplest and most poetically evocative works.

Born in Nyack, New York, Hopper studied at the Chase School of Art under Robert Henri and Kenneth Hayes Miller. Later he worked independently in Paris, where the French Impressionists inspired him to paint out of doors. On his return home he dropped all European influences, declaring that an American artist must depend on no foreign styles or methods. A painting of his was exhibited in the Armory Show of 1913; in his Chase School days he had met John Sloan and other members of The Eight, and had been a fellow student of George Bellows and Rockwell Kent.

Hopper worked chiefly in New York City and Brooklyn, and along the New England coast, especially Cape Cod, Gloucester, Massachusetts, and towns in Maine. Completely unsentimental, he gave a deep poignancy to his Victorian mansions threatened by the railroad, his New England churches and rooming houses, his cheap restaurants, movie theaters, and motels. There is a special brilliance in the sunlight of *Rooms by the Sea,* a brightness of light reflected from the water as it illuminates the clean bare walls and floor.

92. JOSEF ALBERS

American (b. Germany), 1888–

*The Gate,* 1936

Oil on composition board

18¾ x 20⅝ in.

Collection of the Société Anonyme

1941.325

The composition of *The Gate* combines four-sided shapes in different tones of gray, which appear transparent and seem to overlap; they surround and frame a radiant white patch. The deeper gray—almost black—bordering on this white center is blurred at its edges as though driven out of focus by the glow of the white. The gray areas, sharply outlined in white, stand out against a broad band of violet painted over, but not completely covering, an undercoat of dark gray; flecks of the latter color show through the violet, adding richness to the texture. Purely as a picture, this composition illustrates Albers's impeccable taste and sense of balance; the precision of his eye and workmanship have the combined beauty and discipline of mathematics. His fundamental concerns, however, go far deeper than mere aesthetic satisfaction. For years he has made a study of color, its physical and psychic properties, its character and behavior. "In visual perception," he wrote, "a color is almost never seen as it really is—as it physically is. This fact makes color the most relative medium in art." Similarly he has studied line, and the optical illusions and ambiguities that lines and angles can produce. The white lines in *The Gate,* subtly tilted diagonals, verticals, and horizontals, immediately set up a contradiction of inside and outside, a swinging toward or away from the spectator.

Josef Albers was born in Bottrop, Germany. He studied in Berlin, Essen, and Munich, and at the Bauhaus in Weimar. From 1923 to 1933 he was on the Bauhaus faculty, giving courses in fundamental design, drawing, and lettering. He served as assistant director in 1928–31. Two years later he and his wife Anni, also an artist, came to the United States, where he was head of the art department at Black Mountain College, North Carolina, in 1933–49. He taught at Harvard in 1936–41, and in the Yale School of Fine Arts, first as visiting critic in 1949–50, and then as chairman of the department of design in 1950–59. Since then he has continued as visiting critic. He lives in Orange, Connecticut. His research in color, and his system of teaching, are set forth in his monumental book *Interaction of Color,* which describes the procedures he followed in his enormously influential courses at Yale. "Good teaching," he once wrote, "is more a giving of right questions than a giving of right answers."

## 93. YVES TANGUY

American (b. France), 1900–1955

*From Pale Hands to Weary Skies*
*(De Mains pâles aux cieux lassés),*
1950

Oil on canvas

35⅝ x 28⅛ in.

Bequest of Kay Sage Tanguy

1963.43.4

"Calm and immaculate they may be, these silent and extraordinarily lonely places, but their serenity barely conceals some present menace." These words of George Heard Hamilton characterize the mature work of Tanguy, after the artist had passed from his early Dadaist association into the world of Surrealism and thence into a kind of interplanetary space peculiarly his own. His fantastic forms entirely his own invention without reference to natural objects or creatures, nevertheless seem obedient to natural laws of growth and evolution; as geology or biology they are entirely plausible, like the creations in C. S. Lewis's interplanetary novels. In this painting the four vertical structures (in contrast to the sharp white silhouettes that separate them) might be taken as stages in an evolution, moving from the vaguer flowing shapes at the left to the amazing intricacy of the one at the extreme right. The absolute precision with which details are represented is like some Chinese ivory carving, or the fluid, writhing curves of Viking wood reliefs. The light, bright colors counterbalance the mood of mystery evoked by Tanguy's characteristic misty background blotting out a horizon.

Often described as "lunar landscapes," Tanguy's compositions may still be entitled to that epithet in spite of our present-day knowledge of the moon's surface. For this is a world of genuine dreams, a world which science may invade but never control. The title of the picture, like its form, belongs to the poetic imagination; it suggests, but does not describe or explain.

Born in Paris, Tanguy left a career in the merchant marine to become a self-taught painter, inspired by a picture of De Chirico's. He was associated with the Dadaists Max Ernst, Joan Miró, André Masson, and André Breton, joining the Surrealists in 1925. In 1939 he came to the United States, acquiring American citizenship in 1948. For some years he lived in Connecticut with his wife Kay Sage, a professional painter strongly influenced by her husband.

94. RICHARD ANUSZKIEWICZ

American, 1930–

*Splendor of Red,* 1965

Liquitex on canvas

72 x 72 in.

Gift of Seymour H. Knox, B.A. 1920

1968.29

*Splendor of Red* belongs in the category of Op art, an important development in painting of the 1960s as a reaction against the free form and personal or emotional statement of Abstract Expressionism. It employs mechanical techniques—ruler, compass, masking tape, and so forth—in the creation of precisely drawn, carefully calculated compositions employing line and color, not imitatively or to suggest objects in light and space, but for their own inherent power to affect not only one another but to produce illusions of actual movement in space. Painting of this kind works on the observer's physical responses to what he sees and is persuaded to think he sees. The brilliant red in this canvas seems to move forward, vibrating like a neon sign; the movement is reinforced by the interaction of precisely measured blue and green lines radiating toward, or from, the center. Stare even briefly at the canvas, look quickly away, and the after-image of green will seem for an instant as "real" as the painted red square. Stare again, and the three colors will seem to run together and overlap in a shifting pulsation of tones. In contrast to the methods of the Renaissance masters or the Impressionists, who looked at their compositions as objects in a room or out of doors, Op techniques aim to project their illusionary space forward or backward to involve the observer, who becomes quite literally the instrument for receiving the visual vibrations set up by color and shape. If he is really looking, he cannot escape the picture's purely physical action upon him.

Richard Anuszkiewicz was born in Erie, Pennsylvania, and studied at the Cleveland Institute of Art and at Kent State University, where he received a B.S. in education. He holds an M.F.A. degree from the Yale University Art School, where Josef Albers's teaching of color theory was a major influence. His work has been exhibited widely in the United States and in Europe. He lives in New Jersey.

95. VICTOR SERVRANCKX

Belgian, 1897–

*No. XLVI: The Town,* 1922

Oil on canvas

$28\frac{5}{8}$ x $38\frac{1}{2}$ in.

Collection of the Société Anonyme

1941.684

In his simplification of urban subject matter to abstract forms, Servranckx reminds one of Fernand Léger in the 1920s. But Servranckx's townscape is more purely geometric, being made up of verticals, horizontals, diagonals, and round arches: a ruler-and-compass framework with strong, Mondrian-like colors filling the enclosed areas. This is an art of flat pattern, of precisely defined shapes that anticipate the "hard edge" paintings of the 1960s. Interior and exterior views of architecture are integrated into a whole which, condensed and flat though it is, nevertheless implies spaces both extended and enclosed. This canvas, although perhaps only a small step away from commercial art, has great elegance; the intricate all-over design is masterfully organized and balanced.

Servranckx studied at the Academy in Brussels, and he ultimately became a professor there. He had his first one-man exhibition in Brussels at the age of twenty. In 1925 he won a gold medal in the Paris Exposition of Decorative Arts, and he executed murals for the Brussels Exposition in 1935. He has also designed modern furniture. Like so many artists represented in the Société Anonyme collection, he was first introduced to America through the Société's exhibition of 1926 at the Brooklyn Museum.

1922 SERVRANCKX

## 96. RENÉ MAGRITTE

Belgian, 1898–

*Pandora's Box (La Boîte de Pandore)*, 1951

Oil on canvas

$17\frac{7}{8}$ x $21\frac{5}{8}$ in.

Gift of Dr. and Mrs. John A. Cook, B.A. 1932

1961.8

Colorplate 20

Magritte paints familiar, everyday objects in equally familiar settings, all in painstakingly finished, realistic detail; however, they are always in some way ambiguous or inconsistent, like sights experienced in dreams. There is also, as a rule, complete absence of movement; things seem to have been immobilized by some sinister occult power. This is the supernatural world of the Surrealists, with whom Magritte was associated in the 1920s. But unlike Salvador Dali or Max Ernst, Magritte does not invent monsters; he evokes mystery in objects which are commonplace even to the point of banality.

*Pandora's Box* takes its title from the Greek legend of the casket filled by the gods with all kinds of evils which were released upon mankind through the curiosity of Pandora, the first woman. As with other pictures by Magritte, the observer must provide his own interpretation, usually an impossible task; the title is part of the puzzle. George Heard Hamilton has well described these paintings as "insoluble visual rebuses."

Magritte spent the years 1927–30 in the neighborhood of Paris, where he came under the influence of Giorgio De Chirico and Max Ernst, and was favorably noticed by André Breton. In addition to exhibiting his paintings, in 1929 he set forth his own principles in an article in *La Révolution surréaliste,* including the statement that "an object never fulfils the same function as its name or its image." Since 1930 he has made Brussels his permanent home.

## 97. MATTA (ROBERTO MATTA ECHAURREN)

Chilean, 1911–

*La Vie est touchée,* 1957

Oil on canvas

57 x 80 in.

Gift of Dr. and Mrs. John A. Cook, B.A. 1932

1960.28

Although trained as an architect in Paris under Le Corbusier, Matta turned from that profession to concentrate on painting. Associated with the Surrealists in the late 1930s, he first explored a kind of supernatural interplanetary space; fluid shapes like primitive organisms, brilliantly colored, heave and explode as though forming new continents or accomplishing their own destruction. An example of this early work, *Fabulous Racetrack of Death,* is in Yale's collection of the Société Anonyme.

*La Vie est touchée* illustrates Matta's more recent concern with our present age, and, perhaps, the future. Steel constructions are suggested; one may be reminded of suspension bridges, cables, fluorescent lights, radar screens. Space is implied not only by vaporous floating forms but by certain details that seem to conform to the laws of linear perspective; one thinks of a city seen in fog or atmospheric pollution. At the same time a curious illusion of mirror reflections creates disquieting ambiguities in space. Splashes of blue at the upper left of the composition suggest the sky; patches of intense emerald green are set off by smaller touches of red and yellow, glowing like lights in the mist. This is essentially a dehumanized world, impersonal, mysterious, yet vibrantly alive.

## 98. PIET MONDRIAN

Dutch, 1872–1944

*Fox Trot A,* 1927

Oil on canvas

43¼ in., diagonally

Collection of the Société Anonyme

1942.355

To those who find Mondrian's paintings empty of all beauty and meaning, it may come as a surprise to learn that his aim was profoundly philosophical and spiritual: in his own words, "a search for a beauty so pure and complete that it would redeem mankind through the revelation of universal harmony." Brought up in Holland as a strict Calvinist, he later became a life member of the Theosophical Society. Although his early artistic training was along traditional lines, he gradually discarded not only subject matter but, finally, all suggestions of natural light, descriptive color, and material space. He reduced his palette to the primary colors of red, blue, and yellow, plus black, white, and sometimes gray. Vertical or horizontal black lines of varying thickness divide the white canvas into rectangles of different sizes. Any kind of composition around a central point, or any symmetry in design, are avoided. Through these formal relationships Mondrian hoped to "make the absolute appear in the relativity of time and space." His work, along with that of Theo van Doesburg and other adherents of De Stijl, is known as Neo-Plasticism—"a new image of the world."

*Fox Trot A* is one of Mondrian's few compositions designed on a diagonal. Continuing space beyond the edges of the canvas is suggested by the failure of the lefthand vertical to meet the horizontal, and the extension of both the horizontal and the righthand vertical beyond their point of intersection. The title, like the painter's later *Broadway Boogie-Woogie,* is symbolic of the rhythm and measure so important in his thinking.

The son of a schoolteacher and nephew of a successful landscape painter, Mondrian (Pieter Cornelis Mondriaan) began in his uncle's footsteps; Yale owns an early, large, naturalistic landscape drawing. Gradually he shifted toward abstraction, especially by 1910 when he visited Paris. Five years later he and Theo van Doesburg founded the magazine *De Stijl,* in which Mondrian published a number of articles on Neo-Plasticism. The last four years of his life were spent in New York, where he became greatly interested in boogie-woogie music and formed a record collection.

99. HENRI MATISSE

French, 1869–1954

*Still Life with Plaster Figure,* 1906

Oil on canvas

$21\frac{1}{4} \times 17\frac{3}{4}$ in.

Bequest of Kate Lancaster Brewster

1948.121

Matisse painted this sparkling still life in the spring or summer of 1906; it was exhibited in the Salon d'Automne of that year. The previous year had seen the shock and excitement of the Salon in which the Fauves ("wild beasts") acquired their nickname. Matisse became the leader of this group, which, though stylistically diversified, had in common new uses of color for purposes of expression rather than Impressionist description.

*Still Life with Plaster Figure* is a kind of painting within a painting, since Matisse included an earlier canvas of his, *Flowers Painted at Cavalière,* as a backdrop behind the table. The plaster statuette is a model for his bronze *Standing Nude,* also of 1906; he used the same plaster model in another painting, *Still Life with Melon,* now in the Barnes Foundation, Merion, Pennsylvania. The objects on the table include some that he brought back from a trip to Algeria.

Stylistically this painting falls between Matisse's early, more traditional manner and his fully developed style which organizes color into relatively flat, clearly differentiated areas. The effect here is of a bright, richly textured rug or tapestry.

Matisse gave up his early studies of law to devote himself to painting. He worked with Adolphe Bouguereau and Gustave Moreau; in the 1890s he became interested in Impressionism and developed a deep admiration for Cézanne, whom he called "le Bon Dieu de la peinture." He traveled widely, visiting north Africa, Moscow, the United States, and Oceania. His last great work was the Chapel of the Rosary at Vence, France, done when he was bedridden and over eighty years old.

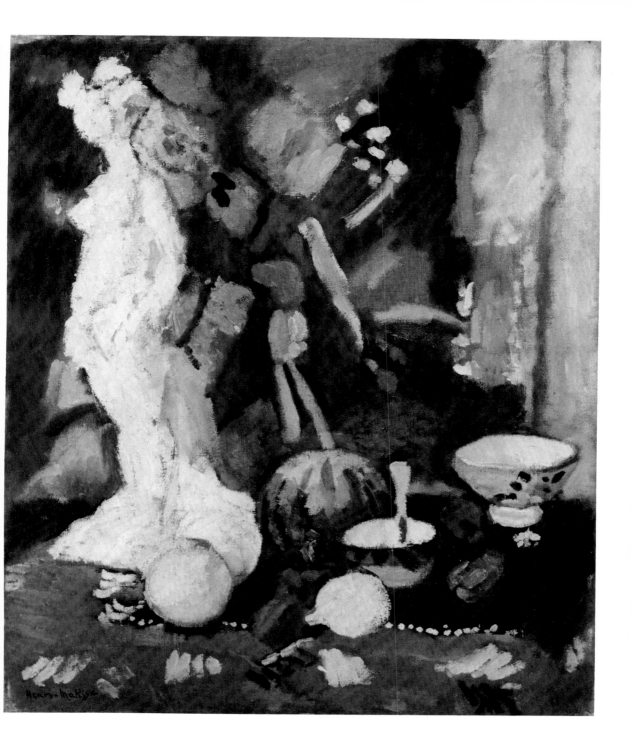

100. JACQUES VILLON

French, 1875–1963

*In Memoriam,* 1919

Oil on burlap

51⅛ x 32¼ in.

Collection of the Société Anonyme

1941.741

Although the Cubists specifically renounced emotional as well as representational elements inherent in subject matter, one cannot miss the expressive quality in this painting. Recognizably based on a draped human figure, it recalls, in theme if not in form, the great elegiac monuments of the past: the *Mourning Demeter* of the fourth century B.C., or Augustus Saint-Gaudens's *Adams Memorial.* Heavy drapery, dignity of bearing, gravity of mood—not all of these are explicitly present in Villon's Cubist form, but the sweeping curves and interlocking planes of color evoke a mood of solemn contemplation: stoic perhaps, yet not without hope and joy. Katherine Dreier found in it a "deep experience of resurrection." The muted orange glows against the steel gray of the background, contrasting with dark slate blue and green, tans and browns, and a flash of lemon yellow.

Villon (whose real name was Gaston Duchamp) was the eldest of four artist members of a family of seven, the others being Raymond Duchamp-Villon, Marcel Duchamp, and Suzanne Duchamp. A distinguished etcher and illustrator, he produced in 1920–30 a number of aquatint copies of paintings by Cézanne, Van Gogh, and others; some of these are in the collection of the Yale University Art Gallery's print room. He was an important member of the Cubist group. George Heard Hamilton has written: "As time is apprehended and defined only by memory and reflection, so Villon poises, in his search for time-filled space, the moving planes of memory and reflection which compose his noble *In Memoriam.*"

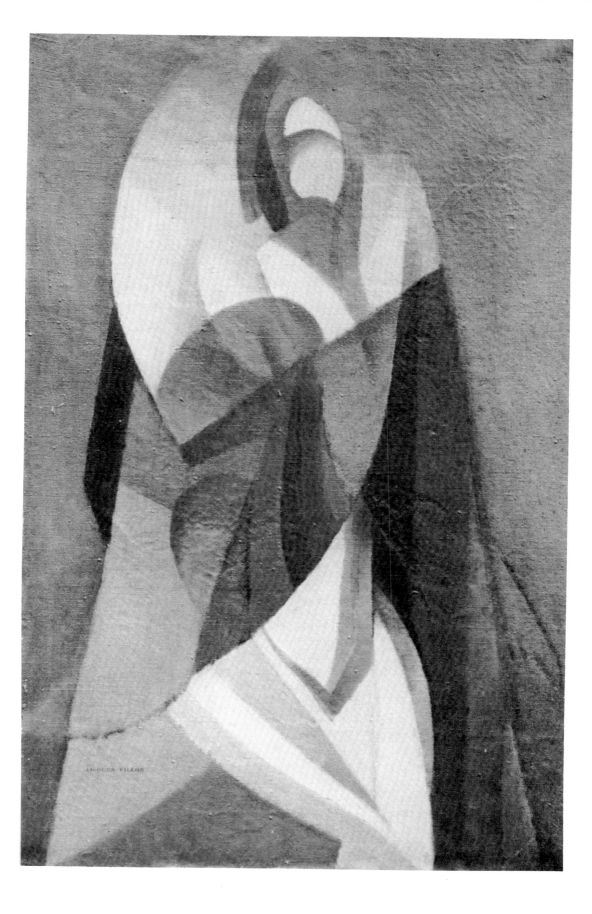

JACQUES VILLON

101. FERNAND LÉGER

French, 1881–1955

*The Viaduct*, 1925

Oil on canvas

$25\frac{1}{2}$ x $36\frac{3}{16}$ in.

The Philip L. Goodwin, B.A. 1907,
Collection

1958.18

Like many of his contemporaries, Léger was deeply impressed by the beauty to be found in modern machinery: man-made forms that characterize the industrial civilization of the twentieth century. In contrast to the Futurists, who concerned themselves with the dynamics of violent movement, Léger used his industrial elements, especially in the '20s, as units in clear, smoothly painted, essentially stable and orderly compositions. Forms are rendered in broad areas of color, only slightly modeled in light and shade to suggest solid masses; perspective is arbitrary, adjusted to the requirements of design. Effects of natural light and atmosphere are avoided; texture is uniformly smooth. Objects are treated almost as abstract symbols of themselves.

In a lecture, "The Esthetic of the Machine," delivered at the Collège de France in 1925, Léger said: "The made object is there, absolute, polychrome, pure and exact, beautiful in itself . . . I have never been amused to copy a machine. I invent images of machines as others do landscapes, with imagination. The mechanical element is not a set purpose for me, or an attitude, but a way to give a sensation of strength and power."

As a young man Léger was employed as an architectural draftsman and retoucher of photographs. He studied with Jean Léon Gérôme at the École des Beaux-Arts. In 1910 he met Picasso and Braque and came under the influence of Cubism; in the '20s he was associated with Amédée Ozenfant and Le Corbusier, leaders of the Purist movement. Interested in films and the ballet, he produced *Le Ballet Mécanique* in 1924.

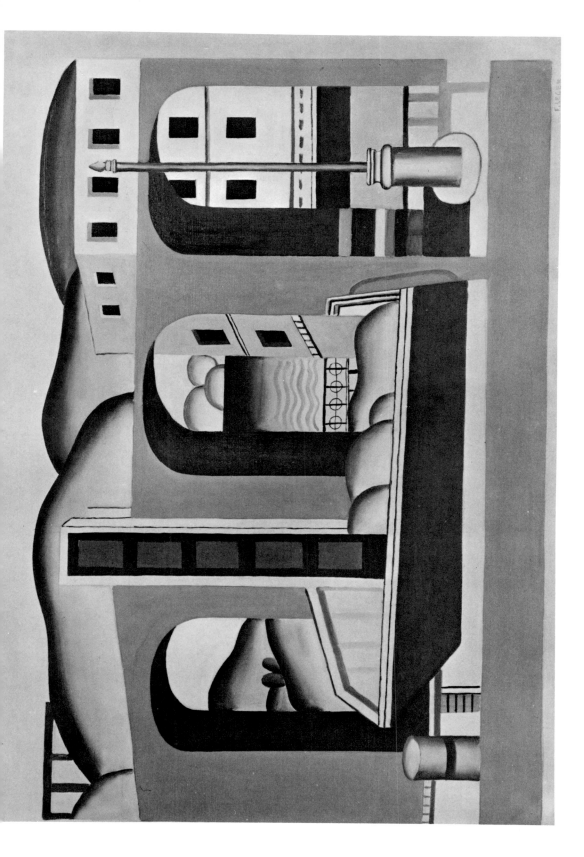

102. GEORGES BRAQUE

French, 1882–1963

*The Stove (Le Poële),* 1942–43

Oil on canvas

57⅜ x 34¾ in.

Gift of Paul Rosenberg & Company in memory of Paul Rosenberg

1960.34

Colorplate 22

Braque painted this picture in Paris, where he stayed during most of the German occupation, 1940–45. It was exhibited in the Salon d'Automne of 1943, where it hung in a room entirely devoted to his work.

Born in Argenteuil-sur-Seine, a place dear to the French Impressionists, Braque began his artistic career as apprentice to a house painter; his work included the imitation, in paint, of various kinds of wood and stone for the decoration of interiors. It has been suggested that this experience is reflected in his earlier collages and Cubist compositions involving contrasts of texture. He studied at Le Havre and then, in 1904, at the Académie Julian in Paris. Associated with the Fauves—Matisse, Othon Friesz, Paul Signac, and others—he later came under the influence of Cézanne, whose treatment of form became a source of Cubism, originated jointly by Braque and Picasso around 1909. Later Braque, like Picasso, furnished designs for the ballet. He also produced distinguished sculpture.

Braque's canvases always have a strongly decorative cast. In *The Stove* there is considerable modeling of form in broad, boldly applied strokes, but perspective, except in the case of the stove itself, is largely arbitrary. Braque's color harmonies—in this case an orchestration of his favorite blues, lemon yellow, and chocolate brown—have never been more attractive; unromantic utilitarian objects are as radiant as flowers or the tapestries which his textured patterns tend to suggest. Extremely successful tapestries have in fact been woven from Braque's designs.

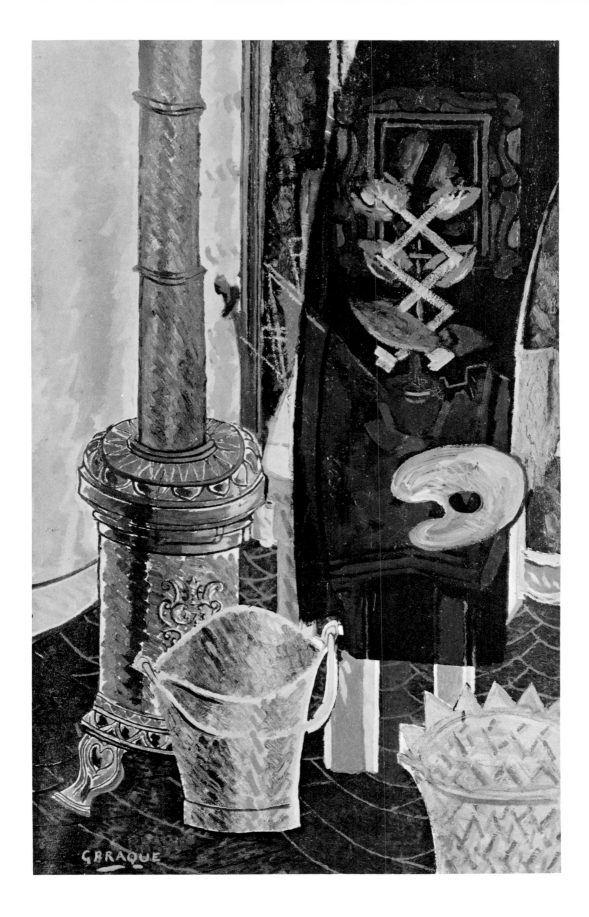

GBRAQUE

103. GEORGES BRAQUE

French, 1882–1963

*Still Life with Flowers,* 1946

Oil on canvas

31 x 39 in.

Bequest of Susan Vanderpoel Clark

1967.82.1

Perhaps the most striking of the several Braque canvases owned by Yale, *Still Life with Flowers* is a splendid example of the painter's handling of color and texture. There is first of all an unusual orchestration of greens, from a dark tone to a light pea green; shadows are violet, some in grayish-white areas, others in stripes alternating with intense lapis blue. Orange-yellow areas appear at the lower corners of the canvas; browns become almost black. Finally, there are patches of the clear lemon yellow of which Braque was fond. As usual, there is no true perspective; the emphatically two-dimensional surface is enriched by a variety of paint textures, some thick, others very thin. The picture, while decorative, is far more than that; the paint itself speaks with arresting power.

Braque's early experience in wall decoration imitating patterned wood and stone inlay, and his association with Picasso in the development of Cubism, are well known. But what in Picasso's synthetic Cubism tends to elegant design, tends to become in Braque's later work essentially statements of color for its own sake, expressed in terms of a textural richness that has more than once been successfully translated into woven rugs or tapestries. *Still Life with Flowers* has an emotional impact which one may even call dramatic.

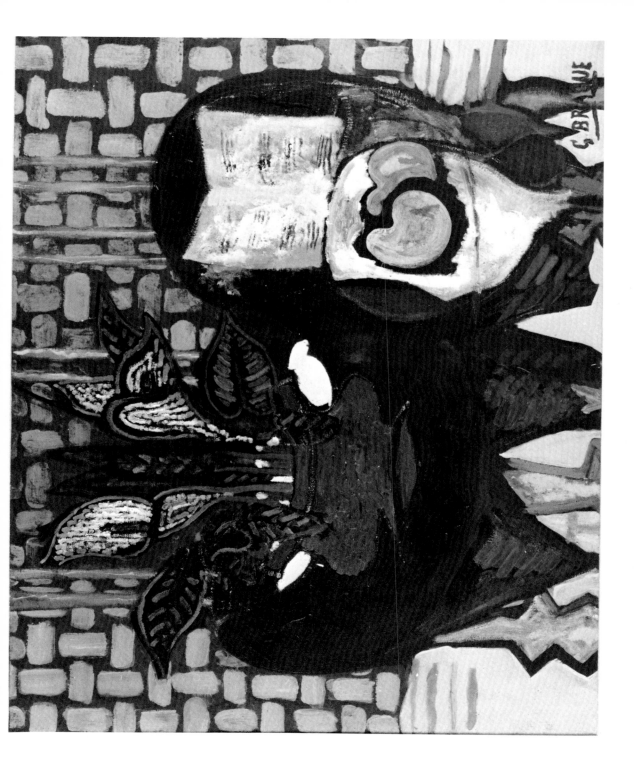

104. VICTOR VASARELY

Hungarian, 1908–

*Vonal-K-SZ*

Tempera on canvas

78¼ x 78¼ in.

Solomon Byron Smith,
B.A. 1928, Fund

1969.32

"The art of tomorrow will be a community treasure, or it will be nothing." In these words Vasarely has voiced his belief that all art must have a civic, public character; it must be taken from its traditional position as an individualistic creation for an exclusive clientele, and made to serve society and the common man. Moreover, it must be designed in terms of modern tools and technology; it should be planned for mass production, machine made like objects of practical function. "Everything made by man is human," he has said. "The tool is the extension of the hand, the machine is the extension of the tool. If the brush is accepted, the aerial photograph and the camera must likewise be admitted."

Along with such technological thinking goes Vasarely's mathematical approach to his art: "Every creation of man is formal and geometrical, like the internal structure of the universe." He is an important figure in the Op movement, which stresses precise handling and investigates the optical properties of line and color in nonobjective fields. For Vasarely, however, the goal of art is "the integration of plastic beauty with environment."

"Vonal" is a Hungarian word for the French "trait"—in this connection perhaps best translated as "stripe" or "track." Early in his career Vasarely made studies of tigers and zebras, whose hide patterns fascinated him. During his so-called Vonal Period, 1966–71, he developed the stripe idea in abstract patterns of movement in space, some of them, like the Yale canvas, called "reseaux-couloirs," or "corridor-grilles." Delicate mechanical adjustments of stripes of different widths, in black, blue, silver, and white, force us to see this picture as the opening of a curving tunnel. Two signatures indicate that the canvas may be hung in either of two positions.

Vasarely was born in Pecs, Hungary. He was trained in medicine at the University of Budapest, and he then studied art at the Poldini-Volkmann Academy and the Bortnyik Bauhaus. He visited Paris in 1930. Until 1944 he concentrated on graphics, influenced at first by commercial design and by Surrealism. His earliest abstractions, dating from the 1940s, show Constructivist elements. He has worked extensively in plastics, and many of his designs have been repeated in tapestry, including *Vonal-K-SZ*. A comprehensive collection of his work, which he presented to the town, is on view in the sixteenth-century castle of Gordes in Provence, where he has spent several summers.

105. AMEDEO MODIGLIANI

Italian, 1884–1920

*Portrait of a Young Woman*

Oil on canvas

18 x 11 in.

Bequest of Kate Lancaster Brewster

1948.123

Colorplate 23

The son of impoverished Jewish intellectuals, Modigliani was born in Leghorn and studied in Florence and Venice. While still in his teens he contracted tuberculosis, which, along with alcoholism and the effects of poverty, caused his death at the age of thirty-six. Primarily interested in sculpture, he went to Paris in 1906, where he came under the influence of Cézanne and of the African sculpture which was then having so marked an effect on Picasso and others. His work developed affinities with that of Brancusi, whom he met about 1909; he began to carve similar heads with small features, long noses, and overall elliptical shapes. But by 1915 he gave up sculpture, partly in discouragement and partly because the stone dust was affecting his lungs.

Modigliani's portraits tend to follow a formula—an oval head tilted slightly on a long neck, a small mouth, and a nose which becomes longer in his later work. The smoothly flowing contours are outlined against a plain background which sets off the elegant, slightly melancholy figure. Yale's portrait follows this general pattern, but like other examples of Modigliani's best work it conveys a real sense of the sitter's personality; the stylization itself brings her to life as a reserved and sensitive individual. The delicate modeling of the face, especially around the forehead, eyes, and nose, is masterly.

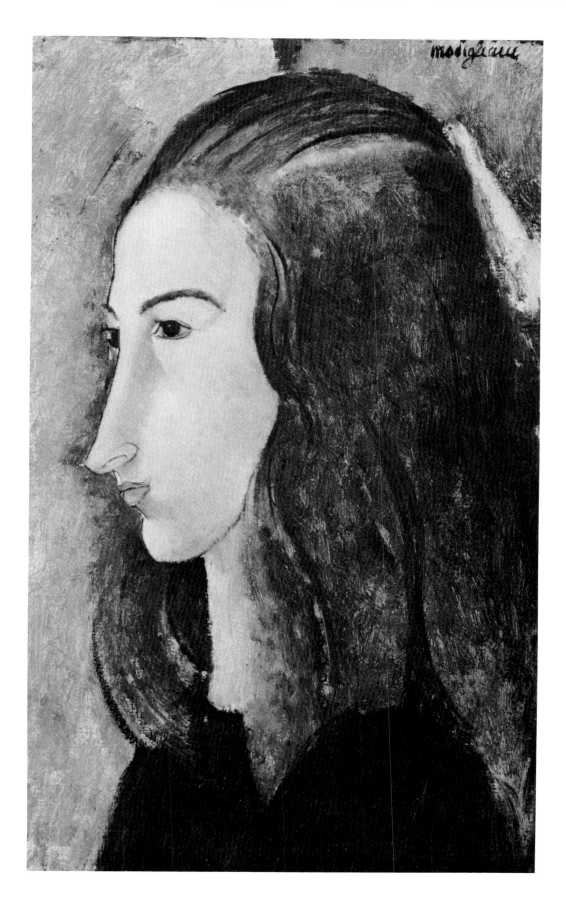

## 106. GIORGIO DE CHIRICO

Italian, 1888–

*The Torment of the Poet,* 1914

Oil on canvas

20¾ x 16⅛ in.

Bequest of Kay Sage Tanguy

1963.43.2

The son of a Sicilian father and a Genoese mother, Giorgio de Chirico was born in Volo, a seaport on the Thessalonian coast, where his father was working as an engineer. The Argonauts are said to have set sail from Volo in quest of the Golden Fleece; the young De Chirico seems to have been haunted by thoughts of legendary voyages controlled by the gods or by strange adverse forces. His early paintings, full of baffling details, create a new world of mystery and magic. *The Torment of the Poet* belongs to his so-called Metaphysical period, developed in the years just before World War I. He often used faceless mannequins such as the one in this picture who irrationally wears the classic robe of a fifth-century Athenian statue such as a maiden from the Erectheum porch. The austere architecture, in arbitrary perspective, is classical in character, recalling especially the arcades in fifteenth-century Italian Renaissance paintings which De Chirico admired. Unidentifiable objects in the foreground are part of the artist's personal and private language of symbols. The ancient Greek figure stands ghostlike in the midst of a world dislocated and mysterious, yet set out with the precision of a vivid dream.

De Chirico's Metaphysical period reflects his interest in the writings of Nietzsche and the German Romantic painters Arnold Böcklin and Caspar David Friedrich. After spending the years 1905–07 in Munich, he lived in Italy (Milan, Florence, Turin) until 1911, when he went to Paris. His father's engineering drawings may account for the architectural elements in his style at that time, and there are constant references to modern industry, especially the railroad. But what De Chirico paints in sharp outline and strong illumination has the reality of a dream world, not the objective, swiftly recorded world of the Impressionists.

G. de Chirico

107. WASSILY KANDINSKY

Russian, 1866–1944

*The Waterfall,* 1909

Oil on composition board

$27\frac{9}{16}$ x $38\frac{3}{8}$ in.

Collection of the Société Anonyme

1941.529

This picture belongs to the early part of the painter's career, shortly before he turned to pure abstraction. Elements of landscape are recognizable, but they have been translated into a rich tapestry of color and texture suggestive of an oriental rug. The style and point of view are related to those of the German Expressionists, with whom Kandinsky was associated at the time. He himself was interested in music, poetry, and drama, notably the plays of Maeterlinck and the operas of Wagner. *The Waterfall,* in its bright color scheme of deep blue, rose, green, turquoise, and mother-of-pearl pink, reflects the influence of peasant art; some years earlier Kandinsky had pursued anthropological and judicial studies of peasant culture in northeastern Russia.

Born in Moscow, Kandinsky studied political economy, anthropology, and law, becoming professor of law in his native city in 1896. Soon after this, impressed by Monet's *Haystacks* which he saw in an Impressionist exhibition in Moscow, and by the Rembrandts in the Hermitage, St. Petersburg (now Leningrad), he gave up his legal career and went to Munich, where in 1897–99 he studied painting and came in contact with leaders of various new schools of aesthetic theory. In 1903–06 he traveled in Italy and France, and visited Tunis in north Africa. In 1908 he was again in Munich, and from then on was an important figure in international art movements. He was represented in the Armory Show of 1913 in New York. In 1914 he returned to Russia, remaining there until 1921 when he went back to Germany. His first one-man exhibition in New York was arranged in 1923 by the Société Anonyme, of which he was made honorary vice-president in that year. In 1928 he designed settings for Moussorgsky's *Pictures at an Exhibition,* produced in Dessau. He worked in the graphic arts, and published plays, prose-poems, and an autobiography, in addition to his most influential treatise, *Concerning the Spiritual in Art.* He died in Paris.

108. WASSILY KANDINSKY

Russian, 1866–1944

*Composition No. 238:*
*Bright Circle,* 1921

Oil on canvas

54¼ x 70¾ in.

Collection of the Société Anonyme

1941.528

This canvas was painted in the year of Kandinsky's return to Germany from Russia, where he had spent seven years as an influential teacher and museum director in his birthplace, Moscow. The following year, 1922, marked his appointment as professor at the Bauhaus, established first in Weimar and later in Dessau. *Composition No. 238: Bright Circle* is an example of his late style, in which purely geometric forms predominate: straight lines, circles, and triangles. Completely nonobjective, these colored shapes are arranged in an orderly, animated two-dimensional pattern, held in suspension and firmly locked in pictorial space by virtue of their interacting tensions. This style marks the final stage in Kandinsky's efforts to free his painting from all representational and traditionally emotive qualities.

The philosophical and aesthetic principles underlying his late style were set forth by Kandinsky himself in his most important literary work, *Concerning the Spiritual in Art,* which was published in 1912, the year in which he founded, with Franz Marc, the Blaue Reiter ("Blue Rider") group in Germany. In this essay, to quote Katherine S. Dreier, he "gave birth to the idea that eventually the rhythm of line and color, of color in juxtaposition to color, built up architecturally on principles of construction as is music, would speak to the eye as music does to the ear." Kandinsky's theories and his painting have had a profound influence on the nonobjective art of the twentieth century.

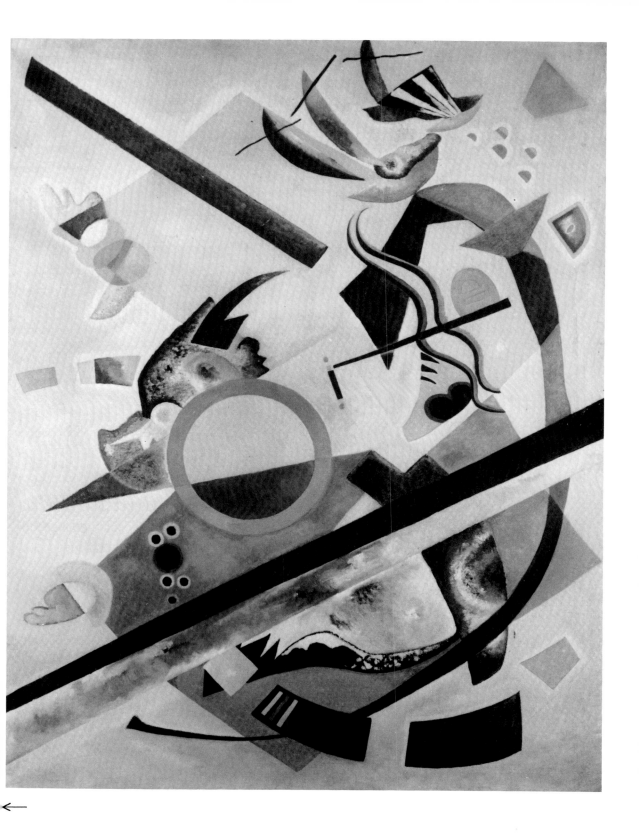

109. KASIMIR MALEVICH

Russian, 1878–1935

*Scissors Grinder,* 1912

Oil on canvas

31⅜ x 31⅜ in.

Collection of the Société Anonyme

1941.553

Colorplate 25

When this canvas, alternatively called *Knife Grinder,* was exhibited in 1913 at the Target in Moscow, Malevich was calling his work "Cubo-Futurist." The prismatic forms are in a general way Cubistic; the repeated, overlapping shapes of foot, hands, and scissor blades recall the Futurist formula for expressing movement. Marcel Duchamp's *Nude Descending the Staircase* was painted in the same year. Malevich's forms, however, unlike those of Duchamp, are brightly colored; like Léger's, they seem to be made of metal sheets and cylinders. But Malevich, like the Russian Futurist poets of his generation, saw in the machine not so much a glorification of power and movement as such—the basic aim of the Italians—as a celebration of Russia's emerging and socially challenging industrial society. Malevich himself, as George Heard Hamilton has written, "always insisted on the ethical and philosophical values of his art." This seems to have been true even after 1914, when he turned from his early style, so well illustrated in the *Scissors Grinder,* to the pure abstraction of Suprematism ("the supremacy of feeling in creative art") which he proclaimed in 1914. Feeling was not to be aroused through association with recognizable objects or situations, but by the direct experience of color and proportion in absolute purity. In this he is related to Mondrian, the later Kandinsky, and El Lissitzky whom he strongly influenced.

Born in Kiev, Malevich taught at the First Free State School of Arts and Crafts in Moscow, and later at the Museum of Artistic Culture in Petrograd (now Leningrad). As a Christian mystic, he saw his art as a vehicle for the expression of antimaterialistic ideals; even when, later in his career, he turned to architecture, the theatre, and industrial design, he never had so utilitarian an approach as did many who, like some of the Bauhaus group, came so profitably under his influence.

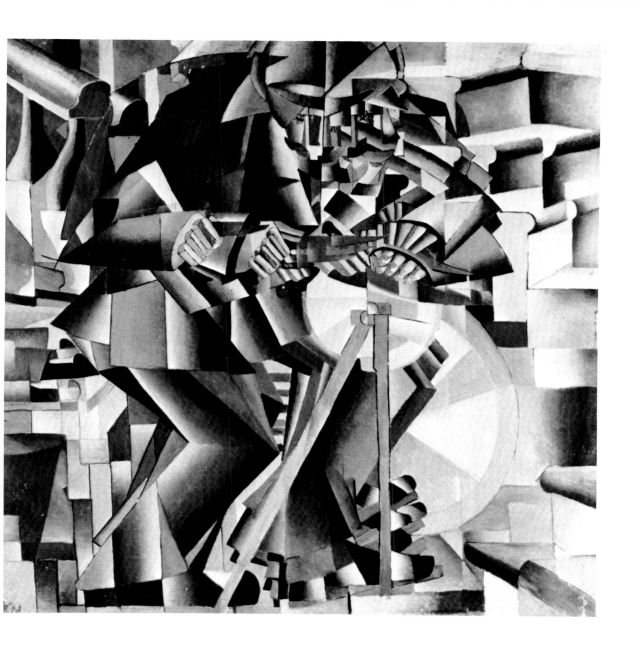

110. EL LISSITZKY

Russian, 1890–1947

*Proun* 99

Oil on wood

50¾ x 39 in.

Collection of the Société Anonyme

1941.548

"Proun" is a word coined by El Lissitzky, meaning "For the New Art," and defined by him as "a station for changing trains from architecture to painting." To *pro,* "for," he added the initials of *Uchilishche Novago,* "New Art." When he succeeded Chagall as director of the Vitebsk School of Art, where he had been professor of architecture and graphic arts, he renamed the school the Institute for New Art (Uchilishche Novago Iskusstva).

El (Eleazar) Lissitzky was born in Smolensk, Russia. He studied engineering in Darmstadt, and taught in Vitebsk. Meeting Malevich and Vladimir Tatlin in 1919, he came under the influence of Suprematism and Constructivism, abandoning the "Cubo-Futurism" which, like Malevich, he had been practicing. Driven to Berlin and then to Switzerland after the Revolution, he published critical articles and children's books. As an associate of Miës van der Rohe, Theo van Doesburg, and others, he did much to extend the influence of Russian abstract art in the west. In Yale's *Catalogue of the Collection of the Société Anonyme* the German critic Alexander Dorner has written: "This modest and quiet man was possessed by a messianic drive to liberate man's vision and thereby man's action from the shackles of traditional absolutes. Expelled from his own country by the reactionary and unimaginative narrowness of the Soviet regime, and living on borrowed time under the shadow of a deadly disease . . . he visualized and organized new ways of exhibiting, and was a pioneer in printing and photomontage."

Wholly abstract in form, *Proun* 99 has clean lines and pure geometric structure that suggest the engineering vocabulary of modern architecture. It has the balance and precision of well ordered instruments and machinery, but the balance is that of equilibrium rather than of symmetry.

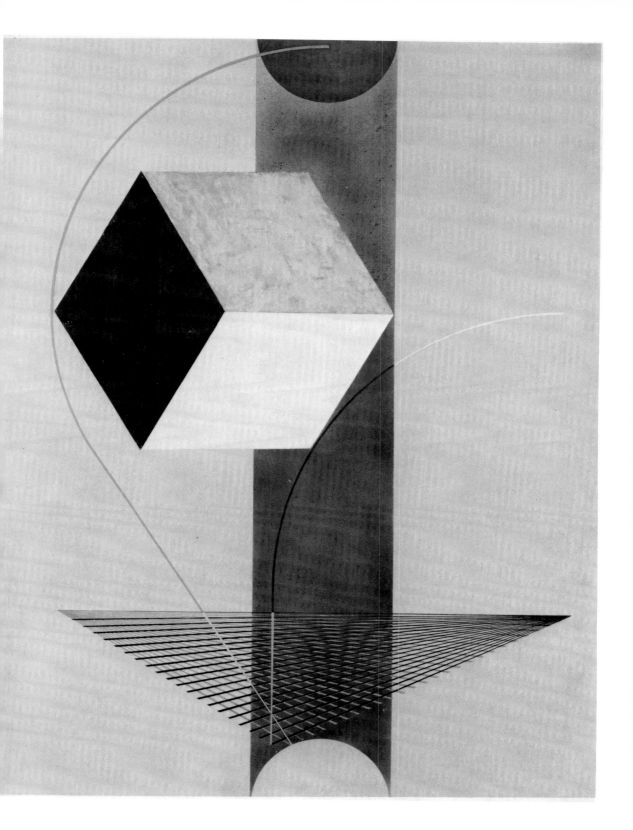

111. JUAN GRIS

Spanish, 1887–1927

*Abstraction No. II: Le Journal*
*(Still Life in Yellow and Blue)*

Oil on canvas

$36\frac{1}{4}$ x $23\frac{1}{2}$ in.

Collection of the Société Anonyme

1941.489

Juan Gris (whose real name was José Gonzales) began his career as a student of engineering at the arts and trades school in Madrid, his birthplace. In 1906 he went to Paris, where he met Picasso and Braque and came into contact with Cubism. Strongly influenced by the later, synthetic phase of Cubism, he developed his own version of it, concentrating on purity of shapes and fastidious design which is essentially two dimensional. The decorative element is strong; contrasts of texture tend to be eliminated in favor of smoothly painted, clearly differentiated areas of color. Marcel Duchamp has spoken of Gris's "self-imposed discipline of simplification." His canvases have a special elegance, although they may lack something of Braque's surface richness and Picasso's energy.

*Abstraction No. II: Le Journal* makes use of the familiar Cubist vocabulary: table, newspaper, suggestions of paneled wall and tiled floor. In addition to yellow and blue, the colors include dark red, terra cotta, black, turquoise, gray, and white. Dotted areas make up rather more than half of the composition: red on turquoise or black, blue on yellow or dark gray, yellow on gray or white. Longer strokes of red on terra cotta suggest the grain of wood. Most of the shapes have diagonal boundaries, animating the canvas as a whole.

Like Picasso and Miró, Gris designed settings and costumes for the ballets of Diaghilev; he also provided illustrations for a number of books, including one by Gertrude Stein.

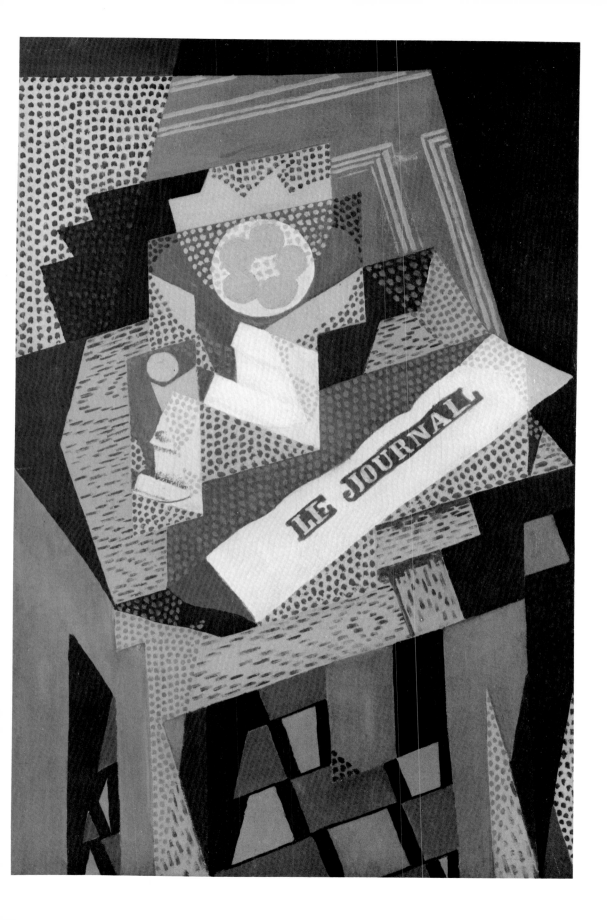

112. PABLO RUIZ PICASSO

Spanish, 1881–

*Dog and Cock (Chien et Coq)*, 1921

Oil on canvas

61 x 30⅛ in.

Gift of Stephen Carlton Clark,
B.A. 1903

1958.1

Colorplate 26

*Dog and Cock* was painted at Fontainebleau, where Picasso spent the summer of 1921. In style it is close to that of the *Three Musicians* painted in two versions during the same period.

Related to what is known as Synthetic Cubism, jointly originated by Picasso and Braque, *Dog and Cock* translates objects into abstract patterns of flat color and sharp outlines combined without regard to traditional perspective. This "distortion" is based on the Cubist principle that, in the words of George Heard Hamilton, "form is not a finite and fixed characteristic of an object. An object is seen in terms of planes which indicate but do not define its external and internal boundaries." The table with the rooster and various articles upon it, and the hairy black dog underneath, are collapsed and combined into a powerful, posterlike design in which broad areas of flat color are played against smaller patches patterned like printed fabrics in a collage. Picasso's unerring color sense and the large scale of the canvas have transmuted everyday objects into a ringing statement of monumental splendor.

Picasso was born in Málaga but moved to Barcelona with his family in 1896. After studying at the Academies of Barcelona and Madrid, he went to Paris in 1900, coming under the influence of Toulouse-Lautrec, Gauguin, Van Gogh, and the Impressionists. In the over seventy years that have followed he has gone through the amazingly varied phases of expressive, abstract, and classic styles that have given so much excitement and direction to twentieth-century art. After 1935 he ceased to visit Spain, dividing his time between Paris and the south of France. At present he lives in Mougins on the Mediterranean coast.

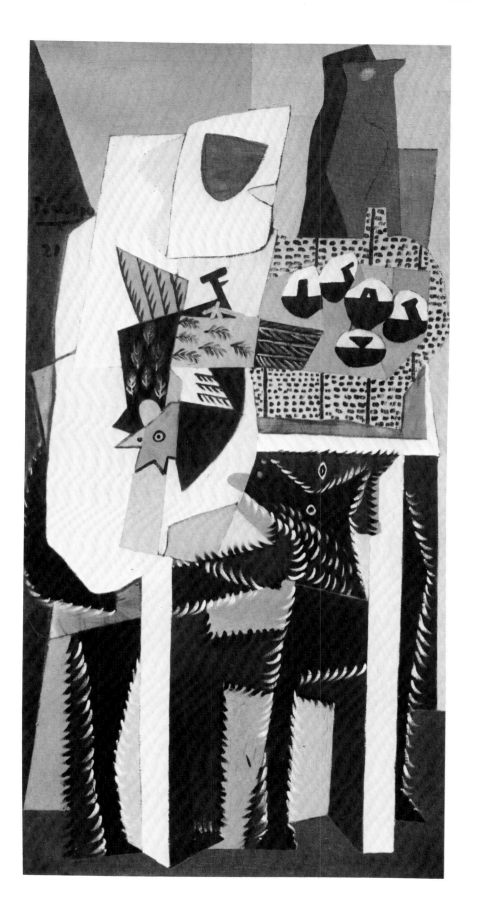

113. PABLO RUIZ PICASSO

Spanish, 1881–

*First Steps,* 1943

Oil on canvas

51¼ x 38¼ in.

Gift of Stephen Carlton Clark, B.A. 1903

1958.27

Colorplate 27

In contrast to countless popular paintings of children—realistic, sentimental, artificially appealing—Picasso's *First Steps* assaults the visitor with the impact of an explosion. The child, larger than life, stamps toward us, his huge eyes staring like those of a Byzantine mosaic, the forms of his dress flattened and angular like sections in a stained glass window. The fluid form of the mother curves around him as a symbol of protection and possession, but he moves in triumph away from her support. The tremendous experience of first steps—a human being walking erect under his own power—is expressed here with overwhelming force. The distorted face of the child, his raised left foot, his eyes fixed on the world beyond his mother's arms, all symbolize in unforgettable fashion the magnitude of his effort and the elemental forces of movement and balance now for the first time brought under his control. These dynamic forces are formally disciplined by Picasso through the balance of angular shapes and color harmonies of blue, gray, pink, and silver. The picture was exhibited in the Salon de la Libération (Salon d'Automne, 1944) in Paris, where Picasso spent most of the war years. The date, "21 mai 1943," is written on the back of the canvas.

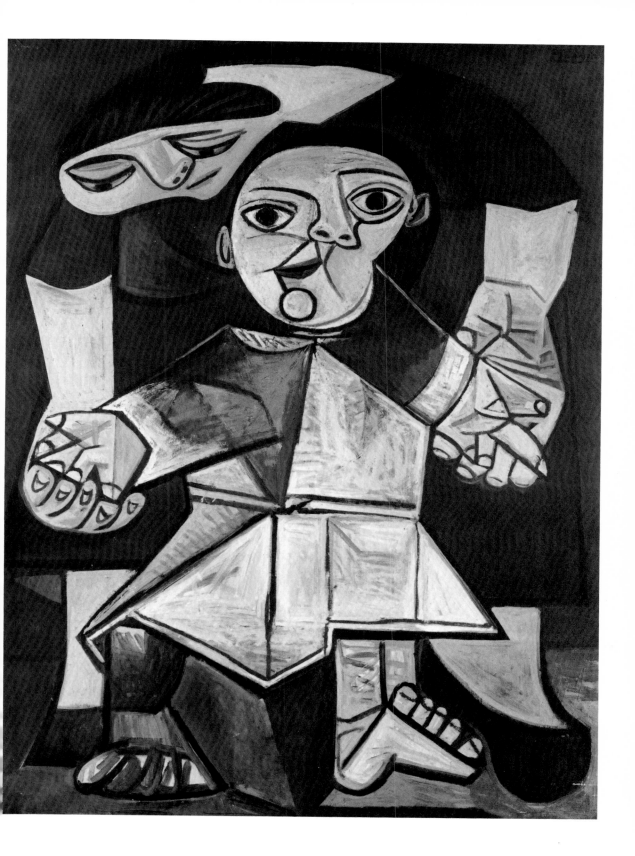

114. JOAN MIRÓ

Spanish, 1893–

*Women and Bird in the Night*
*(Femmes et oiseau dans la nuit)*

Oil on burlap

$17\frac{1}{4}$ x $13\frac{1}{4}$ in.

Bequest of Kay Sage Tanguy

1963.43.1

Miró is a kind of brilliant super-cartoonist whose imagination is matched by an inexhaustible capacity for humor and wit. Sometimes there is a streak of the sinister (and more often, the naughty) in his make-believe, but, like Paul Klee, he always makes his magic convincing. However improvised or unpremeditated his pictures may seem, they are always under the control of a faultless instinct for design and color.

This small painting was a favorite of its former owners, the painters Yves Tanguy and his wife Kay Sage, who bequeathed it to Yale after her husband's death. It hung over the fireplace in their Connecticut living room. It is carefully drawn in black lines combined with flat shapes of red, dark blue, black, and green. White paint, shading into yellow at the upper part of the composition, has been rubbed over the background, leaving bare areas of the beige-colored burlap. A dark blue and black sickle shape, tipped with red, suggests the nocturnal setting indicated in the picture's title, as does an eight-pointed star like an outsized asterisk.

The jack-o'-lantern faces, abstract curves, and zigzags ending in colored dots—symbols of sound and movement?—are as painstakingly precise as a child's drawing, and as cheerful in effect. One thinks also of the mysterious pictographs of primitive peoples. But we should probably look for no deeper meaning than that of the artist's joy in his invention, and the pleasure it communicates to us.

Miró began his career with comparatively realistic farm scenes associated with his birthplace near Barcelona. After studying at the Academy there, he went to Paris in 1919, where he came in contact with the Dadaists and later the Surrealists, but he never completely adopted their principles. Abandoning the representational, he evolved what Marcel Duchamp has called "a new two-dimensional cosmogony, in no way related to abstraction," in which lines, colors, letters, and sometimes recognizable objects are scattered over a flat surface which they define and enliven as a kind of supernatural space. One may recognize a three-dimensional equivalent in the mobiles of Alexander Calder (see No. 134).

Miró has designed settings and costumes for the ballet; he provided murals for the Paris Exposition of 1937, and for the Terrace-Plaza Hotel in Cincinnati, Ohio, in 1946.

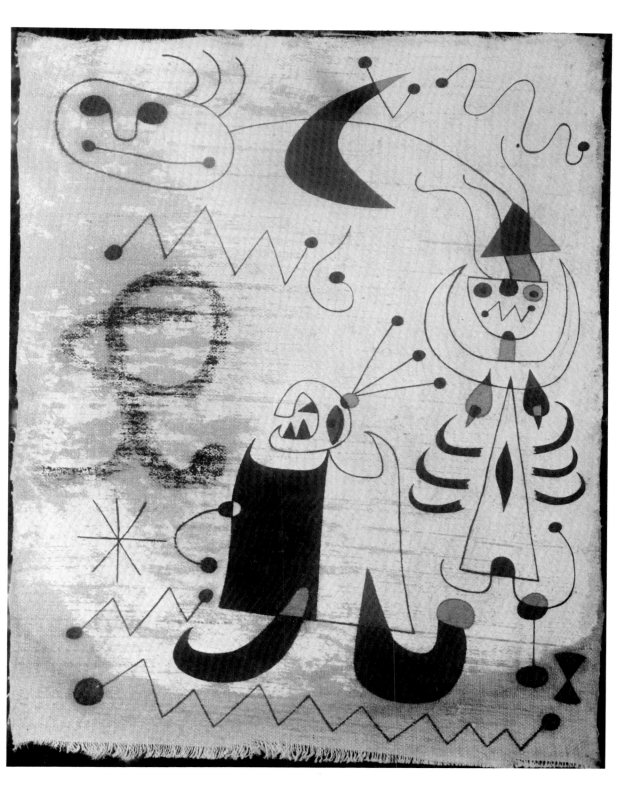

115. SALVADOR DALI

Spanish, 1904–

*The Phantom Cart,* 1933

Oil on wood

6¼ x 8 in.

Gift of Thomas F. Howard

1953.51.1

Colorplate 21

In contrast to the disquieting, gruesome, or visually complex canvases by which Dali is best known, *The Phantom Cart* illustrates one of the more attractive aspects of his genius— a certain poetic tenderness associated with memories of his childhood in northern Spain. Born near Barcelona, he studied at the Academy in Madrid, where he seems to have exercised an evergrowing ability to shock, outrage, or merely annoy the observer. Settling in Paris in the late 1920s, he came into contact with Cubism, Futurism, and the "Pittura Metafisica" of De Chirico (see No. 106) and Carlo Carrà. He was especially influenced by De Chirico's use of deep, empty spaces and devices such as cast shadows with sinister implications. Interested in Surrealism, he soon developed his own version of that art of the subconscious, setting down his paranoiac images in minute detail—the equivalent of the horrifyingly vivid experiences of dreams. As in dreams, objects seem to change their significance and interrelationships without altering their external forms. Thus in this painting the cart (which is itself only a hallucination) is fused with the town, "becoming in a sense its own destination," as Norma Evenson has put it.

Painted two years after the famous "limp watches" of Dali's *Persistence of Memory, The Phantom Cart* carries no unpleasant or disturbing associations. Dali tells us that it is based on his memory of a visit to El Muli de la Torre, which he approached at sunset. There is a touching poetry in the little forms silhouetted against the evening light, a mystery that transcends the mere fascination of the double images which compose the picture.

Sculpture

116. ENGLISH, 12th CENTURY

*Man and Lion*

Indigenous red sandstone

H. 11¾ x L. 22 x W. 11 in.

Enoch Vine Stoddard,
B.A. 1905, Fund

1966.91

Like Samson or Hercules, man and lion seem locked in agonized combat; but inspection shows that the human head is attached to a strange froglike body, over the shoulders of which clambers a kind of lizard. This creature in turn seems to attack a snakelike form—the tail of the "man"? It has been suggested that some later recutting accounts for some of the anatomical confusion of the piece; however, hybrid monsters are quite normal inhabitants of medieval art. The presence of lion and serpent—of reptilian forms in general—recalls the words of Psalm 91: "Thou shalt go upon the lion and the adder; the young lion and the dragon shalt thou tread under thy feet." The lion and the serpent stand for the powers of darkness, to be conquered by man through divine grace. Often a symbol of fortitude and of Christian resurrection, the lion may also signify the devil himself; all reptiles of course have had evil associations since the Garden of Eden. It may be going too far to see in this sculptured struggle, in which the human being is clearly getting the worst of it, an allegory of the two warring natures of man, but there is no denying the reality of the combat itself.

The form of the piece is curious; suggesting a capital or corbel, it can scarcely have been either. Walter Cahn thinks it may have been part of the base of a font. Stylistically it is related to Romanesque carvings at Leominster and Kilpeck in Herefordshire, where a local school of architectural sculpture seems to have flourished and where red sandstone is common. It shows much of the crisp technique and the expressive power for which the church at Kilpeck is famous.

117. FRENCH, 12th–13th CENTURY

*Five Figures from the Church of St. Martin at Angers,* ca. 1175–90

Stone

H. 77 to 55 in.

Gift of Maitland F. Griggs, B.A. 1896

1926.15–19

This group of stone figures, carved about 1175–90, once decorated the choir of the church of St. Martin in Angers, where they are replaced today by copies. A sixth figure, now lost, is known to have existed. In addition to the seated Virgin and Child, the holy personages are believed to be Saints Andrew and John the Evangelist (with haloes) and two local bishop saints, Maurille (or Aubin) and Loup, who wear ecclesiastical vestments. The latter pair were once thought to be Saints Martin and Luke. All the heads and some of the hands were knocked off, presumably during the French Revolution. Traces of polychromy, probably applied originally about 1768, can still be seen.

G.H. Forsyth, an authority on the church of St. Martin, thinks that these figures were originally intended not for the choir but for the west portal; however, that portal was never finished. The seated Virgin has parallels in the trumeau figures on the Portico de la Gloria at Santiago de Compostela in Spain, and at Notre Dame at Noyon; it is possible that the Yale Virgin was carved as a trumeau figure. Stylistically the St. Marton sculptures are related to the twelfth-century figures on the archivolts of the west portal of Chartres cathedral, which also influenced the sculpture of the Loire valley. The treatment of the drapery, with its pronounced linear flutings clinging to columnar bodies, echoes that of portal figures at Mantes and fragments from the cloister of Notre-Dame-en-Vaux in Châlons-sur-Marne. Less convincing comparisons have also been made with Burgundian architectural sculpture.

Such an assemblage of architectural sculptures as the St. Martin group is rarely met with apart from its original setting. These five saints, remarkably fine in workmanship and well preserved except for the deliberate vandalism of an earlier period, constitute a monument of major importance for the study of medieval art.

1926.18

1926.16

1926.17

1926.15

1926.19

118. FRENCH, 14th CENTURY

*Virgin and Child,* ca. 1300

Ivory

H. 10 in.

University purchase,
Maitland F. Griggs, B.A. 1896, Fund

1949.100

Colorplate 28

In this charming little ivory, the sacred and secular are balanced in French Gothic perfection. Mary, Queen of Heaven, is crowned and robed like a princess; her slender elegance reflects the sophisticated tastes and manners of the French court. At the same time, her humanity is stressed through the earthly tenderness and intimacy seen in much High Gothic art. Love takes the place of power; majesty becomes mercy, and the worshipper, like Mary herself, feels joy instead of awe. The theme of the nursing mother—the *Madonna Lactans*—is a symbol both of the Virgin's humility and of her power to save sinful mankind through her intercession on the Day of Judgment. But that day is far distant; the young mother is almost playful in her intimacy with the Child who sucks with such concentration.

The workmanship is exceptionally fine. The curve of the tusk controls to perfection the graceful attitude of the Virgin as she leans slightly backward to balance the weight of the Child on her raised left knee. The folds of the garments, the short veil, and the delicate features of both faces have been carved with the utmost skill. The unknown sculptor probably came from the Île de France, perhaps Paris itself. Large numbers of these small ivories were produced in the thirteenth and fourteenth centuries and were widely exported. Intended for private devotion, they must also have served their aristocratic owners as a constant source of aesthetic delight.

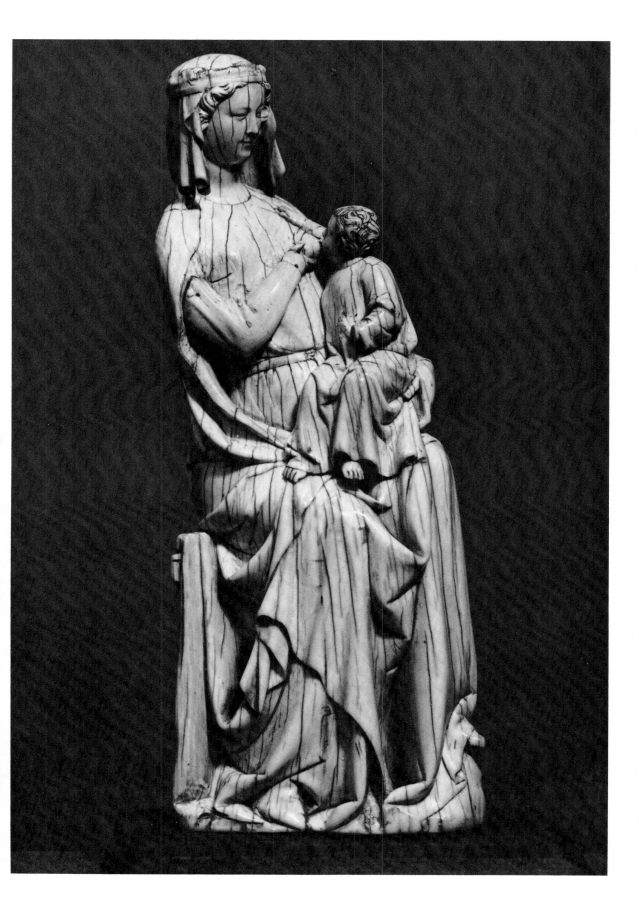

119. TINO DI CAMAINO

Italian, active 1315–1337

*Three Princesses*

Relief: marble and cosmati mosaic

H. 27½ x W. 22½ in.

Gift of Maitland F. Griggs, B.A. 1896

1939.556

These three young women, wearing crowns and the long, clinging robes fashionable in the early fourteenth century, probably represent noblewomen or members of royalty. At one time they were called Virtues, but since they do not carry any identifying attributes (e.g. a mirror for Prudence, scales for Justice) this theory is no longer accepted. Tino di Camaino, to whom the relief has been attributed, carved analogous figures on the tombs for which he was famous, especially those which he made for members of the house of Anjou then ruling in Naples. The Yale *Princesses* very probably formed part of a frieze on or below a sarcophagus, as ladies-in-waiting or relatives of the deceased. W. R. Valentiner has suggested that they may represent three of the four daughters of Philip of Taranto, from whose tomb the relief may have come; all of Philip's daughters married royalty. The cosmati mosaic, in geometric patterns of color and gold, was often used as backgrounds for such reliefs, as were the Gothic arches above the figures' heads.

Tino di Camaino was born in Siena about 1285. He spent some time in Pisa, where he was influenced by Giovanni Pisano, and left several examples of his work. He was also active in Florence where he specialized in tomb sculpture and design. Summoned to Naples in 1323, he worked there until his death in 1337, carrying out commissions both in sculpture and architecture.

120. GERMAN, 16th CENTURY

*Hercules and the Lion,* ca. 1575

Bronze

H. 6¾ in. (with marble base,
H. 8¾ in.)

Maitland F. Griggs, B.A. 1896, Fund
1963.42

Small bronzes such as this one were popular among sophisticated collectors in sixteenth-century Europe. Placed on a table to be seen from above, or turned about in the hands before being replaced in a treasure cupboard, they were enjoyed from many points of view, as one silhouette merged into the next. The connoisseur could appreciate fine craftsmanship while he took a scholar's pleasure in their references to classical antiquity.

Yale's *Hercules and the Lion* is an exceptionally fine example. At one time considered Italian, it is now believed to be the work of a German sculptor under influences from Italy and the Netherlands. In Mannerist tradition, the combat is antirealistic, transformed into a kind of elegant dance in which attitudes and gestures are decoratively coordinated. The heraldic pose of the lion is perfectly countered by the forward thrust of Hercules's left leg and the curve of his back. In addition to this fine rhythmic design, the group is a masterpiece of bronze casting and surface finish. Only two other versions of the Yale piece are known.

Hercules's combat with the Nemean lion was the first of the Twelve Labors imposed on him as punishment for the murder of his children during a fit of insanity sent by Juno. Since the lion's skin was impervious to weapons, Hercules strangled him and thereafter wore his skin (removed by means of a claw) as a protective covering, the attribute by which he may be recognized in art.

121. NORTH ITALIAN SCHOOL,
     EARLY 15th CENTURY

*Annunciation,* in two parts

Marble

*Madonna:* H. 22½ x W. 9½ in.

*Angel:* H. 23 x W. 7¾ in.

Gift of the Yale University
Art Gallery Associates

1933.62A-B

Small reliefs such as these were often made for the decoration of tombs: either the sarcophagus itself (or perhaps a representation rather than the actual burial casket) or the sculptural setting within which the sarcophagus was placed. Although related in subject, these two reliefs were probably separated by some larger relief, very likely a Madonna and Child, as happens so often in medieval or Early Renaissance panel paintings. They were probably placed at opposite corners of a composition, left and right; a twisted column, surmounted by a damaged Corinthianate capital, is carved slightly behind each figure. At one time called Florentine fourteenth-century work, they are now thought to have originated in northern Italy, not long after 1400. Reliefs of this kind were made in fairly large numbers, by sculptors conservative in style and of no more than average skill. Yale's reliefs hark back to Italian Gothic, with its heavy, non-French forms and suggestions of influence from antique sculpture; in this case there are echoes of the classical style in the features of Mary and in the curly, impressionistic hair of the angel.

## 122. ANDREA BRIOSCO (IL RICCIO)

Italian, 1470–1532

*Antaeus,* ca. 1500

Bronze

H. 11⅜ in.

Maitland F. Griggs, B.A. 1896, Fund

1958.72

Charles Seymour, Jr., attributes this figure to the Paduan sculptor Andrea Briosco (1470–1532), known as Il Riccio. He believes that it was modeled on the basis of an engraving by Giovanni Antonio da Brescia after the famous *Laocoön* unearthed in Rome in 1506. The subject has to do with one of the exploits of Hercules, who overcame the giant wrestler Antaeus, son of Poseidon and Gaea the Earth. Ordinary wrestling tactics were useless because every contact with his mother, Earth, renewed Antaeus's strength. Hercules defeated him by holding him in the air and crushing the breath out of him. The story, popular with fifteenth-century Renaissance painters and sculptors such as Pollaiuolo and Mantegna, as a means of demonstrating their knowledge of muscular tension and movement, may be seen here as a psychological interpretation of the inner struggle between man's higher self and his baser nature.

The missing figure of Hercules with which this Antaeus must once have belonged may have been a bronze of similar size, formerly in the German State Collections but believed to have been destroyed in World War II. The Antaeus never received its final finishing or chasing. Its skillfully handled pose suggests the free yet disciplined leap of a trained dancer. In Seymour's words, "The expression of strain is modified by a characteristically Renaissance concern for poise and balance."

Architect, sculptor, goldsmith, and medalist, Riccio was born and died in Padua, where he was trained by Bellano, a pupil of Donatello. He specialized in small bronzes such as Yale's *Antaeus* and did considerable work in Venice.

123. FRANÇOIS GIRARDON

French, 1628–1715

*Maquette for Equestrian Statue of·
Louis XIV,* 1687(?)

Wax

H. 30¼ in.

Gift of Mr. and Mrs. James W.
Fosburgh, B.A. 1933

1959.56

On August 13, 1699, a huge bronze equestrian statue of
King Louis XIV was erected in the Place Louis-le-Grand in
Paris. During the French Revolution it was torn down and
destroyed, and the area renamed the Place Vendôme.
Inspired by the ancient equestrian statue of the emperor
Marcus Aurelius on the Campidoglio in Rome, the
Sun King was represented in pseudo-Roman armor, riding
without stirrups, but wearing his towering baroque wig.
Arrogant, triumphant, he is the embodiment of absolute
monarchy.

All official art at this time was under royal supervision,
artistic authority being vested in the king's superintendent
of works, the painter Charles Le Brun. Working under
Le Brun's direction, Girardon submitted, on January 30,
1687, a *maquette* or small model of the equestrian statue
for the king's approval. Presumably in wax, this may well
have been the red wax *maquette,* now in Yale's collection,
which would thus be the earliest surviving version. A
number of small bronze versions, and one in bronzed
plaster, exist; the finished monument is known through
various old prints. The Yale *maquette* is more elaborately
detailed than are other examples; it has been suggested that
casting difficulties led to the adoption of a simpler form. On
the saddlecloth may be seen the interlacing Ls of Louis's
name, and the fleur-de-lys of France.

Girardon was born in Troyes and studied with the sculptor
Michel Anguier. Sent to Rome by Louis XIV, he returned
to Paris in 1652, entering the Academy five years later.
Le Brun's favorite sculptor, he provided statues and
fountains for Versailles, largely on Le Brun's designs, and
various monuments in Paris, notably the tomb of Cardinal
Richelieu in the church of the Sorbonne.

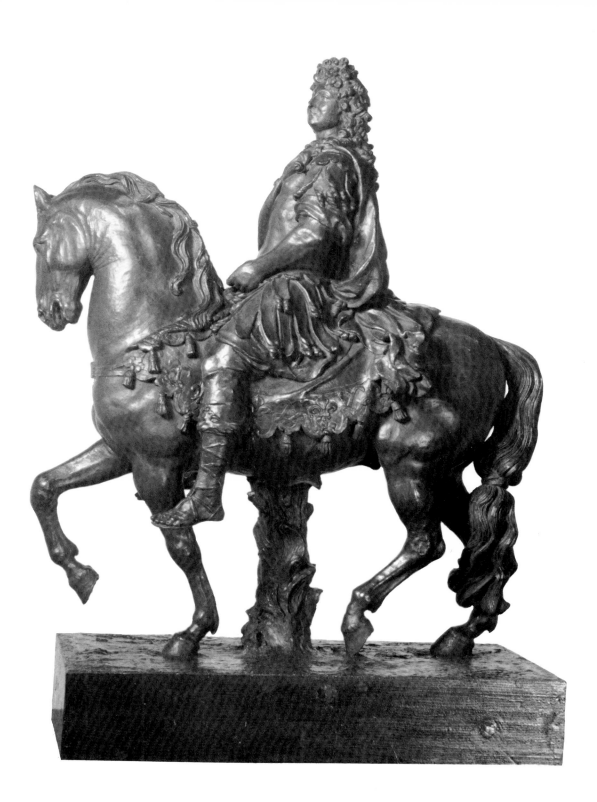

## 124. SPANISH, 17th CENTURY

*Christ, The Man of Sorrows*

Painted wood

H. 27½ in.

Stephen Carlton Clark,
B.A. 1903, Fund

1964.52

During the Counter-Reformation Spain was the leading defender of the Catholic church, and her sculptors, especially in the seventeenth century, were predominantly concerned with religious themes. In Italy the Baroque love of movement and drama was often combined with an intense realism which has always been a part of Spanish art as well, but the theatrical effects of Bernini's work, with its great sweeps of drapery and broad, passionate gestures, are often renounced by the Spanish sculptors in favor of an outwardly restrained, inwardly intense expression of feeling. This is the case with the *Man of Sorrows*. Although the position of the head, with its agonized features, is in the spirit of Baroque (and Counter-Reformation) emotionalism, it cannot be called forced or theatrical.

The medium, painted wood, was popular in Spain at this time when other European countries preferred stone or bronze. Here, the red of the "scarlet robe" mentioned in the Gospel According to St. Matthew is striking in contrast to the pallid skin and dark brown hair. Spanish realism and taste for grim detail are manifested in the streams of blood flowing from Christ's head and down his shoulders, and visible where the rope has chafed the wrists. The color was probably applied, according to custom, by an artist specializing in the polychroming of sculpture. The carving is crisp and strong; avoiding the sensational, the unknown sculptor has made a powerful statement both in form and in meaning.

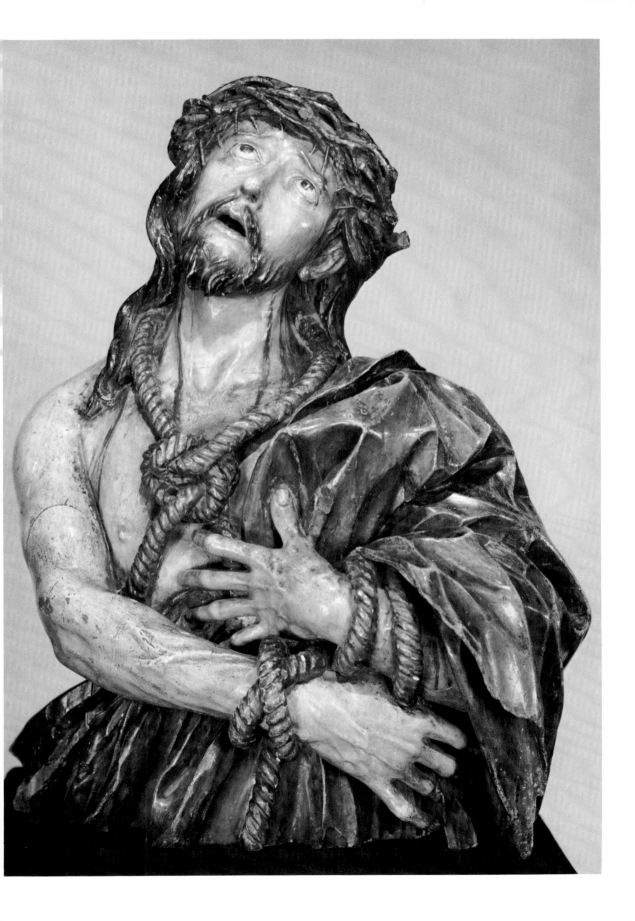

125. NICOLAS COUSTOU

French, 1658–1733

*Neptune,* 1701

Limestone

H. 29¾ x W. 41¼ in.

Director's Purchase Fund, Gift of Mrs. Frederick W. Hilles

1962.24

This type of figure, seated on the ground and accompanied by identifying objects (the dolphin and trident in this piece signify Neptune), derives from Hellenistic prototypes. It was especially popular in the seventeenth and eighteenth centuries, when it was made in all media from monumental stone to gilded bronze and porcelain. With changed accessories, it might represent a river god, a continent, or one of the four seasons. Coustou's *Neptune,* carved from porous gray stone, conforms to the type as imposed by Louis XIV's art dictators; all such official sculpture has a certain sameness. But this figure has an easy grace of pose and crispness of carving that give it distinction. It is a clear statement of Baroque form and movement in space, expressed as much through effects of light and shadow as by anatomical accuracy and animated line. Enlarged, it would serve handsomely on a fountain or public monument.

Nicolas Coustou came of a distinguished family of sculptors; he was the son of a woodworker who had married the sister of Antoine Coysevox, one of Louis XIV's most important sculptors. A brother of Nicolas, Guillaume, had a son, Guillaume II; all of them contributed to the grandiose programs at Versailles and elsewhere. Born in Lyon, Nicolas studied under his uncle in Paris, won the Prix de Rome in 1682, and went to Italy a year later. He was admitted to the Academy in 1693. In addition to work for Versailles, he supplied sculpture for the château at Marly and for the Invalides.

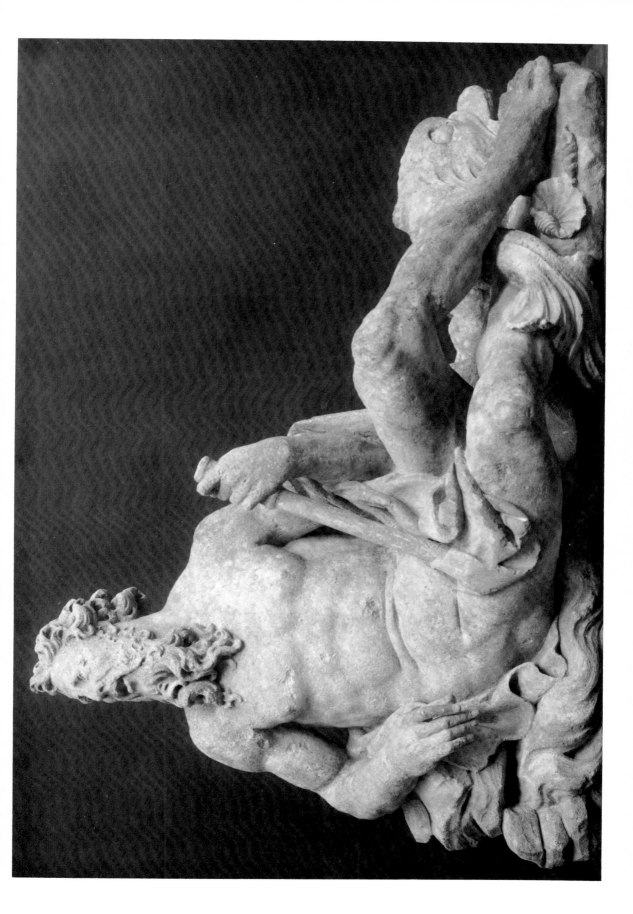

126. LOUIS (CLAUDE MICHEL) CLODION

French, 1738–1814

*Nymphs and Satyrs Playing,* ca. 1765

Wax relief

H. 7 x W. 15¾ in.

Maitland F. Griggs, B.A. 1896, Fund

1967.37

This frolic involves only one genuine satyr complete with horns and goat's feet; he lies on the ground at the right. Three human youths share the game with four nymphs; a fifth nymph lies asleep with an empty wine cup in her hand. One at the far right carries a thyrsus, the pinecone-tipped rod associated with the worshippers of Bacchus; the same motif occurs on the term at the left, crowned by the bust of a satyr.

Modeled in wax, the relief is worked up from a black ground through varying tones of silver gray, to cream where the relief is highest. The craftsmanship is incredibly delicate, especially in the details of lips, noses, curly hair, fingers, and toes. The lightness and frivolity are completely rococo in taste, but there is also a suggestion of influence from the recently uncovered wall paintings of Pompeii, which were just beginning to be known when Clodion was in Rome, and which were to inspire the ceramics of Josiah Wedgwood.

Clodion was born in Nancy, that gem of a rococo city. Both sides of his family produced sculptors. He studied in Rome from 1762 to 1771. Later, with the help of his brothers, he organized a firm for the production of small sculptures and decorative objects such as vases, candelabra, and clocks. These were bought chiefly by amateur collectors in Paris. Personally no paragon of virtue, Clodion, like many a rococo artist, could be naughty as well as charming in his work, which certainly heightened its popularity.

127. JEAN ANTOINE HOUDON

French, 1741–1828

*D'Alembert (Jean le Rond),*
dated 1779

Marble

H. 16 x W. 9¼ in. (without base)

Gift of McA. Donald Ryan,
B.A. 1934, and William A. Ryan,
Ph.B. 1921

1957.47.1

Jean le Rond, known as d'Alembert, friend of Diderot and successor to Voltaire as leader of the *philosophes,* posed for this portrait in or shortly before 1779, the date carved on the bust. Since the style is related to later work by Houdon, it has been suggested that the date may actually be that of the preliminary terra cotta which the sculptor usually made before carving or casting the finished piece. Such a terra cotta, representing d'Alembert, is known to have been sold by Houdon in 1795; this may well have been used for the marble version, in which case the latter must have been finished before the sale of the terra cotta, perhaps in 1794. The marble is handled with consummate delicacy, and the sitter's personality brilliantly caught. Like an ancient Roman of the republican period, d'Alembert is shown undraped, without his eighteenth-century wig. Many of Houdon's portraits have been preserved in more than one copy or version, but this is the only one of d'Alembert known to exist, although both plaster and terra-cotta studies are recorded.

D'Alembert was a French social philosopher, mathematician, and theoretical physicist, of high standing in the Académie Française and the Académie Royale des Sciences. He wrote the *Discours préliminaire* of Diderot's *Dictionnaire encyclopédique.* Rather cold and shy, he was characterized by Madame du Deffand as having a "heart entirely dried out by philosophy" and an "unripened wit," an opinion which Houdon's portrait will at least challenge if not deny. Charles Seymour, Jr., has called him "a combination of an urban Natural Man, Voltaire's Candide, and a latter-day Stoic."

The son of a domestic servant, Houdon won the Prix de Rome in 1768. Although he produced occasional mythological subjects, his chief greatness lies in his unsurpassed portraits, notably those of George Washington, Benjamin Franklin, and John Paul Jones among the Americans, and the great seated statue of Voltaire in the Comédie-Française in Paris.

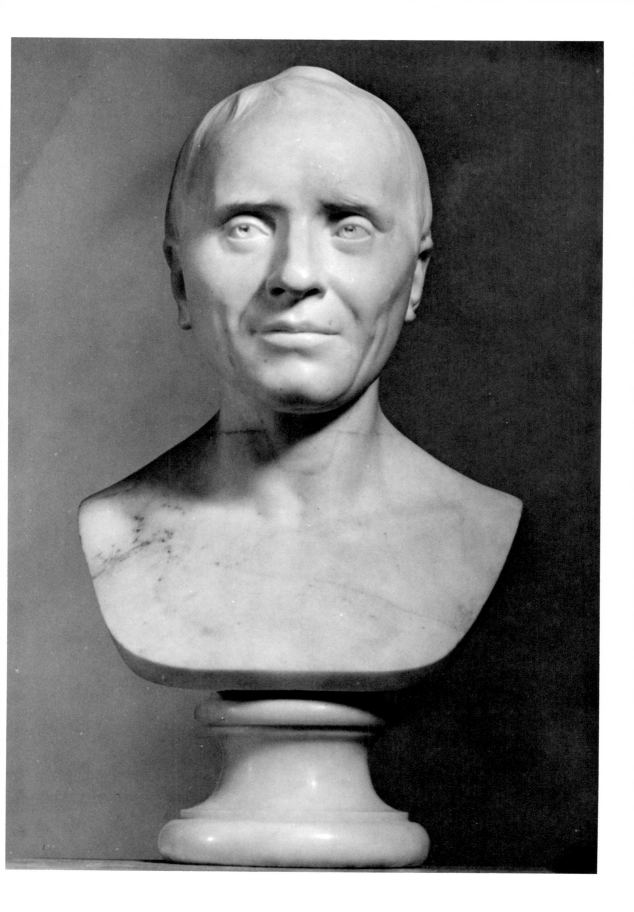

## 128. BAVARIAN (?) OR TYROLEAN, EARLY 18th CENTURY

*Religious or Mythological Figure*

Wood painted over gesso ground

H. 68½ in.

Maitland F. Griggs, B.A. 1896, Fund

1961.28

This energetic, wind-blown figure is characteristic of late Baroque taste under strong Italian influence stemming from Bernini. By the addition of a single attribute, which he may originally have carried, he could be identified as Poseidon (under which name he came to Yale) or some other god of antiquity; he has also been called a prophet (which is unlikely, though a reed cross and scroll would make him John the Baptist). He might even have been Winter in a series of the Four Seasons. He certainly belonged to a decorative architectural setting such as was provided for him and other Baroque sculptures in the St. John's Wood flat which housed the collection of Mr. Francis Stoner in London ("early-curly to late straight," i.e. 1600–1800, according to Mr. Stoner). He might have fitted into a religious ensemble; translated into stone, he would have graced the formal gardens of a nobleman's château.

Painted wood was a popular medium in Germany and other northern European countries, particularly in Bavaria and the Tyrol; the tradition goes back to medieval times. Here, the richly animated forms and sweeping movement of the drapery with its strong modeling in light and shadow, create an effect more joyous and festive than tensely dramatic—as though rococo chamber music were replacing the Baroque oratorio. But the Baroque formal idiom is still operating, and it is not surprising that the Yale figure has actually been thought Italian: Genoese perhaps, related to the sculptor Antonio Maria Maragliano. Whatever his original name and message, this speaker's eloquence and enthusiasm must be undisputed.

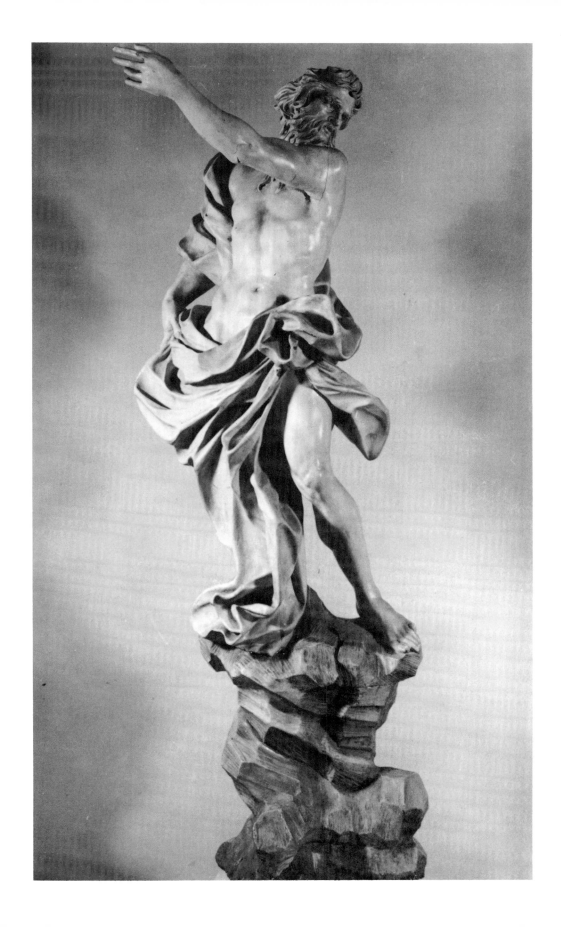

129. SAMUEL FINLEY BREESE MORSE

American, 1791–1872

*The Dying Hercules*

Cast of preparatory sculpture for painting

H. 20 x W. 9 x L. 22½ in.

Gift of the Rev. E. Goodrich Smith, B.A. 1822

1866.4

According to Greek mythology, the centaur Nessus was slain by Hercules when he tried to carry off the hero's wife Deianira (the scene is depicted in the Gallery's painting by Pollaiuolo, No. 11). The dying Nessus gave Deianira a garment soaked in his poisoned blood, saying that it would restore her husband's love if he should prove unfaithful. But when Hercules put it on, he suffered such agony that he built a funeral pyre and died in the flames.

This plaster cast is the only survivor of several which were taken from the original plaster sculpture (now lost) made by Morse in preparation for his huge oil painting, *The Dying Hercules,* now in the Yale Art Gallery. Both the sculpture and the painting were exhibited in 1813 in London, where the sculpture won the gold medal of the Society of Arts. Morse presented Yale's plaster cast to Charles Bulfinch, the architect of the Capitol in Washington, D.C.; he gave it to the Rev. E. Goodrich Smith, who presented it to Yale.

Modern opinion finds Morse's portraits far more distinguished than his studies of the antique. But like many of his contemporaries, Morse believed that the noblest themes for the artist were to be found in classical mythology, history, and religion, with portraits ranking well below these. We may find the oil *Dying Hercules* empty and pretentious; however, the plaster study, influenced by the Laocoön, is powerfully handled, suggesting some use of a living model.

A man of widely varied interests, Morse is probably best known for his experiments leading to the invention of the electric telegraph. But his primary enthusiasm was for painting, which he studied with Washington Allston, in Benjamin West's London studio (see No. 58).

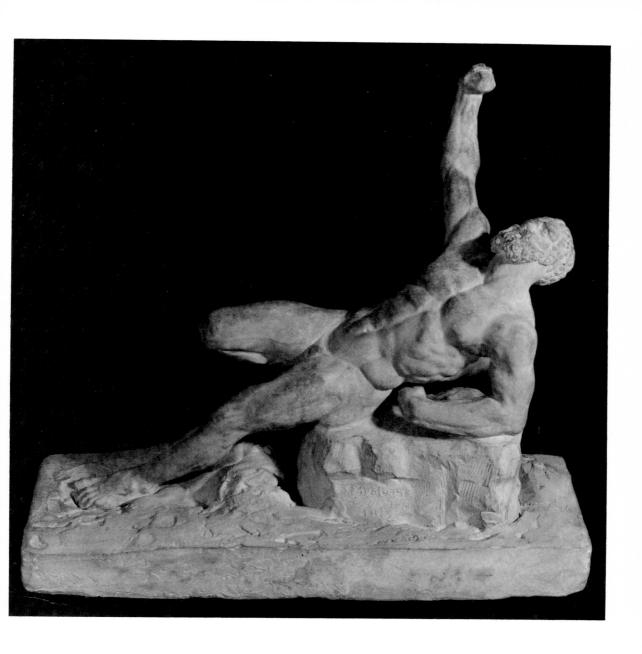

130. HIRAM POWERS

American, 1805–1873

*The Greek Slave,* ca. 1847

Marble

H. 90 in. (including pedestal)

University purchase,
Olive Louise Dann Fund

1962.43

"So undressed, yet so refined"—such was Henry James's comment on *The Greek Slave.* Even Queen Victoria approved of it when she saw it at the Crystal Palace in London. Inspired by the Greek war of independence against Turkey, the statue belongs stylistically to the Neoclassic movement that dominated academic circles in the early nineteenth century. Powers derived the pose of the figure from the celebrated Medici Venus; the smooth surface of the marble and its melting contours were the accepted forms for embodying ancient Greek ideals of perfection. But the fringed garment draped over the column, based on contemporary Greek costume, and the chain with a cross indicating the owner's Christian faith, are carved with the realistic detail dear to Victorian taste.

Powers's first version of the subject proved so popular that five replicas were commissioned. The one now owned by Yale was originally ordered by Prince Demidoff for his Italian villa, San Donato; it was subsequently bought by the American millionaire A. T. Stewart, to grace his one-hundred-room Fifth Avenue mansion in the 1870s.

Powers was born near Woodstock, Vermont. He worked for a time in a clock and organ factory in Cincinnati, then spent three years in Washington, D.C., carving portrait busts. In 1837 he sailed for Italy, working in Florence until his death.

*The Greek Slave* inspired many a poetic tribute, among them a sonnet by Elizabeth Barrett Browning, who saw the statue as a plea for the abolition of slavery:

Appeal, fair stone,
From God's pure height of beauty, against man's wrong;
Catch up in thy divine face not alone
East grief but West, and strike and shame the strong,
By thunders of white silence overthrown.

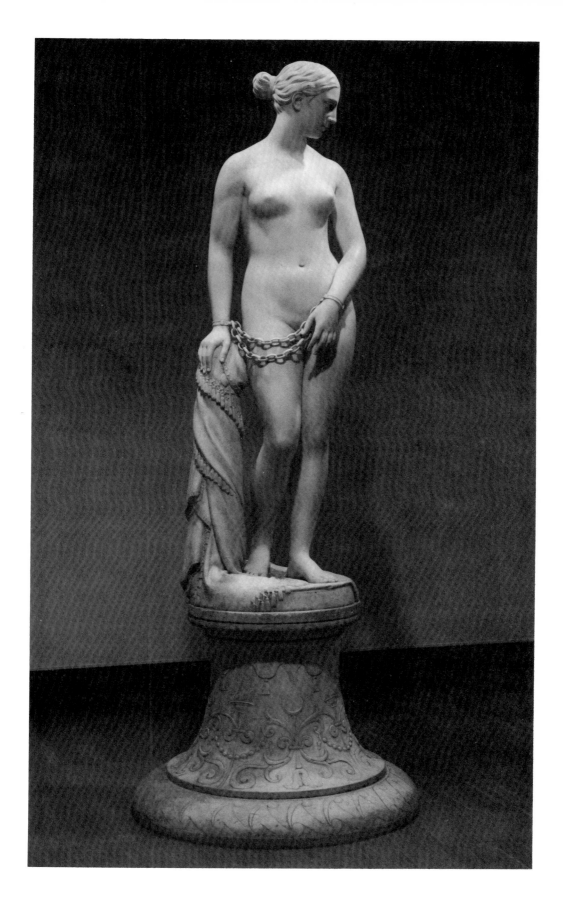

131. WILLIAM RIMMER

American, 1816–1879

*Dying Centaur,* 1871

Plaster

H. 22 x W. 27 in.

John Hill Morgan, B.A. 1893;
Leonard C. Hanna, Jr., B.A. 1913;
Stephen Carlton Clark, B.A. 1903;
and Mabel Brady Garvan Funds

1968.38

Almost entirely self-taught, both as artist and as physician (he was finally licensed in 1855 after ten years of practice), Rimmer was a pioneer among American sculptors in the study of the nude. He caused dismay in Boston and New York by insisting that students in his anatomy classes, including women, should work from nude models. "He loved to design [the human body] at the point of collapse or the peak of extreme tension," wrote Lincoln Kirstein. Of the *Dying Centaur* he said, "[It] shows his physical ache, the wrench of the cerebral against the muscular animal.... Rimmer knocked hands from arms, partly perhaps to suggest a kinship with ruined and romantic antiquity, but in the *Centaur* at least, to heighten its strain and pathos, to intensify the agonized, unattainable grasping and unresolved struggle in the dual nature of man." The complex pose is brilliantly handled; Oliver Larkin has commented that it tells "its full story only when experienced from all sides."

Rimmer was born in Liverpool, the son of a father who believed himself to be the exiled son of Louis XVI and Marie Antoinette. Migrating to America, the family settled in Boston. Although well-educated by his father, Rimmer found it necessary to help support his own wife and children by working as a cobbler, but sculpture and painting were his consuming interests. For a time he lived in Quincy, Massachusetts, where he treated the workers in the local granite quarries and wrenched sculptural forms from the granite itself. He was a brilliant teacher, specializing in artistic anatomy, which he taught to John La Farge, William Morris Hunt, and Daniel Chester French. From 1866 to 1870 he was director of the School of Design for Women at Cooper Union in New York. Many of his superb anatomical drawings were published during his lifetime, but his plaster sculptures were not cast in bronze until some twenty-five years after his death. A number of his paintings, many drawings, and a few lithographs and etchings have survived.

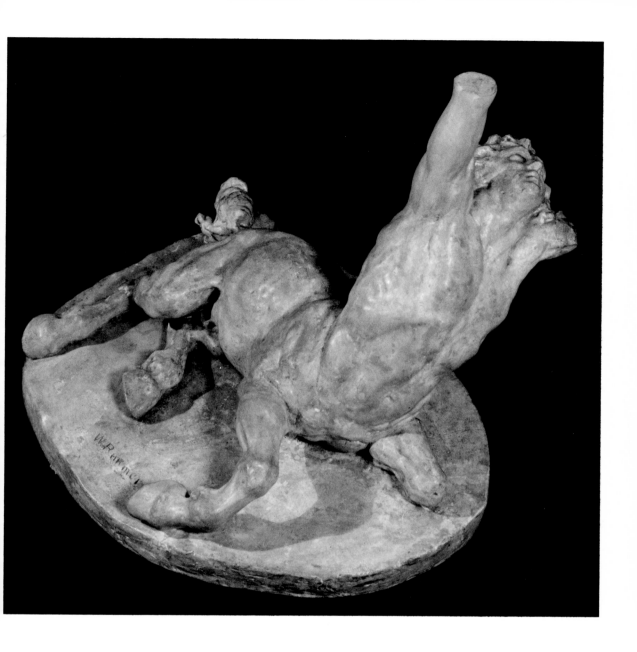

## 132. FRENCH, LATE 19th OR EARLY 20th CENTURY

*Female Figures,* ca. 1900

Wood (beech?)

H. 63 in. (with base, H. 89 in.)

Leonard C. Hanna, Jr., B.A. 1913, Fund

1964.13.1–2

These two figures originally served as *torchères* (candelabra) in a private house in Paris at the turn of the last century. They are delightful examples of the style known as Art Nouveau which enjoyed popularity throughout Europe, ca. 1890–1910; it was known in Germany as Jugendstil, in Vienna as Sezessionstil, and as Modernista in Spain. Although it affected all branches of art, it began in the field of interior design and the decorative arts, growing out of the English Arts and Crafts Movement of the 1880s inspired by John Ruskin and William Morris. Aiming to break free from historical and eclectic styles, it drew its forms from plant life and other natural forms, translating these into a system of flowing lines that curved broadly or moved in delicate spirals like the tendrils of a vine. The style is especially charming when applied to book design, jewelry, and other craftsmanly objects; it produced graceful, imaginative furniture, to which Yale's *Female Figures* are related.

Although each figure assumes the classic pose of an ancient Greek caryatid, the proportions and the clinging drapery have a French slenderness and elegance descending from the courtly Renaissance tradition of Jean Goujon and later, Clodion and Falconet. But instead of the playful artificialities of the rococo, there is a kind of suavity, almost languor, combined with the appealing naturalism of the faces. Minor differences of detail give sparkle and individuality to each figure. The carving of the pedestals has the slow curves of poured honey.

Large-scale Art Nouveau figures, especially in wood, are extremely rare. Although the style of these has been linked with such names as Jules Dalou, Pierre Roche, and Antonin Mercié, no definite attribution has been made.

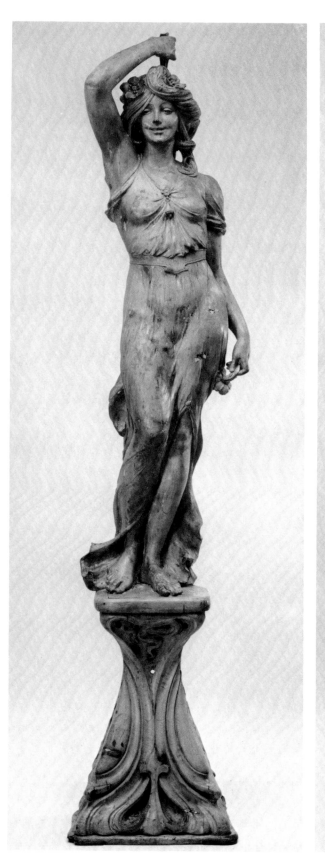
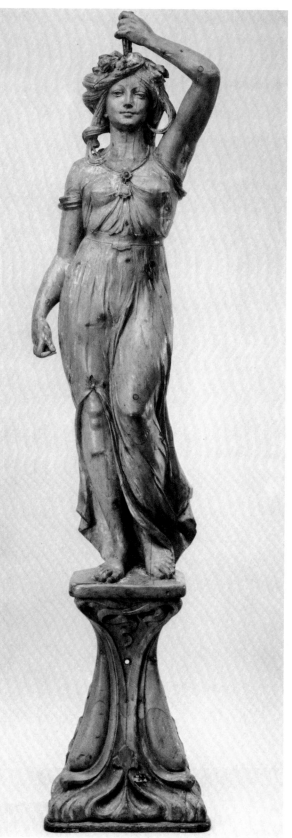

133. NAUM GABO

American (b. Russia), 1890–

*Construction in Space with Balance on Two Points*, 1925

Plastic, glass, metal, and wood

H. 26½ x D. 40 in.

Gift of H. Wade White

1956.23.1

"The realization of our perceptions of the world in forms of space and time is the only aim of our pictorial and plastic art.... The plumb-line in our hand, eyes as precise as a ruler, in a spirit as taut as a compass ... we construct our work as the universe constructs its own, as the engineer constructs his bridge, as the mathematician his formula of the orbits." So wrote Gabo in the *Realist Manifesto* he published in 1920 with his brother Antoine Pevsner, thus stating the fundamental principle of their art. Space was defined as "continuous depth"; line in sculpture, they said, is not meant "to delimit the boundaries of things but to show the trends of hidden rhythms and forces in them." Gabo's purely abstract forms, often constructed in transparent materials such as glass and plastic, beautifully achieve his own ideal of "a new kind of classicism, free in conception but disciplined in application." The old artistic principles of balance, order, stability, and movement in terms of figures or material objects now assert their own beauty without descriptive associations. Long before our present-day exploration of interplanetary space, Gabo was constructing an art prophetic of a space age.

Naum Gabo (actually, Naum Gabo Neemia Pevsner) was a brother of the artists Antoine and Alexei Pevsner. Born in Briansk, Russia, he studied medicine in Munich in 1910 but turned soon thereafter to natural science and engineering; he also attended Heinrich Wölfflin's lectures in art history. In 1914, at the beginning of World War I, he went to Denmark, Sweden, and Norway, where he began using the name Gabo in identifying his first constructions. He returned to Russia in 1917 and met Kandinsky, Malevich, and Tatlin. Three years later his *Realist Manifesto* was published in Moscow. In 1922 he went to Berlin, and then to Paris and London; in 1938 he first visited the United States, becoming an American citizen in 1952. In England in 1937–46, he came back once more to the United States and now lives in Middlebury, Connecticut. In 1927 he worked for Diaghilev on ballet sets and costumes, and he has designed several large monuments in connection with industrial architecture and public buildings. The movement in space implied by his sculptures has sometimes been made actual by the use of motors which turn them on their bases.

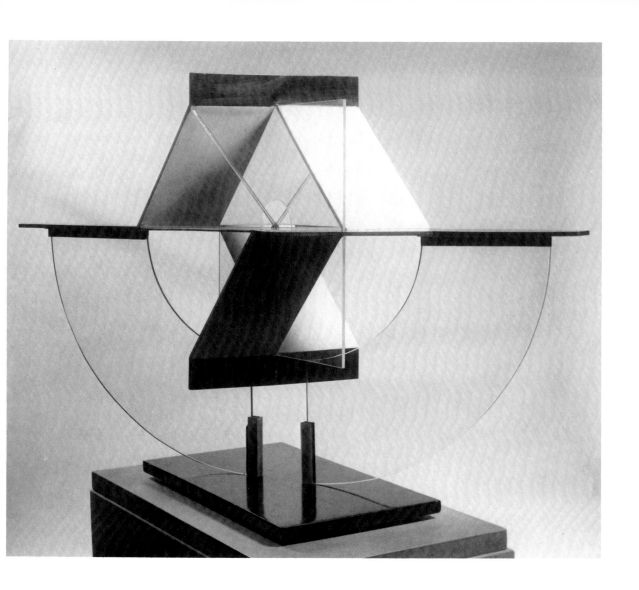

134. ALEXANDER CALDER

American, 1898–

*Fourth Flurry,* 1948

Mobile: sheet metal and wire

$68\frac{1}{2}$ x 86 in. (maximum sweep)

Gift of Katherine S. Dreier for the
Collection of the Société Anonyme

1948.298

Marcel Duchamp, who is said to have invented the term "mobile," once described Calder's constructions in Plato's words: "They carry a pleasure peculiar to themselves." *Fourth Flurry* obviously suggests the floating dip and swirl of falling snowflakes; but whether or not one recognizes a parallel with natural forms and their movements, one instinctively responds to and enjoys the qualities of balance, rhythm, and endlessly changing patterns. The shadows cast on the adjacent wall provide an additional source of pleasure. To quote Duchamp again, Calder's mobiles give delight through their "unpredictable arabesques" and their "element of lasting surprise." The sculptor's technical skill is equalled by his inexhaustible imagination.

Calder's facility with metal construction grew out of his early engineering training. He was born in Philadelphia; both his father and his grandfather were sculptors. He began by studying painting, and then made sculptures in wood. In 1926 he devised his famous wire-figure *Circus,* and made numerous children's toys also in wire; later he used the same material for the creation of brilliant, witty portraits and small figures. In addition to his mobiles, begun in 1931, and his stationary sheet metal constructions known as stabiles, he has produced abstract paintings, stage designs, and book illustrations. With great economy of means he has achieved an astonishing repertory of expression, ranging from the playful and occasionally naughty, on a small scale (he greatly admires Miró), to the stirring and even majestic in some of his large mobiles and stabiles. His use of primary colors and black and white reflects the influence of Mondrian. He lives in Roxbury, Connecticut, but spends much time in France.

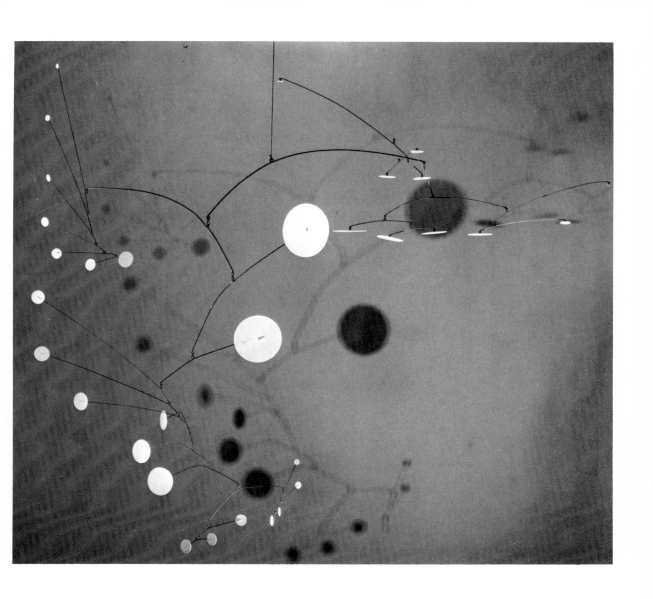

135. SEYMOUR LIPTON

American, 1903–

*Sentinel,* 1959

Nickel silver on Monel metal

H. 89¾ in.

Leonard C. Hanna, Jr., B.A. 1913, Fund

1959.49

Of *Sentinel* the sculptor has written: "When I make a work I become involved in a sculptural or plastic reality through a language of forms peculiar to my own needs. I always hope to invent a formal configuration that is validated by a felt experience of my own life related to the world. Some inner bell has to ring for me to know that everything is O.K. In this case when the work was finished the sense of a powerful guardian figure (which was an aspect of a 'hero' involvement) suggested the name 'Sentinel.' The 'name' I usually look for is suggested by the central presence of the work as I feel it within me; both to serve my own sense of identification and to help analyze attention of the viewer into this central vortex of experience."

Lipton was born in New York, where he still lives. A self-taught sculptor, with a degree in dentistry from Columbia University, he first made portrait heads in clay and marble, and then began carving, often in wood, small figures and groups expressing his sympathies with the social conditions of the Depression years and the Spanish civil war. Gradually his work, now usually in metal, grew more abstract, the human figure giving way to animal and plant forms expressing pain, struggle, growth, and destruction. By the 1950s these savage forms had evolved into a quieter language no less intense but no longer so anguished and aggressive—constructions which, like *Sentinel,* are symbols of dignity and power. In Albert Elsen's words, "*Sentinel* is Lipton's 'character' [in the sense of Chinese calligraphy which the sculptor admires] for the awesome mystery of inner life, its alternation between calm and wildness contained as he terms it 'within an emotional coat of arms.' "

The technique used in *Sentinel,* nickel silver brazed on Monel metal, goes back to Lipton's experiments with steel in the 1940s; it involves the melting of nickel silver rods over the surface of cutout and soldered metal sheets, using an oxyacetylene torch. Lipton has taught at the New School for Social Research and Cooper Union in New York, and at New Jersey State Teachers College in Newark. In 1957–59 he was visiting critic at the Yale Art School. Among his commissions for architectural sculpture are those for Eero Saarinen's IBM Watson Research Center at Yorktown Heights, New York, and *Archangel,* for Max Abramowitz's Philharmonic Hall, Lincoln Center, New York.

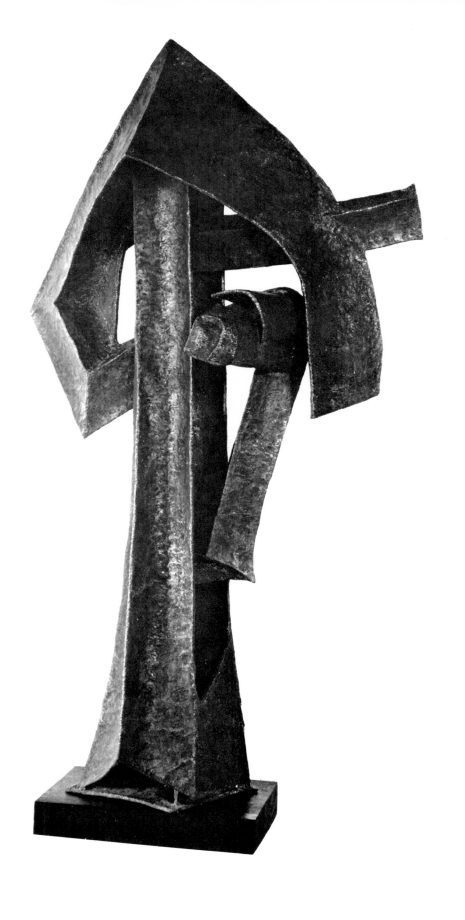

136. ISAMU NOGUCHI

American, 1904–

*Metamorphosis,* 1946

White Italian marble

H. 68½ in.

Henry John Heinz II, B.A. 1931, Fund

1968.48

"It seems to me that the natural mediums of wood and stone, alive before man was, have the greater capacity to comfort us with the reality of our being. They are as familiar as the earth, a matter of sensibility. . . . Sculpture is the definition of form in space, visible to the mobile spectator as participant."

These words of Noguchi express both his deep respect for the medium and his point of view with regard to its use in sculpture. *Metamorphosis* belongs to the period in the 1940s when, in New York, he worked with thin slabs of marble commercially cut for the facing of buildings, and relatively inexpensive. They proved to be perfectly suited to express his interest in problems of abstract form, balance, and space. Beauty of surface enhances the poised, inter-locking shapes, at once animated and stable and perhaps suggesting certain fantastic constructions in the later paintings of Yves Tanguy, though without the latter's surreal overtones.

The son of a Japanese father and a Scottish-Irish mother, Noguchi was born in Los Angeles but spent his boyhood in Japan. After some schooling in Indiana, he studied sculpture with Gutzon Borglum in Stamford, Connecticut, and with Onorio Ruotolo in New York. In 1926 an exhibition of Brancusi's sculpture aroused his enthusiasm, and in the following years a Guggenheim Fellowship took him to Paris, where he worked in Brancusi's studio. Returning to New York in 1929, he supported himself by making portrait heads of his friends, among them Martha Graham for whom he later designed sets. He returned to Japan in 1930–31 and has since made many trips there; he was especially stimulated by Japanese ceramics. He has designed furniture and a number of gardens conceived in terms of Oriental philosophy, notably those for UNESCO in New York (1958) and the Beinecke Rare Book and Manuscript Library of Yale University (1964).

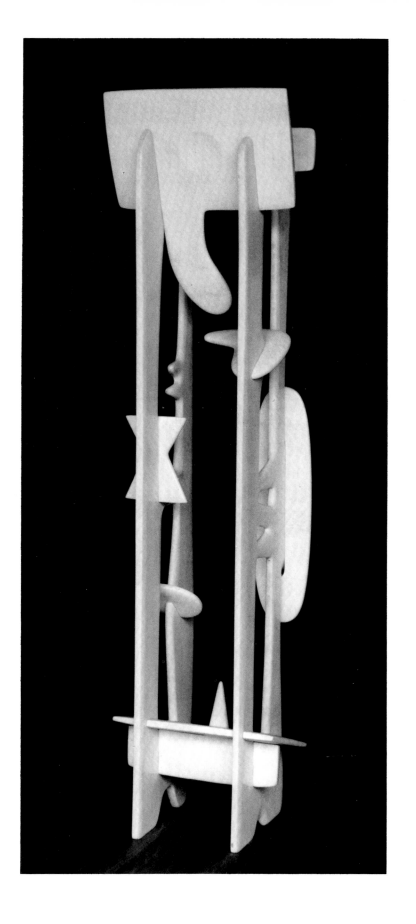

137. DAVID SMITH

American, 1906–1965

*Man and Woman in a Cathedral,*
1956

Welded steel

H. 85⅜ in.

Gift of Mrs. Frederick W. Hilles

1957.39.1

According to the sculptor, this piece was not named until after its completion; he designed it, he said, on the basis of formal relationships, without verbal identification. Like many of his works, it is unique; there are no preliminary drawings and no duplications. One may, perhaps, in view of the title, see excitement and wonder in the two jagged "figures" linked together structurally and emotionally; the tall verticals could be read as symbolizing aspiration, or literally as "exaltation" in response to an awesome environment or experience. But although he had strong opinions on human values and behavior (he was an effective teacher, speaker, and writer) Smith the sculptor was primarily concerned with form rather than with illustrative content or meaning.

Described by Frank O'Hara as "a great, hulking, plain-spoken art-worker out of Whitman or Dreiser," Smith had his first taste of metalworking at the age of nineteen, in an automobile plant in South Bend, Indiana. He began his artistic career as a painter, studying in Ohio, Washington, D.C., and with John Sloan and Jan Matulka at the Art Students League in New York. In 1929 he bought an old farm in Bolton Landing, New York, which became his permanent home. Various trips abroad, and friendships with such painters as Stuart Davis, Arshile Gorky, and Willem de Kooning, stirred his interest in abstract, surrealist, expressionist, and constructivist art. He admired the sculpture of Picasso and Julio Gonzalez, under whose influence he made his first welded steel compositions in 1932. Cubism also helped to direct his vision and thinking. His final phase, cut short by his death in an automobile accident, is seen in his CUBI series, of which Yale's fine example, *CUBI XXII,* stands in the Gallery courtyard (see No. 138).

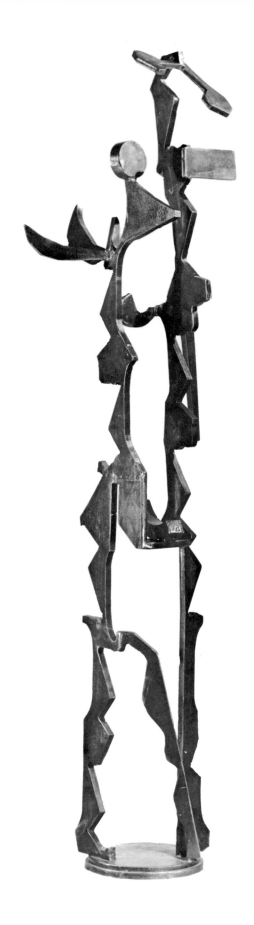

138. DAVID SMITH

American, 1906–1965

*CUBI XXII*, 1964

Stainless steel

H. 103¾ x W. 77¼ in.

Stephen Carlton Clark, B.A. 1903, Fund

1968.31

David Smith's CUBI series, begun in 1963 and still under development at the time of his death, was his final statement in sculpture. Frank O'Hara has described it as follows: "The CUBI series presents the stainless steel volumes balancing one on another, signalling like semaphores, climbing into the air with the seeming effortlessness and spontaneity of a masterful drawing, while retaining the sobriety of their daring defiance of gravity." *CUBI XXII* is composed of rectangular volumes placed vertically and horizontally; others in the series make use of diagonals. Surfaces are enriched by burnishing, which the sculptor always insisted on doing himself. Abstract though they are, they embody qualities of human feeling which are never absent from David Smith's sculpture, varied though his work has been; one cannot escape their innate dignity and power.

To the critic Thomas B. Hess the sculptor once said, "You know who I am and what I stand for. I have no allegiance, but I stand, and I know what challenge is, and I challenge everything and everybody. And I think that is what every artist has to do. The minute you show a work, you challenge every other artist.... We're challenging the world ... I'm going to work to the best of my ability to the day I die, challenging what's given to me."

In February 1965, Smith was appointed by President Lyndon B. Johnson to the National Council on the Arts. Three months later he met his tragic death.

139. HERBERT FERBER

American, 1906–

*Calligraph Gee III,* 1964

Copper

H. 105 x W. 74 x D. ca. 24 in.

Gift of the artist

1969.84

Ferber has long been interested in freeing sculpture from dependence on the traditional base or pedestal, aiming at integrating it closely with its environmental space. His "Calligraph" series of metal sculptures, completely as they relate to space, at the same time suggest an analogy with letters or characters written on a two-dimensional surface, free of all implications of measure and distance. Like Seymour Lipton and others, Ferber is interested in oriental calligraphy, and his curving metal forms drive and swing through space as an ink-filled brush sweeps over silk or paper, leaving an image to be enjoyed as sheer form, needing no verbal translation. He has developed a powerful symbolic language in which to express and communicate his response to personal and universal experience.

Ferber (Herbert Ferber Silver) was born in New York City, where he still lives. He received a B.S. degree from Columbia University in 1927, and in 1930 a D.D.S. from the College of Oral and Dental Surgery (he still practices dentistry.) During this time he studied sculpture at the Beaux-Arts Institute of Design, which taught only architectural sculpture. He was deeply impressed by African sculpture and by the work of Maillol, Barlach, and Zorach. A visit to Mexico in 1935 aroused his enthusiasm for Pre-Columbian art. In 1938 he went to Europe, where he admired French Romanesque sculpture. A period in the 1940s when he was influenced by Henry Moore gave place to an interest in abstract expressionism. In 1949 he began using the blowtorch for soldering metal. Among his architectural sculptures are ... *And the Bush was not Consumed,* for the B'nai Israel Synagogue in Milburn, New Jersey (1952), and commissions for Brandeis University in Waltham, Massachusetts, and the Temple of Aaron, St. Paul, Minnesota.

140. GEORGE RICKEY

American, 1907–

*Two Planes, Vertical-Horizontal II,*
1970

Stainless steel

H. $14\frac{1}{2}$ x W. $10\frac{1}{2}$ ft.

Gift of Mr. and Mrs. Richard Shields,
B.A. 1929

1970.45

Since 1950 George Rickey has been a pioneer in the exploration of kinetic sculpture, designing abstract forms in metal which are set in motion by everchanging air currents or, like pendulums, through kinetic powers inherent in their own weight and balance. In the sculptor's words, "All the environment is moving, at some pace or other, in some direction or other under laws which are equally a manifestation of nature and a subject for art." His sculptures may suggest natural forms such as tall grasses or trees, or, like Yale's example, they may be purely geometric shapes. In either case the shifting patterns of metal, enhanced by the play of light and shadow over textured surfaces, provide a source of rhythmic delight. Again in Rickey's words, "The artist finds waiting for him, as subject, not the trees, not the flowers, not the landscape, but the waving of branches and the trembling of stems, the piling up or scudding of clouds, the rising and setting and waxing of heavenly bodies; the creeping of spilled water on the floor; the repertory of the sea . . . manifestations in nature of the very quality that painting and sculpture have hitherto left out." It is fascinating to watch these steel rectangles, like majestic acrobats in slow motion, swing, hesitate, recover, or plunge forward as they are moved in a perpetually changing choreography, by the joint forces of the breeze and of their own response to the laws of gravity.

Rickey was born in South Bend, Indiana, and was educated in England, Scotland, France, and the United States. He has exhibited widely and has won major awards, including a Guggenheim Fellowship. Since 1950 he has concentrated on sculpture, and has taught in several universities. He is the author of a number of books and articles, chiefly in the field of Constructivist art. He lives and works in East Chatham, New York.

141. JAMES ROSATI

American, 1912–

*Dialogue,* 1964–69

Painted Cor-ten steel

H. 7 ft. 10 in. x W. 11 ft. 5 in. x
L. 16 ft. 5 in.

Seymour H. Knox, B.A. 1920, Fund

1969.119

*Dialogue* comprises two separate sections which interact through tilting planes and diagonals whose dynamic thrust and balance imply intercommunication in spite of their abstract forms. Rosati has always felt the importance of a human element in his work, even after he abandoned the suggestion of human figures in his early sculpture for the purely abstract style developed in the 1960s. In his words, "No matter how abstract the form might be, the presence of man is still there." In contrast to the sculptures of David Smith and George Rickey, to be seen elsewhere in the Yale Gallery courtyard, Rosati's work avoids verticals, horizontals, and rectangles; no two lines or planes are parallel. "Like natural crystals," comments William C. Seitz, "these volumes suggest Euclidean forms, but their unique configuration cannot be absorbed by conceptual archetypes and they exist, therefore, only in immediate perception." Again unlike Smith and Rickey, Rosati avoids surface textures, giving his metal surfaces a flat painted finish on which light and shadow create constant changes— "chiaroscuro *happening*," as the sculptor himself has said. He conceives his sculptures as part of an outdoor environment, on a large scale relating to architecture. In its vivid expression of measure and movement one may sense his continuing love of music. One should walk around *Dialogue,* seeing it from every angle, and also observe it from a window in one of the Gallery's upper floors, in order to appreciate to the fullest its richness of form and expression.

Born in Washington, Pennsylvania, and at first a painter, Rosati began concentrating on sculpture in 1943 in Pittsburgh, where he had played the violin in the Pittsburgh String Symphony. He moved to New York in 1944, where he came in contact with Willem de Kooning, Franz Kline, Ibram Lassaw, Reuben Nakian, and others. He especially admires Cézanne, Matisse, Rodin, Maillol, Mondrian, and Brancusi. He has taught at the Newark School of Fine and Industrial Art, Pratt Institute in Brooklyn, Cooper Union in New York, and was visiting critic at Yale in 1960–62 and at Dartmouth in 1963. His work has been exhibited widely in Europe as well as in the United States, and his many awards include a Guggenheim Fellowship in 1964. In that year he became associate professor of sculpture at Yale, and he is now professor-adjunct in the Yale School of Art and Architecture. A one-man show of his work was presented at Yale in the spring of 1970.

142. DIMITRI HADZI

American, 1921–

*Floating Helmets,* 1965

Bronze

H. 11 ft. 4 in.

Leonard C. Hanna, Jr., B.A. 1913, Fund

1965.53

In a letter to Andrew Ritchie, Hadzi has commented on his *Floating Helmets* as follows:

"This sculpture is one of a numerous series based on the Helmet motif. Like another group of my sculptures . . . devoted to the Shield motif, the Helmets originated during the winter of 1957–58, when I spent several months preparing studies and models for an international competition for a memorial at the concentration camp at Auschwitz, Poland. This was a turning point in my development as an artist, in which I dropped the mythological and other themes that had previously held my attention, and took up the war motifs that have predominated in my work ever since. . . . In these sculptures I intend to evoke a complicated and often paradoxical range of meanings. The curving upper form of the Yale piece is thus protective as well as threatening—helmet, turtle shell, mushroom, atom bomb.

"Compositionally, *Floating Helmets* is an experimental work. It is the first of a group of large sculptures in which I have been concerned with interior as well as exterior space. The sculpture here becomes a sort of architectural structure, having an interior, or at least an underneath, that provides an essential part of the spectator's experience."

Hadzi was born in New York; he now lives and works in Rome. He studied art at Cooper Union and the Brooklyn Museum of Art. Since his work was first shown in 1956 at a New Talent exhibition at the Museum of Modern Art, New York, he has had numerous one-man shows, and has exhibited at the Venice Biennale, the Whitney Museum of American Art, the Museum of Auschwitz in Poland, and in London, Munich, and Düsseldorf. *Floating Helmets,* his largest sculpture to date, followed his *K. 458, The Hunt* (Philharmonic Hall, Lincoln Center, New York), which was inspired by a Mozart quartet.

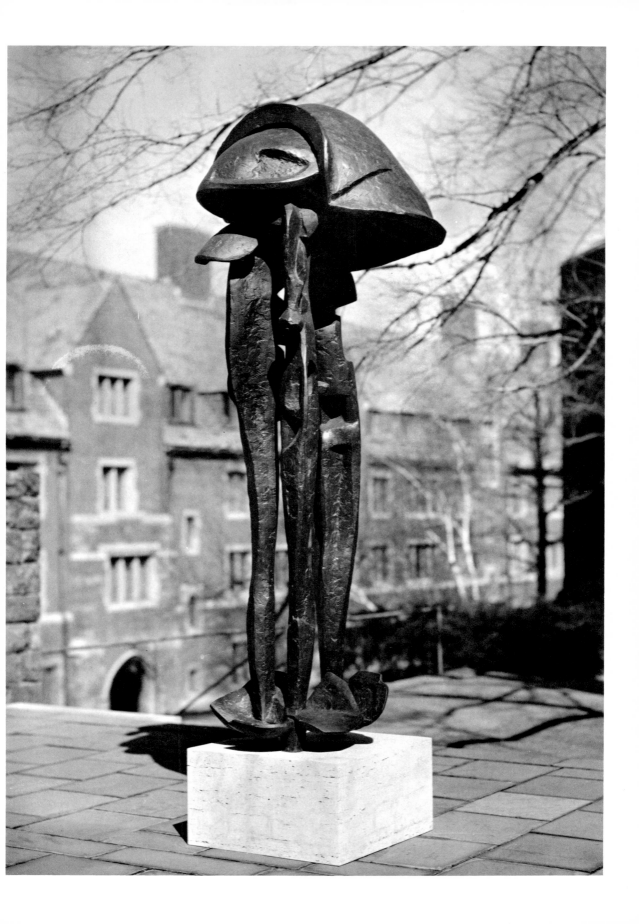

143. SIR JACOB EPSTEIN

British (b. United States), 1880–1959

*Venus,* 1917

Marble

H. 7 ft. 8¾ in.

Gift of Winston F. C. Guest, B.A. 1927

1957.38

This statue was carved during the brief period of Epstein's interest in Cubism. Since 1912 he had been living in Paris, where he met Modigliani, Brancusi, and Picasso, and shared their enthusiasm for African Negro sculpture and the ancient arts of the Mediterranean and the Near East. Egyptian and Cycladic elements can be detected in the head and torso of this *Venus,* blended with the flattened planes and crisp edges associated with Cubism. The figure is alive with Epstein's personal sense of vital force and rhythm; the flexed knees and the curves of the birds' bodies suggest that Venus—the "foam-born Aphrodite" of Homer—actually rides the waves. Epstein carved the figure in England, in a studio on the Sussex coast; he had gone there in 1913 from Paris, which he found an unsatisfactory environment for his work. The *Venus* was begun in 1914 and finished three years later.

Born in New York City, Epstein grew up in the polyglot surroundings of the Lower East Side. In 1901 he worked in a bronze foundry, studying sculpture in the evenings with George Gray Barnard. In 1902–06 he was in Paris, attending classes at the École des Beaux-Arts and later at the Académie Julian. In 1906 he went to England, where he received in 1907 his first important commission, the stone figures for the exterior of the new British Medical Association building. These provoked the first of many bitter controversies, in which he was supported by leading artists and writers of the day. Later works such as the tomb of Oscar Wilde in Paris, the Hudson Memorial in Hyde Park, and the gaunt, expressionist Christ figures, were among those most violently criticized. His superb bronze portrait heads and busts, which include many of the greatest men of the century, numerous women, and children, are vividly alive in a realist tradition that gained them general acceptance. Yale's *Venus,* in the more abstract manner Epstein used for allegorical or symbolic themes, is a landmark in the development of one of the twentieth century's greatest sculptors.

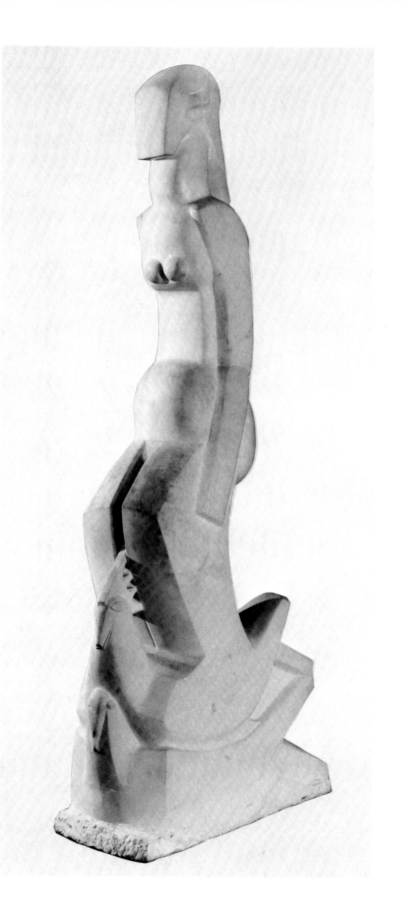

144. HENRY MOORE

British, 1898–

*Draped Seated Woman,* 1957–58

Bronze

H. 72½ in.

Gift of Mr. and Mrs. Alex L. Hillman

1959.19

One of the greatest sculptors of the twentieth century, Henry Moore is perhaps best known for his abstract carvings in wood or stone, but he has shown an increasing enthusiasm for bronze. During World War II he made a series of drawings of sleepers in London's underground bomb shelters; these studies stimulated his interest in drapery and contributed much to his later draped figures in bronze, of which Yale's *Seated Woman* is an important example. At the time of its acquisition, in 1959, the sculptor wrote to Andrew Ritchie:

"Besides revealing the form it covers, drapery can have infinitely varied surfaces and rhythms, large or small folds going round the form showing its section—or along it emphasizing its direction, lying slackly between points, or stretching taut from one point to another, showing thrusts from within. . . .

"Beneath surface interest there must be a satisfactory arrangement of forms—an alert alive pose, for power in sculpture is given by a strong tense spring in the relationship of the large masses to each other."

Like the great carved goddesses of ancient Greece, *Seated Woman* is both relaxed and dynamic, natural and monumental. The small, abstractly modeled head suppresses individual human quality in favor of a generalized, supernatural humanity of great dignity and power expressed through the splendid body.

Henry Moore was born in Yorkshire, England, the son of a coal miner. After military service in World War I, he studied at the Leeds School of Art and the Royal College of Art in London. Later he made trips to France, Italy, and Spain. He first visited the United States in 1946. Among the sources of his art are medieval, Renaissance, Sumerian, African Negro, and Pre-Columbian sculpture; he was also influenced by the abstract work of Picasso. He now lives in Hertfordshire, England. "All good art," he wrote in *The Listener* (August 18, 1937), "has contained both abstract and surrealist elements, just as it has contained both classical and romantic elements—order and surprise, intellect and imagination, conscious and unconscious. . . . I think the humanist organic element will always be for me of fundamental importance in sculpture, giving sculpture its vitality." *Draped Seated Woman* is a triumphant synthesis of the qualities Moore seeks to embody.

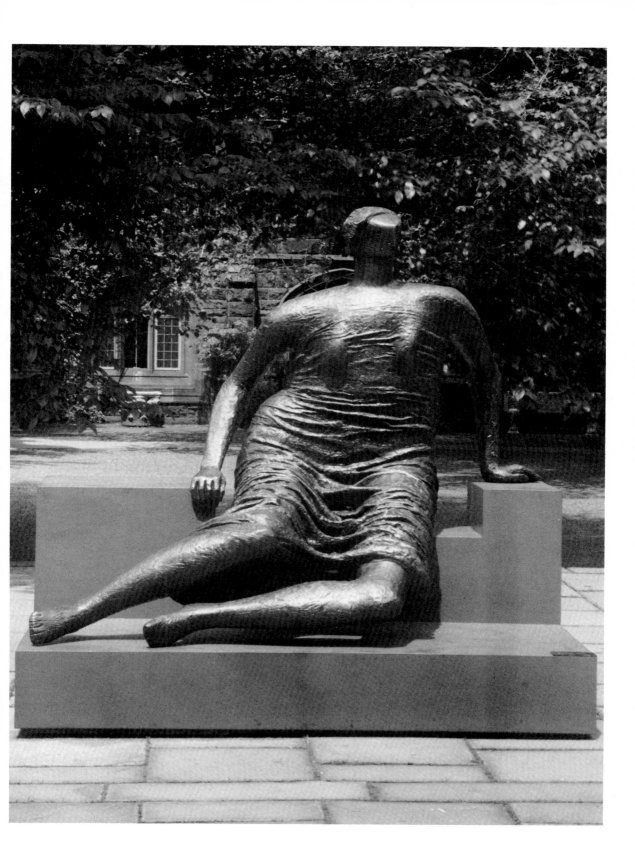

145. BARBARA HEPWORTH

British, 1903–

*Sea Form (Porthmeor),* 1958

Bronze

H. 30⅝ x W. 45 x D. 10½ in.

University purchase

1961.32

Porthmeor is a place name in Cornwall, where Barbara Hepworth has been living in St. Ives since 1939. This bronze, *Sea Form,* has been well described by a British art critic as a kind of landscape, "half shell, half wave." Made to be seen out of doors, its weathered gray-green and silver patina suggests the tones of rocks and driftwood. Miss Hepworth worked for many years in wood and stone, using direct carving and finishing each piece with exquisite craftsmanship. Since the mid-1950s she has turned to bronze, preparing models in plaster and sheet metal for final casting.

Strongly influenced by the abstract sculpture of Henry Moore and Jean Arp, Miss Hepworth's work echoes the pure form of the latter and the deeply humanizing expression of the former. Like Moore, she is concerned with symbolic relationships between man and nature; in this she is akin, also, to the ancient Greeks for whose arts, like those of Italy, she has a profound admiration. Of her own work she has said, "The dominant feeling will always be the love of humanity and nature; and the love of sculpture itself."

Barbara Hepworth was born in Wakefield, Yorkshire, and studied at the Leeds School of Art and the Royal College of Art in London. She spent three years in Italy, and many years later, in 1954, visited Greece. Early in her career she gave up modeling in favor of direct carving, creating smooth, serene shapes in which hollows are combined with simplified, abstract volumes. Since she first exhibited in 1928 her professional stature and international reputation have continued to grow. In 1953 she won second place in the competition for a monument to the Unknown Political Prisoner, and in the following year she designed costumes and sets for Tippet's opera *The Midsummer Marriage,* produced at Covent Garden, London. Among her largest works is the fifteen-foot bronze sculpture of 1958–59 for State House in High Holborn, London.

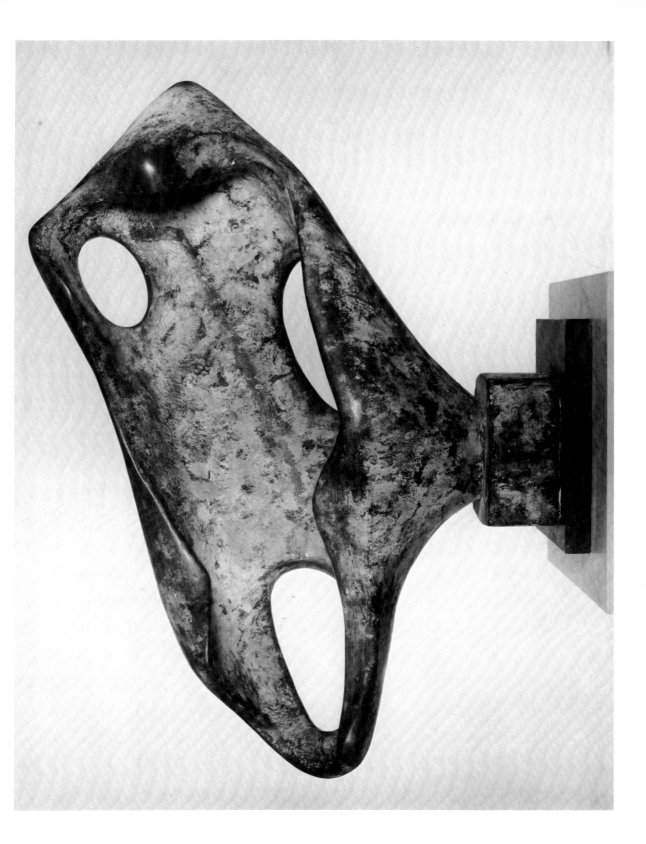

## 146. EDUARDO PAOLOZZI

British, 1924–

*The King*

Bronze

H. $105\frac{3}{4}$ x W. 24 in.

Director's Purchase Fund and Gift of the Yale University Art Gallery Associates

1963.50

"A metamorphosis of quite ordinary things into something wonderful." These words of Paolozzi's suggest a key to such figures as this one, made in the late 1950s when he was combining actual or imitated machine parts and scrap metal into powerfully imaginative and sometimes sinister creatures, never quite dehumanized. The mechanized objects become metaphorical expressions of human life, whether ironic, humorous, enigmatic, or threatening. The British critic David Thompson has spoken of Paolozzi's "big robots that grope their dark and unsteady way towards some kind of identity." He writes, "It is in the richly encrusted surfaces rather than the formal interest of his work that he displays the wealth of his prodigal and highly romantic imagination." One is not surprised to learn that among the sculptor's early enthusiasms were drawings by Picasso for *Guernica* and by Paul Klee. Figures such as *The King* and the bronze *Krokadeel* of 1959 have been compared to the nightmare personages in the paintings of Jean Dubuffet. Like empty suits of armor, they persuade us of a mysterious, invisible life inside them.

Paolozzi was born in Edinburgh, Scotland; his father was Italian. He studied at the Edinburgh College of Art in 1943 and at the Slade School of Art in London in 1944–47. From 1949 to 1955 he taught textile design at the Central School of Arts and Crafts in London, and he was visiting professor at the Hamburg Hochschule, Germany, in 1960–62. His work has been exhibited in many parts of the world. Among his important commissions are two sculptures for the 1951 Festival of Britain and a fountain for a park in Hamburg, finished in 1953. Paolozzi lives in London and at Thorpe-le-Soken on the east coast of Essex, England.

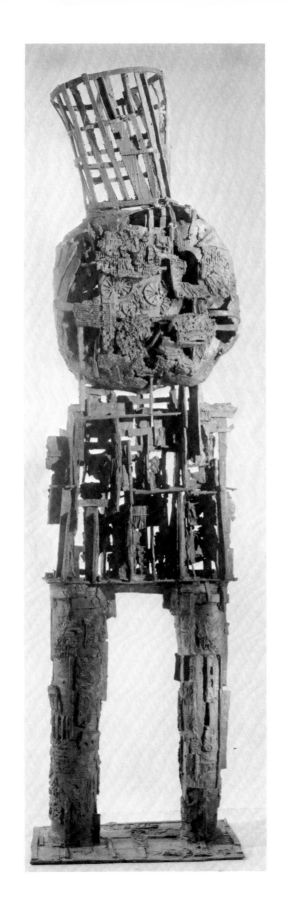

147. ARISTIDE MAILLOL

French, 1861–1944

*Air (L'Air)*

Lead

H. 50½ in. x L. 94¼ in.

Gift of Mr. and Mrs.
Henry J. Heinz II, B.A. 1931

1959.11

This lead figure, a late work by the artist, was cast post-humously; the original stone monument was commissioned by the city of Toulouse, France, as a memorial to the airmen of World War I. Maillol used the theme of the recumbent figure some years earlier in his stone monument to Cézanne of 1912–25.

Influenced by Greek sculpture, Michelangelo, and Rodin, Maillol concentrated almost exclusively on the female nude, to which he gave a truly classic dignity and time-lessness. "Sculpture is architecture, the balance of masses," he wrote. "That is what I want to give my statue, that thing alive, yet immaterial." A very few poses, based on underlying geometry, served his purposes. Like the Greek sculptors of the temple at Olympia he simplified natural forms, which he studied intensively, to their fundamental masses and contours, avoiding individualizing detail. He deeply admired Egyptian sculpture and the paintings of Cézanne.

Born in Banyuls, a Mediterranean fishing village, Maillol studied painting in Paris with Gérôme and Cabanel. Association with Gauguin and members of the Nabi group spurred his interest in tapestry design and manufacture, but the resulting eyestrain turned him, at the age of forty, to sculpture. His first popular recognition in that medium came from his *Mediterranean,* shown at the Salon d'Automne of 1905. A visit to Greece in 1908 with Count Kessler, owner of a private press in Weimar, led to a series of woodcut illustrations for Virgil's *Eclogues.* He also illustrated Longus's *Daphnis and Chloe,* and works by Horace and Ovid.

Yale's *Air* was chosen for exhibition in the Brussels World's Fair of 1958. It is a complete synthesis of the sculptor's aims and achievements; the solid, ideally generalized forms are poised with a miraculous lightness expressive of the monument's symbolic intention. Maillol would surely have approved of its present garden setting, for he once said, "Sculpture is made for open air."

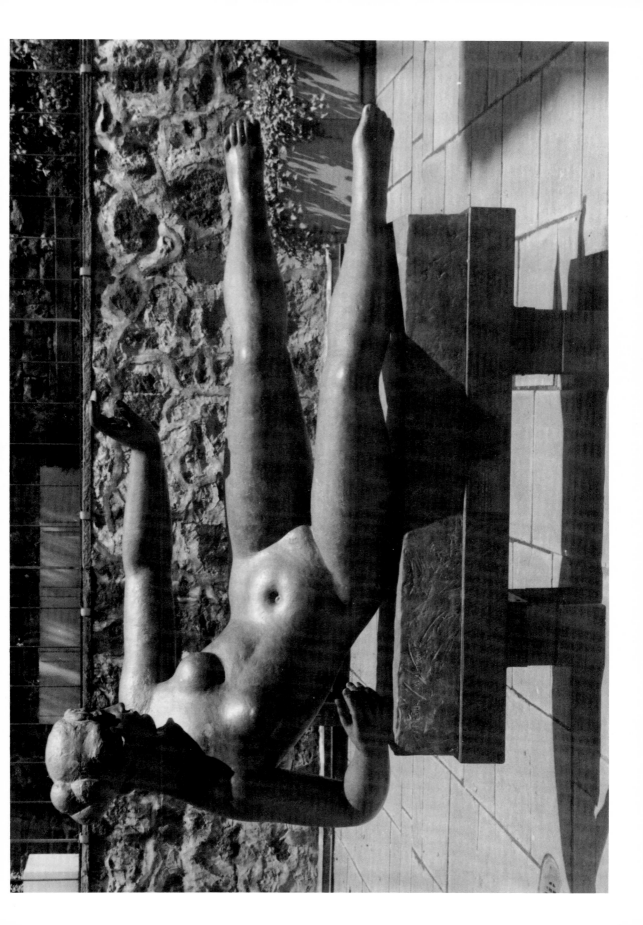

148. RAYMOND
DUCHAMP-VILLON

French, 1876–1918

*Seated Woman,* 1914

Bronze

H. 27 in.

Collection of the Société Anonyme

1952.30.7

The expressive curves and simplified masses of this figure
reflect the influence of Cubism, which powerfully affected
the sculptor in 1912. Two years later he produced his
famous *Horse,* which contains elements of Futurism as
well. Dynamic rather than static, restless with the potential
movement that was Duchamp-Villon's consuming interest,
*Seated Woman* nevertheless has stability: a repose achieved
through complete control of its energy-charged masses
and contours. This type of figure has had a marked, and
regrettable, influence on commercial art, which has
cheapened its forms through facile and banal imitations.

The sculptor was a brother of Jacques Villon and Marcel
Duchamp. He studied medicine for three years, turning to
sculpture about 1898. He was largely self-taught, although
at the beginning of his career he was influenced by Rodin.
In 1901 his work was shown for the first time at the
Société Nationale des Beaux-Arts in Paris. Between 1905
and 1913 he exhibited at the Salon d'Automne, and in
1913 he was represented in the Armory Show in New
York, at which his brother Marcel Duchamp's *Nude
Descending the Staircase* caused such a furor.

At the outbreak of World War I Duchamp-Villon joined
the army as a doctor; he died in 1918 as a result of blood
poisoning contracted during his service.

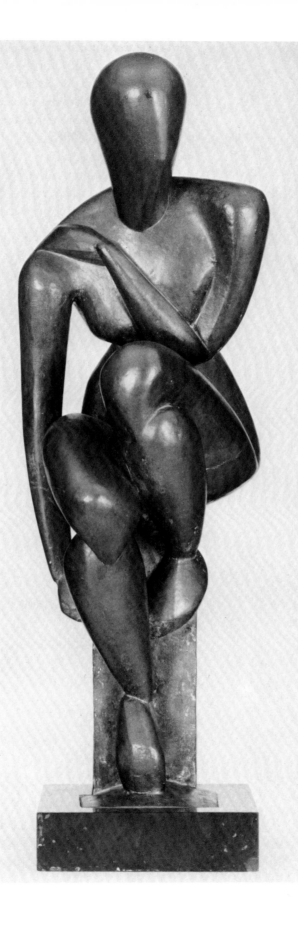

149. ANTOINE PEVSNER

French (b. Russia), 1885–1962

*Portrait of Marcel Duchamp,* 1926

Celluloid on copper

H. 37 x W. 25¾ in.

Collection of the Société Anonyme

1941.628

"Art must cease being representational in order to become creative.... Sculpture of mass is dependent on lighting, while our constructions carry shadow and light within themselves." These statements by Antoine Pevsner and his brother, the sculptor Naum Gabo, suggest the theories underlying their work (see No. 133). Both were associated with the Constructivist movement which developed in Russia shortly after World War I; their joint *Realist Manifesto* appeared in Moscow in 1920. Constructivism directed its efforts toward a synthesis of the plastic arts which should express the space-time reality in terms of twentieth-century developments in science and technology. In contrast, however, to such Constructivists as Vladimir Tatlin and Alexander Rodchenko, Pevsner and Gabo repudiated sociological intentions in their art, hoping to achieve universal appeal through purely abstract, non-representational forms divorced from socialist purposes. They used space as their primary medium of expression, as traditional sculptors create with mass. Like Gabo, Pevsner used transparent or translucent materials, especially celluloid, but he gradually came to prefer sheet metal.

Marcel Duchamp, the subject of this *Portrait,* painted the famous *Nude Descending the Staircase.* George Heard Hamilton has called the Duchamp portrait "a witty paraphrase of Gabo's earlier *Heads."* Flat shapes of celluloid (which have grown darker and more opaque with time) are arranged on a background of copper, most of them at right angles to the picture plane, so that their edges function like lines in a drawing, and space itself replaces the implied planes and volumes. The piece was commissioned in 1926 by the Société Anonyme in New York, and was exhibited in Brooklyn in that year.

Antoine (Anton) Pevsner was born in Orel, Russia, and studied in Kiev and St. Petersburg. In 1911 he went to Paris, where he met Modigliani and Alexander Archipenko. He and Gabo were in Norway during the Russian Revolution, returning home in 1920; they went back to Paris in 1923, and Pevsner became a French citizen in 1930. Both brothers designed ballet sets and costumes for Diaghilev.

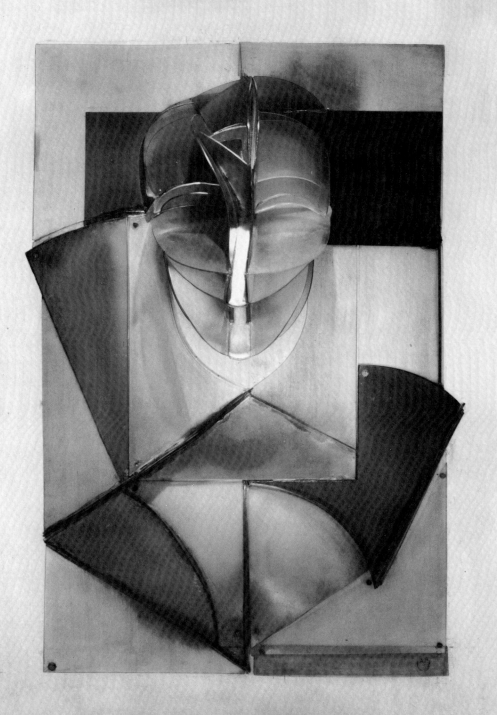

Antoine Pevsner 1924

150. JACQUES LIPCHITZ

French (b. Lithuania), 1891–

*Man with a Mandolin,* 1917

Stone

H. 29¾ in.

Collection of the Société Anonyme

1941.547

From the time he was eight years old, Lipchitz has worked in sculpture. Born in Lithuania, the son of a building contractor, he went in 1909 to Paris, where he studied at the Académie Julian and learned in commercial ateliers the techniques of stonecutting, modeling, and casting. About 1914 he was profoundly affected by Cubist painting and African Negro sculpture. It is to this phase of his work that Yale's *Man with a Mandolin* belongs. Built up in a series of flat surfaces bounded by straight lines and curves, the warm gray stone figure parallels, in three dimensions, the collages of the Synthetic Cubist painters of the day: Picasso, Braque, Juan Gris. With only a rudimentary suggestion of the subject—man, instrument, and music— the small carving is a handsome composition in which light and shadow provide color contrast and define solid masses; there is a formal balance suggestive of architecture. It is interesting to recall that Lipchitz greatly admires Cézanne and Rodin; the latter he has called "the supreme master of light composition in sculpture."

Lipchitz abandoned this pure Cubism a decade or so later in favor of a wholly different style in which mythological and other themes were presented in curved, energetically moving forms, often involving interrelationships of solids and empty spaces. But in 1945 he stated that "Cubism . . . was not a school, an esthetic, or merely a discipline—it was a new view of the universe. . . . Cubism was essentially a search for a new syntax. . . . I am still a Cubist, but expressing myself freely with all the means at my disposal from the Cubist point of view, not merely limiting myself to Cubism's syntax."

Lipchitz settled in the United States in 1941. His major undertaking in architectural sculpture, commissioned in 1944, was the façade relief *Prometheus,* for the Ministry of Education building in Rio de Janeiro.

151. WILHELM LEHMBRUCK

German, 1881–1919

*Female Torso*, 1910

Cast stone

H. 46 in.

Bequest of Katherine S. Dreier

1953.6.5

This figure illustrates Lehmbruck's fully developed style of 1910 when, during his first year in Paris, he came under the influence of Maillol and to a lesser extent Rodin. The physical proportions, like those of Maillol's figures, echo the standards of classical Greek sculpture, but instead of the French master's more idealized, generalized classicism, there is a personal, introspective quality, especially in the sensitively modeled head. This awareness of human feeling was to take over and dominate Lehmbruck's work, with startling suddenness, within a year from the date of the *Female Torso*. In 1911 he produced his famous *Kneeling Woman,* exaggeratedly slender in form and essentially an expression of an inner mood; 1913 saw the creation of his gaunt, starkly tragic *Standing Youth.* But in the *Female Torso* of 1910, all is serene, balanced, contented; it is an image of dream and fulfillment alike.

Other versions of this figure exist, including full-length examples, in bronze, marble, and cast stone. In the bronze *Standing Woman,* owned by the Museum of Modern Art, New York, a clinging drapery falls from mid-thigh to ankles.

Although he produced paintings, drawings, and prints, Lehmbruck was fundamentally a sculptor. "Sculpture," he wrote, "is the essence of things, of nature, of all that is eternally human." The human body was his vehicle of expression, but he was less interested in its physical potential than in its power to convey feeling—the relationship of mother and child, the ranges of thought and imagination, and, in his late work, suffering and despair. Son of a miner, he was born in Duisburg-Meiderich, Germany, and studied at the Academy of Düsseldorf. A trip to Italy in 1905 was followed by a second in 1912; except for that interlude he was in Paris in 1910–14. During World War I he was in Berlin and for a time in Zurich. He committed suicide in Berlin in 1919.

## 152. GIACOMO MANZÙ

Italian, 1908–

*Descent from the Cross with Cardinal,* II

Bronze

H. 29 x W. 21½ in.

Henry John Heinz II, B.A. 1931, Fund

1968.33

This bronze relief belongs to the series *Variations on a Theme,* made between 1939 and 1943 and dealing with the Crucifixion of Christ. Manzù's anticlerical and communist point of view embodied in these reliefs naturally aroused the disapproval of both Church and Fascist critics. The portly figure of the cardinal, who nowadays recalls the saintly pope John XXIII, was actually intended to symbolize Manzù's communist-atheist views of the Church as self-seeking, bigoted, and heartless. The *Variations* were followed in 1947 by the sculptor's first large exhibition, in the Palazzo Reale, Milan; a year later he won the prize for Italian sculpture at the Venice Biennale. In 1949 when the Vatican decided to commission bronze doors for St. Peter's in Rome, the secular press brought pressure on Pope Pius XII to appoint Manzù. The resulting reliefs are clearly the outgrowth of the earlier *Variations.* The sketchy, impressionistic handling and delicate low relief show the influence of Medardo Rosso first of all, and also that of Donatello. Manzù also admired the work of Maillol.

Although ecclesiastical themes play a large part in his sculpture, Manzù has also modeled sensitive portraits and full-length figures in the round. In these one always feels the touch of tools and fingers on clay—the freshness of the sketch which is so distinctive in the work of Medardo Rosso and certain studies by Rodin. Manzù formed a warm and unexpected friendship with Pope John while the latter was posing for his bust; the sculptor was born in Bergamo, near the village birthplace of the pope, whose death mask he also modeled.

Manzù was the son of a shoemaker who served as sacristan in a convent. As a boy of eleven he was an apprentice in wood carving and gilding, and was trained in stucco work. During his military service in Verona he studied at the Academy there, and then worked independently. In addition to those mentioned, his important commissions include the doors for Salzburg Cathedral and the Stations of the Cross for the church of Sant'Eugenio in Rome. He lives in Milan.

153. CONSTANTIN BRANCUSI

Romanian, 1876–1957

*Yellow Bird,* after 1912

Marble with limestone base

H. 86¼ in. (with base)

Collection of the Société Anonyme

1952.30.1

"Simplicity is not an end in art, but one reaches simplicity in spite of one's self by approaching the real meaning of things." These words of Brancusi suggest his dual concern with outward form and inner significance. The smooth flow of his surfaces and contours—what industrial designers used to call streamlining—defines essentials in volume and implies movement; at the same time these shapes embody symbols of organic life, whether animal or human: the potential or latent life of the egg, or the released vitality of the living creature. The simplified, abstract forms never become pure geometry, however; as Andrew Ritchie has said, "It is the mystical mastery of the artist Brancusi over his material that seems to tell him when the dividing line between organic life and dead geometry has been reached." The tactile and visual appeal of polished stone or metal, and the subtle suggestion of living organism and inner meaning, combine to make Brancusi's work instantly attractive even when it seems baffling. Inevitably the sculptor exerted a strong influence on twentieth-century art.

Brancusi was born in Hobitza, Romania. Early training as a cabinet maker may have stimulated his love for materials and fine craftsmanship. After a thorough academic training in Bucharest, he settled in 1904 in Paris, where he studied at the École des Beaux-Arts. He declined an invitation to study with Rodin, who had taken an interest in his work, but left the École on the older sculptor's advice. Like certain other sculptors who were then in revolt against Rodin's style and ideas, Brancusi turned to primitive arts and the sculpture of the Far East, at the same time absorbing something of the mystical and philosophical thought underlying those arts.

*Yellow Bird* was carved several years before Brancusi's famous *Bird in Space,* which exists in both stone and metal versions. There is great elegance in the tawny marble shape, poised upon the crisp angles of its limestone base. One is reminded of the serene curves of a Chinese porcelain vase.

154. ALBERTO GIACOMETTI

Swiss, 1901–1966

*Hands Holding the Void,* 1934

Plaster

H. 61½ in.

Anonymous gift

1950.730

This original plaster sculpture belongs to the period of Giacometti's association with the Surrealists, whom he joined in 1929 and abandoned some seven years later. In form the figure echoes his earlier "flat" sculpture—a declaration of independence from realistic imitation of the visible world. Greatly as the sculptor's style was to change after 1934, *Hands Holding the Void* illustrates two of his fundamental and continuing concerns: the exploration of space and the communication of mystical experience. The spare figure, reduced almost to abstract geometry, is a metaphor of awe in the presence of the unseen or the supernatural. Revelation or hallucination? The staring eyes, abstractions themselves, assert the vision as clearly as do the delicate hands enclosing emptiness. A bird's head, shaped in a tapering oval, is fixed at the right of the figure, recalling certain Egyptian sculptures such as Giacometti admired. In a later bronze casting of this original plaster, the bird has been omitted.

Giacometti was born in Stampa, in the Italian region of Switzerland, the son of a Swiss Impressionist. Existing drawings testify to his early interest in Van Eyck, Dürer, and Rembrandt. A trip to Italy in 1920 aroused his enthusiasm for Tintoretto, Bellini, and Byzantine mosaics. He turned from these to Giotto and Cimabue, and then to Roman Baroque art and Egyptian sculpture seen in Florence. In 1922 he studied under Émile Bourdelle at the Académie de la Grande Chaumière in Paris, where he was influenced by Jean Arp, Jacques Lipchitz, and Henri Laurens, and became interested in the primitive arts of Africa, Mexico, and Oceania. Having given up working from nature, he returned to the model after his years as a Surrealist, evolving his final style in the elongated, haunting nudes that stand or walk like phantom drawings in limitless space, at once the prisoners and the interpreters of the emptiness that encloses them. This interpretation of outer space and inner vision is foreshadowed in the sensitive, enigmatic *Hands Holding the Void.*

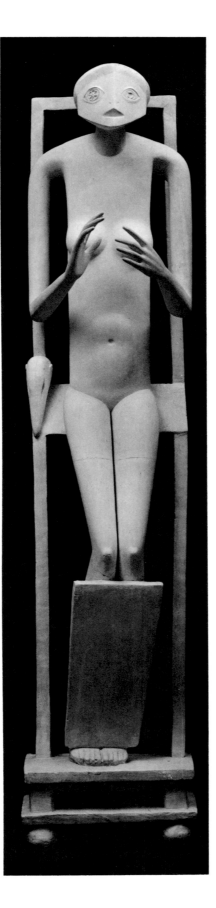

# INDEX OF ARTISTS

*Italicized numbers refer to the colorplates.*

Albers, Josef, 92
Anuszkiewicz, Richard, 94

Bavarian (Tyrolean),
    18th century, 128
Bellotto, Bernardo, 56
Bellows, George Wesley, 87, *19*
Benson, Ambrosius, 5
Bierstadt, Albert, 63
Bonnard, Pierre, 86, *17*
Bosch, Hieronymus, 4, *1*
Brancusi, Constantin, 153
Braque, Georges, 102, 103, *22*
Briosco, Andrea. *See* Riccio
Bruce, Patrick Henry, 89

Calder, Alexander, 134
Camaino, Tino di. *See* Tino
    di Camaino
Cézanne, Paul, 82
Chavannes, Puvis de. *See*
    Puvis de Chavannes
Chirico, Giorgio de. *See*
    De Chirico
Church, Frederick Edwin, 62
Claude Lorrain, 26, *7*
Clodion, Louis (Claude Michel),
    126
Cole, Thomas, 59
Constable, John, 71
Copley, John Singleton, 32–35,
    *4*
Corot, Jean-Baptiste Camille, 73,
    *14*
Courbet, Gustave, 75
Coustou, Nicolas, 125
Cranach, Lucas, the Elder, 6

Dali, Salvador, 115, *21*
De Chirico, Giorgio, 106
Degas, Edgar Hilaire Germain,
    79, 80
De Gheyn, Jacques, 17
Devis, Arthur, 46
Dove, Arthur, 90
Duchamp-Villon, Raymond, 148
Du Jardin, Karel, 22

Eakins, Thomas, 65–68, *18*
Earl, Ralph, 39, 40
Elsheimer, Adam, 27
English, 12th century, 116
Epstein, Jacob, 143

Ferber, Herbert, 139
Francesco di Giorgio, 13
Francia, Il (Francesco Raibolini),
    15
French, 12th-13th century, 117,
    28; 14th century, 118; late
    19th-early 20th century, 132
Fuseli, Henry, 50

Gabo, Naum, 133
Gaddi, Taddeo, 3
Gentile da Fabriano, 8
German, 16th century, 120

Gérôme, Jean Léon, 77
Ghirlandaio, Ridolfo, 16
Giacometti, Alberto, 154
Girardon, François, 123
Gris, Juan, 111

Hadzi, Dimitri, 142
Hals, Frans, 19, 20, 5
Harnett, William Michael, 69
Hepworth, Barbara, 145
Hicks, Edward, 57
Highmore, Joseph, 45
Homer, Winslow, 64, *11*
Hopper, Edward, 91
Houdon, Jean Antoine, 127

Inness, George, 61

Kandinsky, Wassily, 107, 108
King, Samuel, 37

Léger, Fernand, 101
Lehmbruck, Wilhelm, 151
Lipchitz, Jacques, 150
Lipton, Seymour, 135
Lissitzky, El, 110
Lorenzetti, Ambrogio, 2
Lorrain, Claude. *See* Claude
    Lorrain

"Magdalen Master," 1
Magnasco, Alessandro, 53
Magritte, René, 96, *20*
Maillol, Aristide, 147
Malevich, Kasimir, 109, *25*
Manet, Edouard, 78, *12*
Manzù, Giacomo, 152
Master of Messkirch, 7
Matisse, Henri, 99
Matta (Roberto Matta
    Echaurren), 97
Millet, Jean François, 74
Miró, Joán, 114
Modigliani, Amedeo, 105, *23*
Mondrian, Piet, 98
Moore, Henry, 144

Neroccio dei Landi, 13
Noguchi, Isamu, 136
Nomé, François, 28
North Italian, 15th century, 121

"Osservanza Master," 10

Panini, Giovanni Paolo, 54
Paolozzi, Eduardo, 146
Pater, Jean Baptiste, 51, *8*
Peale, Charles Willson, 38
Pevsner, Antoine, 149
Picasso, Pablo, 112, 113, *26–27*
Pollaiuolo, Antonio, 11
Powers, Hiram, 130
Puvis de Chavannes, Pierre, 76,
    *15*

Redon, Odilon, 83
Reynolds, Sir Joshua, 47, 48
Riccio, Il, 122

Rickey, George, 140
Rimmer, William, 131
Robert, Hubert, 52, 9
Rosa, Salvator. *See*
    Salvator Rosa
Rosati, James 141
Rubens, Peter Paul, 23, 24, 6

Salvator Rosa, 29
Samuel George, 70
Sassetta (Stefano di Giovanni),
    9, 10, 2
Servranckx, Victor, 95
Seurat, Georges, 84, 16
Signorelli, Luca, 14
Sisley, Alfred, 81
Smibert, John, 31
Smith, David, 137, 138
Spanish, 17th century, 124
Stefano di Giovanni. *See* Sassetta

Stella, Joseph, 88, 24
Stuart, Gilbert, 41, 42
Stubbs, George, 49, 10

Tanguy, Yves, 93
Teniers, David, the Younger, 25
Tiepolo, Giovanni Battista, 55
Tino di Camaino, 119
Trumbull, John, 43, 44

Uytewael, Joachim Anthonisz, 18

Valdés Leal, Juan de, 30
Van Gogh, Vincent, 72, 13
Vasarely, Victor, 104
Villon, Jacques, 100
Vivarini, Bartolommeo, 12, 3
Vuillard, Edouard, 85

Weenix, Jan Baptist, 21
Weir, Robert Walter, 60
West, Benjamin, 36